Alastair Dunca
was for fourteen years associated with
Christie's, New York, latterly as a Consultant. After joining
the auction house in 1977, he organized and catalogued
a great number of sales devoted to Art Nouveau and
Art Deco and nineteenth-century decorative arts. He has
acted as guest curator for exhibitions at the Smithsonian
Institution, Washington, D.C., and is now an independent
consultant specializing in the decorative arts of the nine-
teenth and twentieth centuries. He is the author of many
books, including *Art Deco Furniture*, *Art Nouveau Furniture*,
American Art Deco and *Masterworks of Louis Comfort
Tiffany*, all published by Thames & Hudson.

Thames & Hudson world of art

This famous series
provides the widest available
range of illustrated books on art in all its aspects.
If you would like to receive a complete list
of titles in print please write to:
THAMES & HUDSON
181A High Holborn, London WC1V 7QX
In the United States please write to:
THAMES & HUDSON INC.
500 Fifth Avenue, New York, New York 10110

Printed in Singapore

194 illustrations, 44 in color

ART DECO

Alastair Duncan

 Thames & Hudson world of art

To Alice

Special acknowledgments to Mary Beth McCaffrey

Title page: Detail of Micarta panel, exhibited at
"A Century of Progress Exposition," Chicago, 1933
(artist unidentified). The Mitchell Wolfson, Jr.
Collection, The Wolfsonian-Florida International
University, Miami Beach, Florida

© 1988 Thames & Hudson Ltd, London

First published in the United States of America in 1988
by Thames & Hudson Inc., 500 Fifth Avenue,
New York, New York 10110

thamesandhudsonusa.com

Reprinted 2000

Library of Congress Catalog Card Number 88-50231
ISBN 0-500-20230-3

Printed and bound in Singapore by C.S. Graphics

Contents

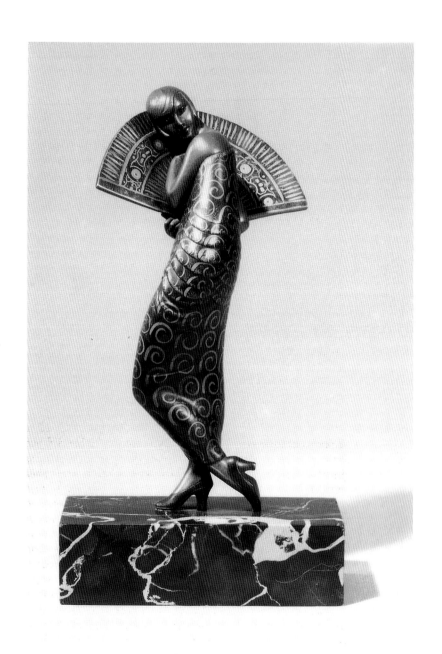

1 Alexandre Kéléty: cold-painted bronze figure of a young woman with a fan, *c.*1926

Introduction

Art Deco was the last truly sumptuous style, a legitimate and highly fertile chapter in the history of the applied arts. There is a continuing debate, however, on the exact definition of the term 'Art Deco' and the extent of the movement it encompassed. The initial belief, fostered when the Art Deco revival began, roughly in the mid-1960s, was that Art Deco was the antithesis of Art Nouveau, and had been spawned in 1920 to eradicate its 1900 predecessor, which history had already judged a grave, but mercifully brief, transgression against good taste. Today this theory is considered incorrect: Art Deco is seen not as the direct opposite of Art Nouveau but, in many aspects, as an extension of it, particularly in its preoccupation with lavish ornamentation, superlative craftsmanship and fine materials. Nor, as has been commonly believed, did Art Deco take root abruptly in 1920 and flower until it was blighted by the economic depression which engulfed Europe and the United States in 1930.

The First World War has generally been taken as the dividing line between the Art Nouveau and Art Deco eras, but the Art Deco style was actually conceived in the years 1908–12, a period usually considered as transitional. Like its predecessors, it was an evolving style that did not start or stop at any precise moment. Many items now accepted as pure Art Deco – furniture and *objets d'art* by Emile-Jacques Ruhlmann, Paul Iribe, Clément Mère and Paul Follot, for example – were designed either before the outbreak of hostilities in 1914, or during the war. The movement cannot therefore be rigidly defined, as it has been, within the decade 1920–30. Its inception was earlier, as was its decline. In fact, were it not for the four-year hiatus created by the First World War, the Art Deco style would have run its full, and natural, course by 1920.

What are the characteristics of Art Deco? In many ways, the style defies precise definition as it drew on a host of diverse, and often conflicting, influences. These were primarily from the world of avant-garde painting in the early years of the century. Elements from Cubism, Russian Constructivism and Italian Futurism – abstraction, distortion and simplification – are readily evident in the decorative arts

vernacular used by most Art Deco exponents. Examination of the style's standard iconography – stylized bouquets of flowers, young maidens, geometric patterns including zigzags, chevrons, and lightning bolts, and the ubiquitous *biche* (doe) – reveals further influences, such as the world of high fashion, Egyptology, the Orient, tribal Africa and the Ballets Russes. To these must be added, from 1925, the growing impact of the machine, depicted by repeating or overlapping images, and, in the 1930s, by streamlined forms derived from the principles of aerodynamic design.

The resulting amalgam of artistic influences is therefore highly complex, to the point that no single word or phrase can describe it fully. Bearing this in mind, the term 'Art Deco', coined in the late 1960s, remains the most appropriate to describe the distinctive decorative arts style which evolved in Europe immediately prior to the First World War, and which remained in fashion in some countries of its adoption until the late 1930s. In France, it manifested itself emotionally; with exuberance, colour and playfulness. In the rest of Europe, and later in the United States, its interpretation was more intellectual, based on concepts of functionalism and economy. This element of 1920s and 1930s design is known today as 'Modernism' to distinguish it from the high-style French variant, which is usually referred to as 'Art Deco'. Both strains were defined at their inception as *moderne*, and both were highly fashionable at different moments between the two World Wars. Together they constitute a broad and scintillating movement within the decorative arts, the first, in fact, inspired by twentieth-century impulses.

Just as the Art Deco style replaced Art Nouveau, so, in France, Art Deco yielded in turn to Modernism. Its demise began at its moment of triumph, the 1925 Exposition Internationale in Paris. The Exposition, planned originally in 1908, but postponed intermittently (due in part to the war), was eventually staged for April to October, 1925. Most European countries participated, except Germany, now a vanquished enemy nation, which claimed that its invitation arrived too late for its designers to prepare adequately. The United States also declined as its Secretary of Commerce, Herbert Hoover, felt that it could not meet the Modernist requirements for entry laid out in the Exposition's charter. Notwithstanding these omissions, the Exposition was considered by most critics as a major showpiece for Modernism, especially for the host nation, whose lavish displays and avant-garde architecture dominated the entire event.

Art Deco's first tenet, that form must follow function, later remained unchallenged by all succeeding schools of design, but its second, which

8

related to decoration, proved its undoing. By 1926 the loosely knit band of French Modernists – Francis Jourdain, Pierre Chareau, Le Corbusier, Robert Mallet-Stevens and René Herbst, among others – had become increasingly outspoken in their criticism of Art Deco designers who catered to select clients in the creation of elaborately crafted *pièces uniques* or limited editions. The Modernist argued that the new age required nothing less than excellent design for everyone, and that quality and mass production were not mutually exclusive. The future of the decorative arts did not rest with the rich, and even less with their aesthetic preferences. An object's greatest beauty lay, conversely, in its perfect adaptation of its usage. Each epoch must create a decorative vocabulary in its own image to meet its specific needs. In the late 1920s this aim was best realized by industry's newest means of production, the machine. Existing concepts of beauty, based on the artisan and his handtools, needed therefore to be redefined to meet the dictates of the new machine age. For the first time, the straight line became a source of beauty.

Modernism made rapid progress in the late 1920s, although most designers positioned themselves well short of the spartan functionalism espoused by its most ardent adherents. As Paul Follot, a veteran decorative arts designer, observed in a 1928 speech, 'We know that the "necessary" alone is not sufficient for man and that the superfluous is indispensable for him . . . or otherwise let us also suppress music, flowers, perfumes . . . and the smiles of ladies!' Follot's viewpoint was shared by most of his designer colleagues. Even if logic called for the immediate elimination of all ornamentation, mankind was simply not prepared psychologically for such an abrupt dislocation in lifestyle. Most designers therefore opted for a middle ground by creating functional machine-made items that retained a measure of decoration, the latter, ironically, often having at first to be finished by hand.

Outside France, functionalism had dominated decorative arts ideology since the end of the Victorian era. In Germany, the formation in 1907 of the Munich Werkbund carried forward the logic and geometry at the heart of the Vienna Secession and Glasgow movements some years earlier. In contrast to the litany of Art Nouveau flowers and maidens in neighbouring France, and its own lingering Jugendstil, the Werkbund placed emphasis on functional design applicable to mass production. A reconciliation between art and industry, updated to accommodate the technological advances of the new century, was implemented. Ornament was given only secondary status. This philosophy reached fruition in the formation in Germany of the Bauhaus,

9

which, in turn, inspired the Modernist strain which took root in American decorative arts in the late 1920s. After the First World War, other European and Scandinavian designers followed the German example by creating Bauhaus-inspired furnishings and objects. Examination of contemporary European art reviews shows that ornamentation was sparingly applied outside France. A certain amount was tolerated, but the high-style embellishments of Paris between 1910 and 1925 were viewed as a Gallic eccentricity which would not be assimilated elsewhere. The style's only foreign success was in American architecture, where it was adopted by a new generation of architects to enhance their buildings, particularly skyscrapers and movie palaces. In the early 1920s, the United States lacked a modern style of its own, so its architects looked to Paris, as the country always had, for leadership in design.

Furniture

That Art Deco furniture was quintessentially French, and specifically Parisian, becomes increasingly evident as examples from the period are analyzed. Almost nothing of comparable design or quality was produced in the 1920s outside France.

The roots of Art Deco furniture must be sought in the French *ancien régime* and the work of late eighteenth-century cabinetmakers such as Riesener and Weisweiler, a comparison actively encouraged by Ruhlmann, among others. After the exuberant Art Nouveau era, in which furniture designers were considered to have strayed from the path of traditional French taste, there seemed to be the need for a return to purity of form and refinement. Beauty was now considered to lie in the graceful proportions of a chair leg or the understated ivory banding along its apron. Adolf Loos and Francis Jourdain at the beginning of the century had held that the prevailing 1900 fashion for ornamentation was an aberration which would soon yield to a more rigid architectural discipline, and they were right.

Decoration, however, was not abandoned. It remained an integral part of Art Deco furniture. Beauty in the home, it was argued, was essential to man's psychological well-being.

MATERIALS

Ebony, with its jet black surface, buffed repeatedly to draw out its innate majesty, was Art Deco's favourite wood. But by the 1920s it was rare and expensive. Cabinetmakers had to make do either with ebony veneers or with substitute woods. The most popular, because of its distinctive parallel grain, was macassar ebony, from the Island of Celebes in Indonesia. Other imported tropical veneers were palmwood (*palmier*), Brazilian jacaranda (*palissandre de Rio*), zebrawood and calamander, though the two latter were used sparingly as their grains were felt to be overpowering. Apart from these exotic woods, there was also a wide range of traditional veneers: amaranth, amboyna, mahogany, violetwood and sycamore. These were often used in juxtaposition with a contrasting burl wood, such as maple or ash.

Other more or less unexpected materials used in furniture making included lacquer, shagreen, ivory and wrought-iron. Lacquer was employed by Eileen Gray, Jean Dunand, Maurice Jallot and Katsu Hamanaka – to give a touch of opulence to their furniture. But by 1930 its high gloss effects could be reproduced by industrial synthetic varnishes. Shagreen (called *galuchat* in France) is the skin of a small spotted dogfish; it could be left in its bleached state, varnished, or tinted blue or green to accentuate its granular surface pattern. Snakeskin and animal hides, such as ponyskin, were used in a similar way. Ivory, absent from furniture design in 1900, was brought back to give grace and refinement to drawer pulls, *sabots*, or to the slender *chute* which outlined the curve on a cabriolet leg. Wrought-iron also underwent a resurgence. In the hands of Edgar Brandt and Raymond Subes, its unyielding mass became as malleable as putty for furniture, light fixtures and architectural features.

Three Art Deco cabinetmakers exploited this array of newly fashionable materials with particular success: Adolphe Chanaux, Clément Mère and Clément Rousseau. Of these, Chanaux was undoubtedly the most accomplished.

Throughout his career, Chanaux played second fiddle to a group of designers including Groult, Ruhlmann and Frank, who benefited hugely from his creativity. He was equally inventive with *galuchat*, parchment, vellum, ivory, straw marquetry and hand-sewn leather, but very few of his pieces bear his signature.

Clément Mère was a generation older than most Art Deco designers, and at first specialized in items such as letter openers, toiletry items, fans and book covers in *repoussé* leather, *galuchat* and ivory; objects of exquisite refinement and femininity, showing clear Oriental influence, particularly in their patinated leather floral designs. Mère's first adventures with furniture were shown at the Salons of the Société des Artistes Décorateurs and the Société Nationale, around 1910. Preferred woods were macassar ebony, maple and rosewood. Materials were more important to him than shape.

Clément Rousseau's furniture is very rare and much sought after by collectors. Even a table lamp base, pedestal or small *meuble barbière* arouses excitement. The magic lies both in the form of his pieces – they show a very personal, somewhat whimsical, interpretation of late eighteenth-century furniture styles – and in the superb interplay of his materials. Richly grained palmwood or rosewood provide the framework for furniture veneered with stained sharkskin intersected by thin ivory banding, a technique which Rousseau adopted in 1912.

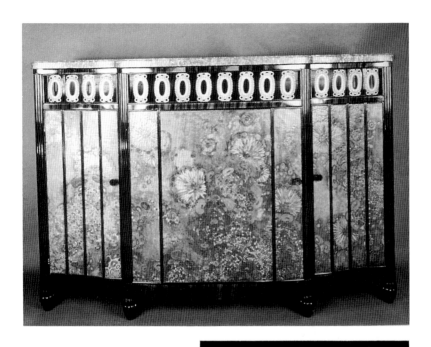

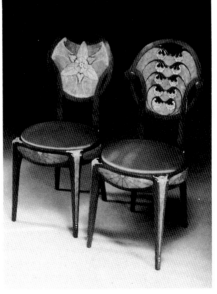

2–4 *Top* Clément Mère: sideboard, macassar ebony, lacquered *repoussé* leather and ivory, *c*.1925 (Collection Primavera Gallery, New York). *Above left* Clément Mère: cabinet, macassar ebony, lacquered *repoussé* leather and ivory, 1920s (Collection de Lorenzo Gallery). *Above right* Clément Rousseau: pair of chairs, rosewood, sharkskin, ivory and mother-of-pearl, *c*.1925 (Collection Virginia Museum of Fine Arts)

5 Emile-Jacques Ruhlmann: *encoignure* in palisander, macassar ebony and ivory, 1916 (Collection Virginia Museum of Fine Arts)

THE 1920/30S FURNITURE DESIGNERS

The Art Deco furniture designers of the interwar years can be grouped loosely into three categories: traditionalists, individualists and Modernists.

Traditionalists

The traditionalist took as his point of departure France's eighteenth- and early nineteenth-century cabinetmaking heritage, a legacy which provided the inspiration for a host of 1920s designers, most of them based in Paris.

Ruhlmann takes pride of place. Had France of the 1920s been a monarchy, Ruhlmann would certainly have held the position of *ébéniste du roi*. No work as fine as his had been seen for 125 years. The forms are elegant, refined and, above all, simple. Although many of his most celebrated works were designed before 1920, his furniture is today considered the epitome of the Art Deco style, and its finest expression.

Born in Paris in 1879 to Alsatian parents, Ruhlmann made his debut at the 1913 Salon d'Automne, an inauspicious moment to start a career. Throughout the war, however, he was intensely productive, designing such masterpieces as his 1916 *encoignure* in ebony, its door veneered with a large basket of stylized blooms. In 1919 he went into partnership

with Pierre Laurent to form Les Etablissements Ruhlmann et Laurent in Paris. Lacking his own cabinetry facilities, Ruhlmann's designs between 1913 and 1924 – that is, for roughly half of his career as a furniture designer – were executed by a range of *ébénistes* in the Faubourg Saint-Antoine, especially Haentges *frères* and Fenot.

The 1925 Exposition made Ruhlmann's international reputation. Until then, he had been largely unknown to the general public, working only with a few privileged clients. His Hôtel du Collectionneur pavilion at the Exposition changed that, however. Hundreds of thousands of visitors flocked through its monumental doors to gaze in awe at the majestic interior.

Only the rarest and most exquisite materials were used by Ruhlmann for his furniture. Rich veneers, such as palisander, amboyna, amaranth, macassar ebony and Cuban mahogany, were inlaid with ivory, tortoiseshell or horn. Dressing-tables were embellished with leather, *galuchat* or parchment panelling. Silk tassels applied to drawer pulls added a further touch of elegance. On rare occasions, a piece was sent to Dunand to be lacquered.

6 Emile-Jacques Ruhlmann: Grand Salon of the Hôtel du Collectionneur at the 1925 Exposition, Paris; the carpet by Gaudissard, fabric designs by Stéphany, the painting above the fireplace by Jean Dupas

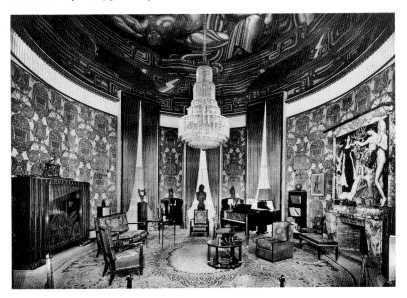

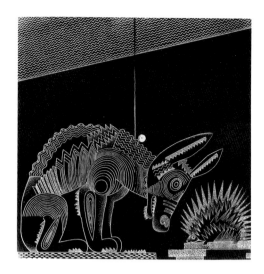

7 Jean Lambert-Rucki:
'Hedgehog and Donkey',
door panels in lacquer by Jean
Dunand for a cabinet by
Emile-Jacques Ruhlmann,
c.1925, exhibited in the
Grand Salon of the Hôtel du
Collectionneur at the 1925
Exposition, Paris

In view of the fact that his reputation rested in part on the use of sumptuous veneers, Ruhlmann reacted with remarkable equanimity to the popularity of metal after 1925. He justified his adoption of metal by saying that it countered the damage caused to wood veneers by the dry heat of centrally heated houses. Ruhlmann's 1932 desk for the Maharajah of Indore is a fine example of the successful incorporation of metal, its princely proportions embracing such chromed accessories as a telephone, swivel lamp and wastepaper basket.

The partnership of Louis Süe and André Mare was formalized in 1919 in La Compagnie des Arts Français. The firm remained in business until 1928, when Jacques Adnet assumed its directorship. Mare returned to painting and Süe continued on his own as an architect-*ensemblier*.

Süe et Mare's furniture was traditionally inspired. They considered the style of Louis-Philippe to be the most recent legitimate style. As Mare explained in 1920: 'It responded to needs which we still have. Its forms are so rational that the motor-car designer of today who draws the interior of a car uses them unconsciously. We are not reviving it; we are not deliberately continuing it, but we find it while seeking out simple solutions, and through it we bind ourselves to the whole of our magnificent past. We are not creating a merely fashionable art.' Süe et Mare's armchairs were lush and inviting, their tufted, colourful velours upholstery offering comfort and luxury. Other models were Baroque, even theatrical. Their imposing desk in Gabonese ebony, purchased directly by the Metropolitan Museum of Art, New York, from the 1925 Exposition, incorporated *ormolu* feet cast as elongated fronds – an updated version of rococo cabinetry.

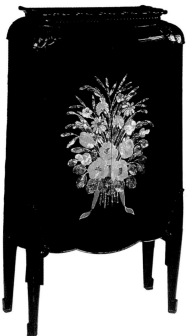
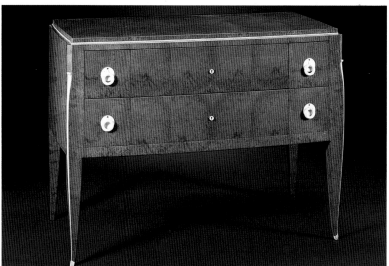

8–10 *Top left* Emile-Jacques Ruhlmann: cabinet, macassar ebony with silvered-bronze lock plate by Janniot, 1920s. *Top right* Süe et Mare: cabinet, ebony, mother-of-pearl and silver, 1927. *Above* Emile-Jacques Ruhlmann: commode, amboyna and ivory, c.1923

Their pavilion at the 1925 Exposition, Un Musée d'Art Contemporain, received almost as much attention as Ruhlmann's nearby Hôtel du Collectionneur. It consisted of a rotunda and gallery, the interior decorated by a team of collaborators, including sculptors, carpet and textile designers and painters. The furniture in carved gilt-wood was upholstered in Aubusson tapestry.

An even more convinced traditionalist, Jules Leleu, pursued a decorative style hallmarked by a devotion to impeccable cabinetry, harmony and the finest materials available. Warm woods became his hallmark – walnut, macassar ebony, amboyna and palisander. Marquetry decoration, never extensive, was in ivory, *galuchat* or horn. Lacquer was introduced in the late 1920s and smoked glass panels and metal mounts in the 1930s. The latter were, however, restricted wherever possible as Leleu believed that, unlike wood, they did not improve with age.

Leleu's commissions included ensembles for embassies and ministries, a dining room for the Elysée Palace and ensembles for the oceanliners *Ile-de-France*, *L'Atlantique*, *Pasteur* and *Normandie*, providing the last-mentioned with its de luxe 'Trouville' apartment (two rooms with lacquered seat furniture, ash piano, Aubusson murals and ivory-coloured Moroccan leather wall panelling).

Like Dufrène and Jallot, Paul Follot made the transition from the 1900 aesthetic to the 1920s with great facility. His prewar furniture, shown at the 1912 and 1913 Salons, incorporated a stylized basket of fruit and summer bloom motif which is today considered an Art Deco classic.

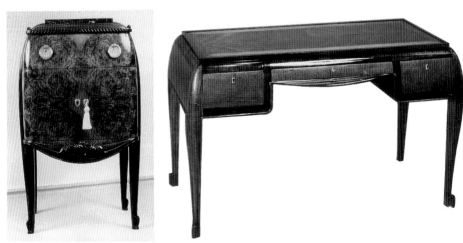

11, 12 *Left* Süe et Mare: chest-of-drawers, rosewood, burl maple and gilt-bronze, 1920s. *Right* Süe et Mare: desk, palisander and amboyna, mid-1920s

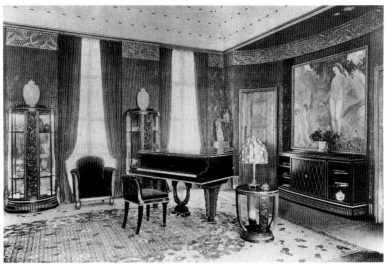

13 Paul Follot: Grand Salon, marketed by Pomone and exhibited at the 1925 Exposition, Paris

In 1923 he became director of the design studio, Pomone, and in 1928 joined Serge Chermayeff at the newly opened Paris branch of Waring & Gillow. Follot designed a wide range of furnishings throughout a lengthy career as an *ensemblier*, in a Neoclassical and aristocratic style. The rich effect of his furniture designs derived from brightly coloured and tufted damask upholstery on gilt-wood frames.

Maurice Dufrène, artistic director of La Maîtrise, the design studio 14 of the large Parisian department store, Les Galeries Lafayette, played a prominent part in providing machine-made editions of furniture at inexpensive prices, believing that this need in no way diminish aesthetic standards. At the 1925 Exposition, examples of his work were on view, literally, everywhere.

The decorating firm of Dominique was established in 1922, and was soon producing a wide range of carpets, fabrics, furniture and wrought-iron. In addition to the annual Salons, the firm participated in the Ambassade Française pavilion at the 1925 Exposition. Its furniture designs were invariably refined and logical. Preferred woods in the early years were palisander, macassar ebony and sycamore. Upholstery was in silk, velours or leather. Many fine examples of the firm's designs were shown from 1926 at the exhibitions of 'Les Cinq'. Noteworthy was a *chiffonière* in thuya wood with silver mounts by Puiforcat and a walnut drop-front secretary veneered in blue-tinted sharkskin. The

19

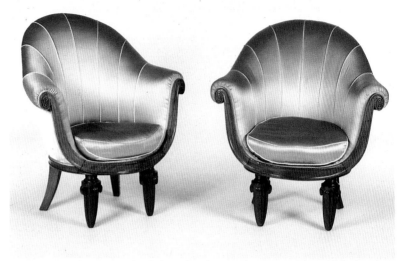

14 Maurice Dufrène: pair of upholstered mahogany *bergères gondoles* exhibited at the Salon d'Automne, 1913

1930s witnessed a dramatic shift to synthetic fabrics, including artificial silk and Rodhia canvas. For the oceanliner *Normandie* some years later, Dominique designed the de luxe apartment 'Rouen'.

Similar in style to Dominique, the decorating firm of Décoration Intérieure Moderne (D.I.M.), was established in 1919 under the direction of René Joubert, Georges Mouveau and (later) Philippe Petit.

The firm was traditional, its inspiration often Louis XVI or Restauration. Editions were small, for an elite clientele. Warm woods, such as palisander, walnut and macassar ebony, imparted the desired feeling of luxury. Decoration was provided most successfully by the incorporation of large panels of burled veneers, such as fernwood, which had a most pronounced grain. Marquetry, always understated, was confined to ivory or coralwood cross-banding or trim.

The furniture of Léon-Albert Jallot, one of the older generation of 1920s decorators, was similarly traditional: formal eighteenth-century shapes decorated with heavily carved floral panels and mouldings. But from 1919 he abandoned this style, relying for decoration on burled veneers, especially jacaranda and wild cherry, to provide contrasting compositions. Marquetry, in ivory or mother-of-pearl, enhanced the wood's rich grain.

29

Léon was joined in 1921 by his son, Maurice (who was as energetic and versatile as his father). At the 1925 Exposition father and son exhibited widely, both singly and in partnership. Furnishings were provided for the Hôtel du Collectionneur (*Grand Salon*), Ambassade Française (smoking room, man's bedroom, reception hall and small *dégagement*), La Société Noël, La Maison de Bretagne and Gouffe Jeune.

The Jallots displayed at the Salons for many years. Their furniture in the 1920s was in wood – palisander, walnut, amboyna, camphor – sometimes enhanced with *galuchat* or eggshell. From 1926 they faced the problem common to all woodworkers: whether to adjust to, or fight, the revolutionary introduction of glass and metal. They chose the former, introducing a distinctive range of modern furniture: stainless steel card-tables with reversible tops, and mirrored cabinets and tea-tables. Lacquered doors, psyches and screens were perennial favourites, with motifs ranging from monkeys and angular fish to pure geometry.

André Groult's reputation as an Art Deco exponent rests today on the woman's bedroom which he exhibited in the Ambassade Française pavilion at the 1925 Exposition. Its *bombé* chest-of-drawers, veneered in

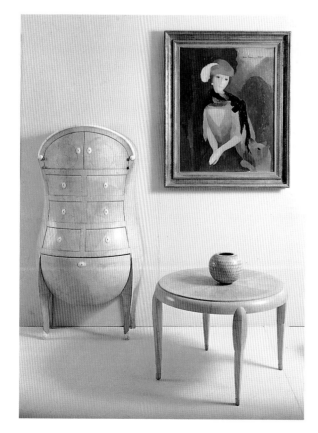

15 Andre Groult: table and *bombé* chest-of-drawers in *galuchat*, the painting by Marie Laurencin (see p. 146). Photo Sully-Jaulmes

16 André Groult: bedroom ensemble, 1925 Exposition, Paris

galuchat with ivory banding, became one of the talking points of the Exposition, its anthropomorphic shape an endless source of conjecture among the critics. The remaining furniture, in a mixture of *galuchat*, ebony and velours upholstery, imparted the intended feeling of elegance and femininity.

18, 19 Also traditional, but evolving the most distinctly personal style of the era, was Armand-Albert Rateau. Among his most important commissions were the Blumenthal family's residences in Paris, Grasse and Passy, and Jeanne Lanvin's apartment in the rue Barbet-de-Jouy, where Rateau decorated the bathroom and bedroom in Lanvin-blue silk embroidered with yellow and white roses, animals, pheasants and palm trees, themes which he reproduced as mounts in the rooms' furniture.

Rateau participated in the 1925 Exposition and, the following year, in a retrospective travelling exhibition which toured eight American museums. In the second half of the 1920s, interiors were completed for the Duchess of Alba, Baron Eugène de Rothschild, Dr Thaleimer and Mlle Stern. His style was distinctive, its inspiration the Orient and antiquity. Pheasants, butterflies, gazelles and acanthus were recurring themes. Early oak furniture gave way to bronzeware enhanced with *verde antico* patina.

Paul Poiret is best known as a couturier, but his boundless creativity also led him into the field of interior decoration. In April 1911, following visits to the Wiener Werkstätte and the Palais Stoclet, he founded L'Ecole Martine, where twelve-year-old girls from the working-class suburbs of Paris were instructed in the study of nature. There was no teaching staff and no formal tuition. The girls were encouraged to visit the Jardin des Plantes and to make sorties into the countryside to sketch flowers. The results, translated into a wide range of designs for textiles – carpets, wallpapers and upholstery fabrics – were spectacular.

The Martine School participated at the annual Salons from 1912. Carpets predominated, either as individual exhibits or as part of entire rooms. A wide range of furnishings were added in the 1920s: pianos, lampshades, cushions, vitrines and lacquered and marquetry tables. The influence of the Ballets Russes and Bakst, in particular, was omnipresent. Chairs, sofas and beds were piled high with sumptuous tasselled cushions and bolsters. The School's furniture designers included Mario Simon, Léo Fontan and, of course, Poiret himself. For the 1925 Exposition, Poiret devised a masterful means of capturing the limelight: three barges, moored in front of the Quai de la Seine, were fitted with characteristically plush interiors and were widely admired.

17 Léo Fontan for the Atelier Martine: *petite commode*, silver-leafed wood, 1923

18 Armand-Albert Rateau: pair of lacquered wood and bronze panels, designed for his residence on the Quai de Conti, Paris, c.1930

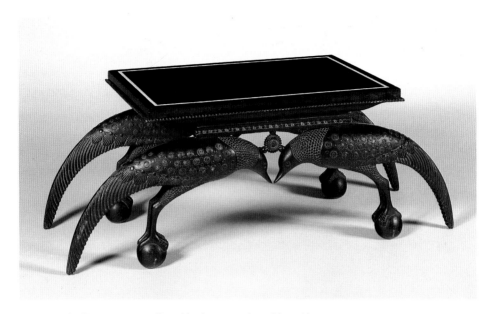

19 Armand-Albert Rateau: coffee table, bronze and marble, mid-1920s

20, 33

Paul Iribe's creativity was confined largely to four short years, from 1910 to 1914. Trained as a commercial artist, Iribe became known as a caricaturist for a range of Parisian journals, but with the encouragement of the couturiers Poriet and Jacques Doucet, he also ventured into the field of interior decoration. For Doucet he designed a selection of furniture, including two *bergères* and a commode, which were donated subsequently to the Musée des Arts Décoratifs, Paris. A further pair of *bergères*, bearing the broad, circular, snail-like, spiralled armrests which characterize Iribe's most spectacular designs, were included in the landmark sale of Doucet's collection at the Hôtel Drouot in 1972.

Iribe's style combined a Louis XV flamboyance with the discipline of 1800. There is also a pleasing touch of femininity and comfort. Preferred woods were zebrawood, with its distinctive grain, macassar ebony and mahogany. A favourite stylized motif was the 'rose Iribe', now a symbol of high Art Deco, despite its prewar conception.

At the beginning of 1920, at twenty-five years of age, Jean-Michel Frank found himself alone with a sizable inheritance, and spent the next five years travelling extensively and establishing himself in Paris's fashionable inner circle. His association with Chanaux and other

25

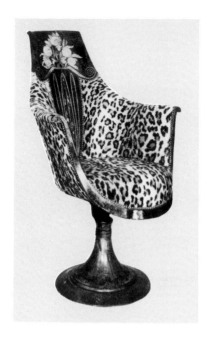

20 Paul Iribe: swivel chair, c.1914

21 Jean-Michel Frank: view of an interior, the cabinet and chair veneered in straw marquetry, the wall in vellum, c.1928 (photo courtesy of Félix Marcilhac)

talented artists and craftsmen, including Alberto and Diego Giacometti (furnishings such as light fixtures, vases and andirons), Salvador Dali (furniture and screens), and Christian Bérard (carpets), brought Frank instant celebrity and many eminent clients. It is his veneers which distinguish his works: straw marquetry, vellum, parchment, snake- and sharkskin, suede, cane and gypsum. Lamp bases, if not in bronze or plaster by the Giacometti brothers, were made of curved strips of ivory or hewn from rock crystal, quartz or alabaster. Furniture woods, initially hidden by the feast of straw and sharkskin, included ebony, sycamore and maple.

Frank's conception of interior decoration was architectural. There is a finely tuned relationship between the length of a sofa and that of a mantelpiece, which, in turn, relates to the dimensions of the windows, the height of the ceiling, or the space of the doors. Also, less furniture was more. A story survives of Jean Cocteau's comments on leaving Frank's sparsely furnished apartment on the rue de Verneuil, 'A nice young man. Very nice, in fact. Pity the burglars got everything.'

Outside France, the Parisian Art Deco high-style was only infrequently adopted in furniture. In Germany, Bruno Paul applied the French fashion for contrasting parquetry veneers in custom-made pieces from

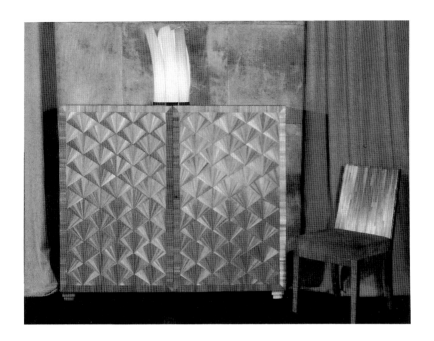

1914, but with little exuberance. In England, Sir Ambrose Heal, Sir Edward Maufe and Betty Joel incorporated a similarly conservative interpretation into their Modernist designs, as did the Russian *émigré*, Serge Ivan Chermayeff. In the United States, it was rejected by the public as too flamboyant for traditional tastes. In New York, the Company of Mastercraftsmen produced a series of marquetry and ivory-inlaid pieces that drew a direct influence from Paris, particularly the works of Dufrène and the department stores. Also in Manhattan, Joseph Urban created some theatrical chair models displayed at the opening of the Wiener Werkstätte in America showrooms in 1922. These were inspired more by the Vienna Secession than by Paris, however, in their choice of colour and mother-of-pearl inlay. In Chicago, Abel Faidy designed a similarly ornate suite of lounge furniture for the Charles and Ruth Singleton residence, in 1927.

Should the furniture of Eliel Saarinen be counted among the products of Art Deco? Some would argue that it should. For his house at the Cranbrook Academy, he designed a dining-room ensemble which drew on the principles of French Modernist design. The chairs have classical fluted backs emphasized by the contrasting colours of the pale fir veneer and intersecting black-painted vertical stripes. The table is

inlaid with an elegant geometric pattern which recalls the restrained parquetry introduced by Dominique and D.I.M. in Paris some years earlier.

Numerous other designers in the United States created Modernist wood furniture under French influence: Eugene Schoen, Hermann Rosse, Ilonka Karasz, Jules Bouy, Herbert Lippmann, Ely Jacques Kahn, Robert Locher and Winold Reiss.

Individualists
This category is reserved for those furniture designers whose brilliant individualism put each one into a class of his or her own. Of these, Eileen Gray was the most eminent.

Born in Ireland, Gray entered London's Slade School of Art in 1898, in her free time learning the technique of Oriental lacquer. In 1902 she went to Paris, where she installed herself five years later in a flat at 21 rue Bonaparte, which she retained for the rest of her life. Lacquer

22 Eileen Gray: 'Le Destin', 4-panel screen in red lacquer with bronze and silver applications, the reverse with an abstract geometric design in black and silver on a red ground (photo Réalités)

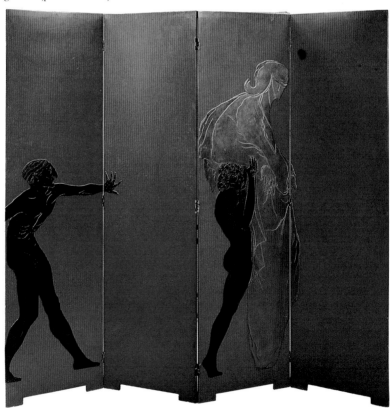

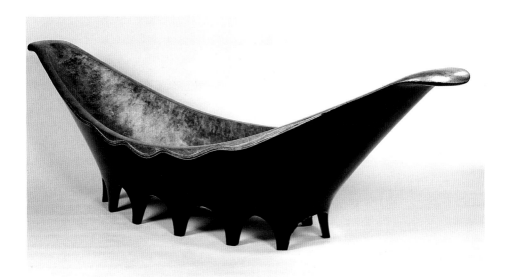

23 Eileen Gray: 'Canoe' chaise longue, lacquered wood and silver leaf, c.1919–20 (Collection Virginia Museum of Fine Arts)

remained her prime interest, and she sought out the Japanese master, Sougawara, to perfect her rudimentary training. Practically from the start, her furniture designs anticipated the International Modern style of fifteen years later. As she recalled in a 1973 interview with Eveline Schlumberger in *Connaissance des Arts*, 'My idea was to make things for our time; something which was possible but which no one was doing. We lived in an incredibly outdated environment.' Her style incorporated a pastiche of Far Eastern and French influences well in advance of her contemporaries, but she rejected the past, and later vehemently denied any kinship with the Art Deco movement.

In 1913 Gray's exhibit at the Salon of the Société des Artistes Décorateurs came to the attention of Jacques Doucet, who commissioned three important *pièces uniques*: the celebrated 'Le Destin' screen, and two tables, one an exotic creation with leg capitals carved as lotus blooms, the other a two-tiered circular model with four pairs of twin block-carved legs. The screen marked the transition soon to emerge in her work. On its front were depicted classical figures; on the reverse, a starkly abstract design – a bold proclamation by the artist that she could move in either direction.

Gray's career was interrupted by the First World War, part of which she spent in London. On returning immediately after the armistice, she

received a major commission from the milliner Suzanne Talbot. The result included some of Gray's most luxurious and theatrical creations –
23 an African-inspired canoe-shaped chaise longue, for example, and an armchair with front legs carved as rearing serpents. Draped animal skins added to the air of luxury. A series of black-lacquered block screens, either freestanding or positioned along the walls of the entrance hall, announced the designer's impending shift to a more architectural design style.

Lacquer continued to dominate her work until around 1925, when she introduced chromed tubular steel and aluminium increasingly into her furniture. An articulated chaise longue in steel, leather and sycamore preceded a similar model by Le Corbusier, and her tubular chairs those of Mies and Breuer. Encouraged and assisted by the Romanian architect Jean Badovici, she built a villa for herself, called 'E-1027', at Roquebrune on the Mediterranean coast between 1927 and 1929. The house's interior consisted of an 'organization of space', containing several well-known models, such as the 'Transat' chair and a circular bedside table. Two further architectural ventures followed: a studio/apartment for Badovici in 1930–31, and a second villa for herself at Castellar in 1934. Her furniture was increasingly ultra-modern and gadgety: cantilevered tables, cabinets with pivoting drawers, tubular chairs, and sliding cupboards and windows.

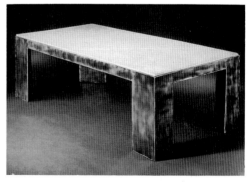

24, 25 *Left* Jean Dunand: wood panel in lacquer and shaded eggshell, late 1920s. *Above* Jean Dunand: table, tortoise-shell lacquer and eggshell, late 1920s (Collection Steven Greenberg)

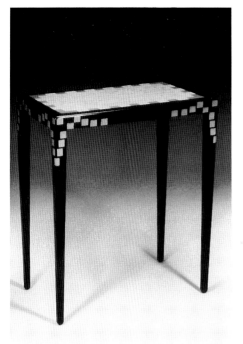
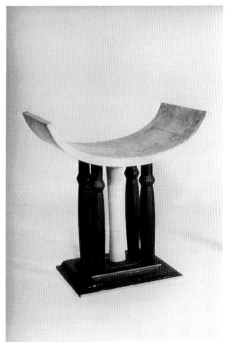

26, 27 *Left* Jean Dunand: table, lacquered wood and eggshell, *c.*1925. *Right* Pierre Legrain: tabouret, exhibited at the 1923 Salon of the Société des Artistes Décorateurs, curule-shaped, in *galuchat* and black lacquer, 1923

Another lacquer exponent was Jean Dunand, whose lengthy career spanned three distinct phases: sculpture, metalware and lacquerwork. He turned to lacquer in 1909, recognizing its lavish gloss and vibrant colours as the ideal embellishment for his metalware. By 1913 the earlier *repoussé* flora on vases had given way to painted overlapping triangles and chevrons. By 1921, his geometric decoration had been expanded to meet the demands of a broadening clientele. Every style was now embraced. Panels were painted with African and Oriental figures, abstractions, realistic landscapes, stylized flowers, exotic fish and birds, and fantastic animals by Jean Lambert-Rucki. Jean Goulden, François-Louis Schmied and Paul Jouve supplied additional designs. The application of panels of *coquille d'oeuf* (crushed eggshell) to many surfaces added greatly to the appeal and novelty of Dunand's work.

Pierre Legrain was originally a graphic artist whose cartoons came to the attention of Paul Iribe. Iribe invited him to collaborate on various projects, including the commission in 1912 to redecorate Doucet's apartment. He continued to design a range of unique pieces of furniture

7

31

which he exhibited at both the 1923 Salon of the Société des Artistes Décorateurs and, more importantly, the following year in an interior designed by Pierre Chareau entitled: 'La Réception et l'Intimité d'un Appartement Moderne'. These items were later incorporated in Doucet's studio-apartment in Neuilly. For Jeanne Tachard, a noted milliner and friend of Doucet, Legrain furnished two apartments and a villa. Other clients were Pierre Meyer, for whose house Legrain designed his celebrated glass and copper Pleyela piano shown at the 1929 exhibition of 'Les Cinq'; Maurice Martin du Gard (a suite of rooms); the Viscount de Noailles (a bedroom) and Suzanne Talbot. Small commercial commissions filled the gaps: leather camera cases for Kodak; cigarette box designs for Camel and Lucky Strike, and a desk set for the Elysée Palace.

Legrain's inspiration was taken primarily from two sources: African tribal art and Cubism. He drew on various Ashanti and Dahomey pieces of furniture – thrones, neck-rests and chieftains' stools – to create his own modernized blend of primitive designs. The Cubist influence came from the artists of the period – Picabia, Modigliani, Picasso and Braque – from whose canvases he drew the concept of three-dimensionality to create powerful angular and stepped forms.

Marcel Coard's furniture was also strongly influenced by tribal art, in his case Oceanic as well as African. Coard's preferred woods were oak – often primitively cut – macassar ebony and palisander. It was, however, his selection of veneers and encrusted materials that gave his pieces their

28 Eugène Printz: bookcase in palmwood, sycamore, copper and silver, 1927–28

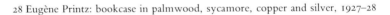

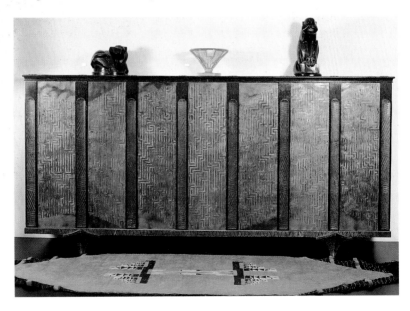

stamp of individualism: parchment, mother-of-pearl, *galuchat*, rock crystal, tinted mirror, marbrite, and glass with a silvered ground. Cabochons of lapis lazuli and amethyst provided decorative accents. Coard's ornamentation was always subordinate to form: the contours of his furniture remained unbroken.

Finally there was Eugène Printz, originally a producer of 'style' pieces, whose decision to switch to contemporary furniture appears to have come at the time of the 1925 Exposition. He made his debut as a Modernist with a bedroom in rosewood at the 1926 Salon of the Société des Artistes Décorateurs.

Printz's highly personal style shows great energy and innovation. A charming interplay of arches and perpendiculars predominates, the crispness of design accentuated by the contrast between dark woods and bright metal mounts. Few of his contemporaries could claim to have developed a more distinctive range of furniture.

Modernists
The Modernists rebelled against the tightness of the Neoclassical discipline, bringing their own interpretation of machine philosophy to the project at hand. Metal was *de rigueur*. In France, the most notable

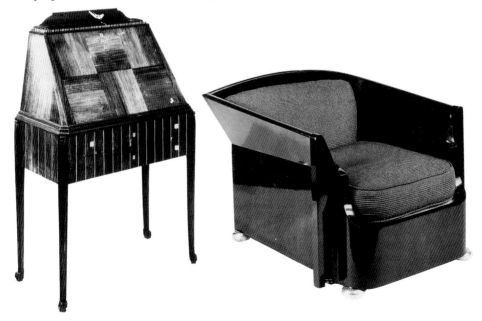

29, 30 *Left* Joubert et Petit: secretaire in palisander with ivory veneer, exhibited in a bedroom ensemble for Mme de G., 1924. *Right* Pierre Chareau: armchair, palisander, metal and upholstery, *c.*1925

Modernist furniture designers were Jacques and Jean Adnet, André-Léon Arbus, Robert Block, Pierre Petit, René Prou, Louis Sognot, Michel Dufet and Paul Dupré-Lafon. These were joined by the architects, who in the 1920s moved increasingly into the field of furniture design: René Herbst, Robert Mallet-Stevens, Jean Burkhalter, Pierre Chareau, André Lurçat, Le Corbusier, Charlotte Perriand and Jean-Charles Moreux.

French Modernist furniture consisted primarily of chromed tubular components designed for inexpensive mass production. Except for those of Chareau, many of the designs produced in the modern idiom are so similar that attribution is impossible without documentation.

Of the French Modernists, Pierre Chareau deserves special mention for his highly distinctive furniture designs. Making his debut at the 1919 Salon d'Automne with a bedroom and office for Dr Jean Dalsace (for whom, ten years later, Chareau designed his celebrated 'Maison de Verre' at 31 rue Saint-Guillaume), Chareau's most important works came towards 1930: in 1927 a golf club at Beauvallon on the Riviera, and in 1929 the Grand Hotel in Tours.

Chareau provided logical solutions to furniture design, a series of basic components which with slight modification could be adapted to

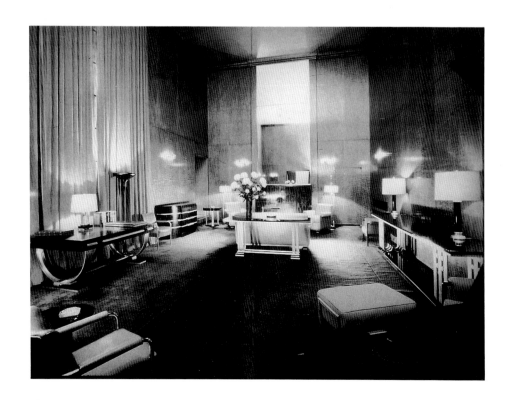

32 Paul T. Frankl: The Livable House Transformed, the living room ensemble displayed at Abraham & Straus, Brooklyn, New York, 1927

various needs. Linen cupboards, bars, filing cabinets, hearth fenders and desks incorporated the same fundamental structure. No attempt was made to mask the item's function: the contours of wood and metal were left brazenly undisguised. Most furniture was made of a combination of wood and wrought-iron. Woods were warm and highly buffed to offset the coldness and austerity of the metal – palisander, *amourette*, walnut, sycamore and violetwood. The iron supports, cast in broad sheets, were treated with a light patina and bolted together. Chair upholstery was in velours, pigskin or, rarely, sable fur.

Perhaps Chareau's most successful furnishings were his light fixtures, the shades constructed of overlapping slices of alabaster placed at angles to each other.

Elsewhere in Europe, Modernism soon became the prevailing philosophy. Ozenfant and Le Corbusier's *L'Après le Cubisme* (1913) had broad appeal for progressive furniture designers in its advocacy of a universal style stripped of ornament. Associated with the Bauhaus, the architect-designers Marcel Breuer, Mart Stam and Ludwig Mies van der Rohe developed a range of cantilevered tubular metal seat furniture. These pieces are today considered classics of twentieth-century design. In Scandinavia, designers such as Bruno Mathsson and Alvar Aalto preferred to incorporate Breuer's functionalism in serial production with traditional materials, such as wood.

31 Donald Deskey: living room for the S. L. 'Roxy' Rothafel apartment above the Radio City Music Hall, aluminium, Bakelite and lacquered wood, *c.*1931 (photo William Rothschild)

In the United States, the Bauhaus-inspired European strain of machine-made, mass-production metal furniture found acceptance in the late 1920s in preference to the earlier Art Deco high-style of Paris.

In metal furniture, Donald Deskey emerged as America's leading designer, combining the luxury of French Modernism with the technology of the Bauhaus. One of the finest examples was his dining-room table for the Abby Rockefeller Milton apartment in 1933–34. Although the piece had a macassar ebony top, it was the inclusion of new materials – polished chrome and glass, and the placement of a bulb beneath the top to provide dramatic lighting effects – that drew the critics' praise. For his interiors for the Radio City Music Hall in 1932, Deskey set convention aside in a display of ostentation intended to buoy a Depression-wracked nation seeking refuge in movies and live entertainment. The private apartment above the Music Hall, which Deskey designed for its impresario, 'Roxy' Rothafel, was even more lavish. Lustrous cherry-panelling and high gold-leafed ceilings rival the most spectacular of Ruhlmann's interior ensembles. The furnishings in the 'Roxy' apartment match the opulence of their setting, being aluminium, rare wood veneers, lacquer, glass and Bakelite.

The German *émigré*, Karl Emanuel Martin (Kem) Weber, was virtually the only decorative arts designer to embrace the Modernist creed on the West Coast. His style was highly distinctive. For the John W. Bissinger residence in San Francisco, Weber created a striking suite of green-painted bedroom furniture enhanced with Hollywood-style metal decorative accents.

Paul T. Frankl is known primarily for his skyscraper furniture, inspired by the setbacks on the tall buildings which soared above his New York gallery. He also created a man's cabinet and series of 'puzzle' desks incorporating materials and finishes that evoked the Secession movement in his native city, Vienna: red and black lacquer, gold and silver-plated metal, and gold and silver leaf.

By the mid-1930s, it was evident that metal had won the battle with wood for the domestic American furniture market. Among those who used it imaginatively were Gilbert Rohde, Wolfgang and Pola Hoffmann, Warren McArthur, Walter Dorwin Teague and the lighting specialist Walter von Nessen. Walter Kantack, a New York metalware manufacturer, also produced inspired pieces of furniture, as did the architect, William Lescaze, of Howe & Lescaze.

Textiles

Around 1925 the role of the textile within an ensemble was reconsidered: should it be designed independently of the furnishings which it would complement, or should it act merely as a decorative accent and, by definition, play a secondary role in the colour and design of an ensemble? In general, textile designs took second place to other disciplines in the decorative arts. But, as the interwar period progressed, wallpapers and, later, fabrics and rugs, gained in importance, since they were often the only note of pure decoration in increasingly austere interiors.

The fragility of both fabrics and carpets means that few examples have survived from the 1920/30 era, and those that do exist have often suffered a degree of discolouration. This unhappy fact can often mislead today's observer with regard to the decorating scheme and the artist's use of colour. Although the study of *pochoirs* or colour reproductions from the period can help to clarify the designer's original intention, these are sometimes as faded as the fabrics themselves.

What becomes clear, however, in any analysis of the printed fabrics and rugs of the Art Deco period is that the different disciplines share common qualities of colour, texture and pattern.

Tastes in colour changed more rapidly in the field of textile design than in any other medium. In the 1920s, vivid, sometimes discordant, shades of lavender (Lanvin blue), orange-red (tango) and hot pink were juxtaposed with lime-greens and chrome yellows to generate a psychedelic palette rivalling that of the 1960s. Such colours dominated Parisian textile design of the period and were partly due to a postwar impulse to celebrate, but even more to the overwhelming influence of Serge Diaghilev's Ballets Russes and its brighlty coloured, exotic costume and scenery designs by Léon Bakst and Alexandre Bénois. These had an immeasurable impact and helped bring about an aesthetic of 'colour for colour's sake'. In the late 1920s, however, the pendulum began to swing the other way. A new conservatism emerged, which encouraged more neutral schemes in interior design. The Depression ushered in the muted, albeit luxurious and costly, interiors of decorators such as Jean-Michel Frank in Paris and Syrie Maugham in London.

Colour accents were restrained. Most popular were tones of charcoal, bottle green and a shade of dusty brown referred to on the Continent as *tête de nègre*. The exuberance of the 1920s Jazz Age yielded to the austerity of the 1930s.

As colours became less vibrant, texture became more important. Indeed, the most significant contribution of the late 1920s and 1930s to textile design may have been the growing belief that the material itself was of primary importance. Among the Modernists, this took the form of a virtual abandoning of printed or other 'applied' decoration – now seen as a cheap substitute for handwoven fabrics – and a concentration on the innate qualities of the fibre. Good weaving alone was expected to draw out the beauty of the fibre through its texture. This attitude was fuelled in part by the philosophy of the Bauhaus weaving workshop, the full effects of which were felt after the First World War in the mass production of rather nondescript woven fabrics.

Interest concentrated in the early 1930s on varied weaves, the use of unusual materials such as raffia and jute, the qualities of handknotted, fringed area rugs, and sculptured carpets such as those designed by Marion Dorn. At the same time, synthetic fibres were developed, such as rayon and acetate. These could be woven into a wide variety of textiles which simulated the textures of traditional linen weaves, silk and wool. In emphasizing the decorative qualities of extremely coarse

33 Paul Iribe: block printed silk, designed for André Groult, 1912

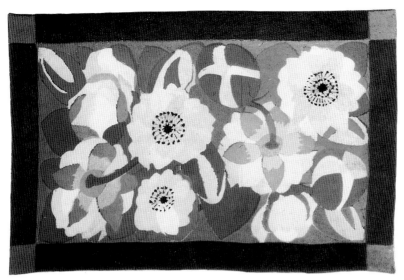

34 Ecole Martine: wool rug, 1920s

or 'natural' textiles, Modernism reversed the trend of the industry. The strident pastiches of the early 1920s yielded to an era of almost apologetic hues and patterns. In Germany, pale striated geometric fabrics became popular, as did wallpapers with minute monochromatic detailing.

In the 1920s textile patterns showed the influence of the new exoticism, and included motifs from the Near-East, Africa, the Orient, folk art, Cubism and Fauvism. The emphasis on flat graphic decoration was felt most strongly on the Continent and in the United States.

WOVEN FABRICS AND PRINTED PAPERS

Paris's most celebrated couturier and ensemblier, Paul Poiret, was one of the seminal figures in the promotion of the exotic and colourful Art Deco style. The most successful sketches from the girls in his Ecole Martine were translated into fabrics by Paul Dumas, and into carpets by the firm of Fenaille. These were then sold at Poiret's Maison Martine. The Martine style was essentially colourful and frivolous, with an exoticism reminiscent of the Ballets Russes. According to Poiret, other influences were Persia, the South Sea Islands and, to a limited extent, the more decorative elements of the Vienna Secession.

For the 1925 Exposition, Poiret designed an exhibit consisting of three barges – *Amours*, *Delices* and *Orgues* – moored beneath the

35 Raoul Dufy: wallpaper design,
block-printed, 1929

Alexandre III bridge. *Orgues* provided the setting for fourteen steam-dried wall-hangings executed by Raoul Dufy. But by this time, Poiret's heyday had passed, hastened by his lack of financial acumen and by public rejection of the elaborate floral style that he had helped to popularize.

Many of Dufy's fabric designs drew on the narrative and pictorial eighteenth-century style in which figures were portrayed in various outdoor pursuits surrounded by arabesques or floral ornament. Patterns included *La Danse*, *Le Pêcheur* and *Le Moissoneur*. Other designs show the facility with which Dufy interpreted decorative fruit and floral trelliswork of the kind associated with Indian calicos (*Croisillons de Pensées*, *Fleurs et Torsades*), and, somewhat later, subdued geometrics (*Rectangles aux Striés*, *Motifs Hindous*, *Coquilles*). Dufy worked exclusively for the Atelier Martine until 1912, when, with Poiret's approval, he joined the giant textile mill, Bianchini-Férier, for which he worked until 1928. From 1930 until 1933 his commissions included printed silk designs for the Maison Onondaga in New York.

40

Sonia Delaunay rivalled Dufy as a textile designer, producing a range of radically Modernist and colourful fabric and rug patterns, in addition to stage set and costume designs.

Many French artist-decorators designed a variety of wall-coverings, drapery and upholstery material in printed silks, cotton and linen – damasks, brocades, brocatelles and lampas – to complement their interiors. Catalogues of the annual Paris Salons in the 1920s and 1930s list textiles by ensembliers such as André Groult, Francis Jourdain, Emile-Jacques Ruhlmann, René Gabriel, René Herbst, Louis Süe and André Mare, Pierre-Paul Montagnac, Fernand Nathan, Léon Jallot, Jacques and Jean Adnet, Tony Selmersheim, Paul Follot and Maurice Dufrène.

Patterns were divided broadly into two categories: floral and geo-metric. The latter often comprised overlapping blocks of colour or abstract linear motifs, or flowers at times combined with animal or anecdotal motifs. In addition, Parisian department stores had their own workshops which provided a matching range of light Modernist designs to supplement their furnishings. Among these were Au Bon Marché's workshop, Pomone (Paul Follot, Germaine Labaye, Marcel Bovis and Mme Schils); Galeries Lafayette's workshop, La Maîtrise (Maurice Dufrène, Léon Marcoussis, Daragnes, Crozet and Mme Lassudrie), Le Printemps' Primavera workshop (S. Olesiewicz, Mme Madeleine Lougez and Paul Dumas) and Le Louvre's workshop, Studium Louvre (Jean Burkhalter and Etienne Kohlmann).

The French were considered masters in the art of tapestry. By tradition, tapestry screens had been used to define interior space and to lend warmth to cold interiors. But the eighteenth- and nineteenth-century concept of the tapestry as a woven reproduction of a painting stifled artistic initiative until the appearance of Jean Lurçat, who designed for Aubusson in the 1930s. Lurçat conceived his panels as geometric compositions which accentuated the interplay of colours. He advocated the use of relatively coarse fibres which both reduced production costs and lent themselves to dramatic, tactile compositions. Tapestries and rugs executed under the artistic direction of Marie Cuttoli for Aubusson were also popular, representing a continuation of the tradition of *trompe l'oeil* reproduction of paintings by modern artists. Cuttoli retained artists such as Georges Braque, Raoul Dufy, Henri Matisse, Georges Rouault, Fernand Léger and Pablo Picasso to submit cartoons for weaving. Most of the fabrics designed by these artists show a remarkable insensitivity to the nature of the material, but were readily accepted by patrons with a taste for contemporary paintings.

41

In the 1920s, seat furniture and screens upholstered in tapestry were widely produced by the foremost interior decorating firms and department stores in Paris. Süe et Mare, in particular, offered furniture upholstered in tapestry designed in both Neoclassical and Modernist styles by Paul Véra, Gustave-Louis Jaulmes, Marianne Clouzot, Marguerite Dubuisson and Maurice Taquoy. For the 1925 Exposition, Charles Dufresne depicted the story of 'Paul et Virginie' in tapestry on the suite of gilt-wood furniture which Süe et Mare displayed in the Grand Salon of their pavilion, Musée d'Art Contemporain. At La Maîtrise, the design studios of Galeries Lafayette, Maurice Dufrène retained Jean Beaumont to design colourful screens and chairs upholstered in tapestry.

Upholstered furniture fabrics were commissioned from France's traditional tapestry and carpet manufacturers: La Manufacture Nationale de Tapis et Couvertes de Beauvais, La Manufacture Nationale des Gobelins, Aubusson, Braquénie et Cie, and Myrbor, all of which retained their own design staff.

The *S.S. Normandie*, launched in 1932, provided a spectacular commission for French *tapissiers* to upholster all the seat furniture in the oceanliner's Grand Salon. Against a background of theatrical splendour, including Dupas' silvered and gilt *verre églomisé* murals and Jean Beaumont's twenty-foot lengths of curtain decorated with cerise wisteria on a cream ground, were hundreds of abundantly stuffed chairs and canapés upholstered in tapestry designed by F. Gaudissart and executed by Aubusson, depicting flowers from various French colonies. The lavish ivory and olive tones on vivid orange-red and grey grounds, set against the gold and silver leaf of the murals, produced an image of splendour unrivalled in the 'floating palaces' of any other nation.

In Great Britain there was growing interest in the 1920s in modern textiles and printed papers. Some of the noteworthy proofs of this were the geometrically patterned fabrics produced by William Foxton and Co. of London, to the designs of Charles Rennie Mackintosh, Minnie McLeish, Gregory Brown and Claude Lovat Fraser, dating as early as the late 1910s.

Examples of Foxton's fabrics were exhibited at the 1925 Exposition, but it was not until the 1930s that the British textile firms warmed to designs in the modern idiom. One of these firms was that owned by the painter, designer and decorator, Allan Walton, who commissioned designs by Vanessa Bell and Duncan Grant, Frank Dobson, Cedric Morris, Margaret Simeon, T. Bradley and H.J. Bull. Another was the Edinburgh Weavers, under the direction of Alistair Morton, for which

36 Raoul Dufy: fabric design for an armchair by Léon Bouchet, 1922

artists such as Hans Tisdall, Ashley Havinden, Terence Prentis, Mario Marini, William Scott, Jo Tilson and Keith Vaughan provided designs. Among the latter firm's more notable lines was the Constructivist fabric jointly designed by Barbara Hepworth and Ben Nicolson in 1937. Other concerns which added Modernist designs to their repertoire were Sir Thomas Barlow's Helios, which sold furniture fabrics exclusively designed by Marianne Straub; Donald Bros Ltd of Dundee, known for its Old Glamis line; and the Old Bleach Linen Co. Ltd, for which Marion Dorn and Paul Nash were the principal designers of woven and printed fabrics.

Vanessa Bell and Duncan Grant's style of painting translated well into their printed fabrics for Allan Walton. Although their Omega Workshops, devoted to the promotion of household furnishings painted with post-Impressionistic designs, had closed in 1919, Bell and Grant continued their efforts in a style that came to depend less on post-Impressionism than on purely decorative appeal. From 1913 until the outbreak of the Second World War they introduced more than a dozen designs which exuded the 'cosy' character of English nineteenth-century printed fabrics and at the same time echoed the vogue for fanciful prints current in France in the 1930s.

In the 1920s, Bell and Grant also designed needlepoint canvases which were successfully worked by Ethel Grant, Duncan Grant's mother, and the painter Mary Hogarth. These were shown in the 1925 Independent Gallery exhibition 'Modern Needlework', and again in 1932 at the Victoria & Albert Museum. Two examples of their decorative commissions stand out from the remainder of their work in the 1930s. The first is the Music Room exhibited at the Lefevre Gallery, London, in 1932. Grant's 'Grapes' design, with its bold repeating motif, was effectively the focal point of the room, cascading down the

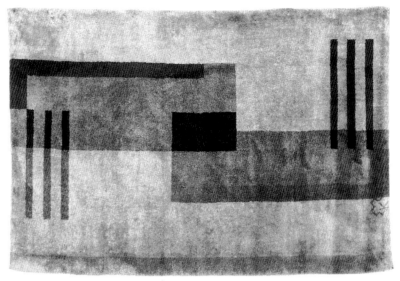

37 Edward McKnight Kauffer: wool carpet, hand-knotted, *c.*1935 (Courtesy of Christie's, London)

full height of the wall, at the same time serving as a backdrop to the seating arrangement composed of two slipper chairs and a large settee. The second was the uncompleted 1935 commission to design the lounge of the Cunard Liner, *R.M.S. Queen Mary*. Grant's design was considered too sophisticated for the average transatlantic traveller and halfway through the project he was dismissed, with compensation. The replacement decor became known as 'Leicester Square Cinema'.

The team of Phyllis Barron and Dorothy Larcher, whose workshop was located first at Hampstead and then in Gloucestershire, was responsible for the revival of interest in printed textiles. Their patterns ranged from Larcher's naturalistic interpretation of flowers traditionally associated with English chintzes, to Barron's simple, but bold, geometrics. Discharge printing, in which acid was used to bleach out a pattern on dyed ground in the manner of Indian calicos, was one of their specialities. They were joined in 1925 by Enid Marx, who two years later established her own workshop, gaining wide acclaim in 1937 for her upholstery designs for the London Passenger Transport Board, and for her work for the Utility Design Scheme during the Second World War.

The painter Paul Nash executed a variety of inventive modern designs for both printed textiles and rugs. Fabrics such as 'Cherry Orchard' of 1933 show the manner in which he formalized naturalistic motifs. His 'Fugue' design of 1936 presented a graphic, though abstract, interpretation of nonvisual subjects.

44

Marion Dorn was best known for her Modernist sculptured carpets, but she also created textile designs. These were influenced by her association with the graphic artist Edward McKnight Kauffer. Her relatively simple and inexpensive designs of the late 1930s included 'Aircraft', which was used in the interiors of the first-class lounge on the oceanliner *Orcades*.

No account of British textile development in the 1930s would be complete without mention of Ethel Mairet. Her Gospels weaving studios in rural Ditchling, Sussex, were part of a larger community founded by the typographer Eric Gill. Mairet had a strong belief in the importance of the artisan and her early weaves reflect her initial distrust of industrial procedures. But encounters with other designers, in particular Gunta Stadler-Stölzl of the Bauhaus, later convined her that her idiosyncratic weaves would lose none of their character in the process of mass production. The fabrics of the postwar era, beginning with the simple weaves of the Utility Design Panel, owed much to Mairet's dedication to weaving as both art and craft.

In Austria, the success of the textile division of the Wiener Werkstätte, set up as a separate workshop around 1910, led to the establishment of an independent retail outlet in 1917. Textiles and carpets were originally designed as part of an overall scheme for specific interiors only, in line with the Wiener Werkstätte's overriding principle of *Gesamtkunstwerk* (the concept of the interior as a total environment), but financial considerations eventually made broad commercial production necessary.

Whereas early textiles and carpets designed by Josef Hoffmann and Koloman Moser were rigidly geometric and almost invariably mono-chromatic or black-and-white, the Wiener Werkstätte textiles of the late 1910s and 1920s grew increasingly more colourful, employing whimsical decorative motifs characteristic of the workshop's designs in other media. In the United States, the Wiener Werkstätte of America Inc. retailed textiles, including table linens, at their New York branch and through Marshall Field's in Chicago. Their imaginative lacework and embroideries combined traditional techniques with a brilliant use of colour. Popular decorative motifs included the fanciful floral prints of Mathilde Flögl, Camilla Burke and Franz von Zülow, and the African-inspired geometry of Maria Likarz-Strauss, in addition to the eccentric 'Spitzbaroc' patterns of Dagobert Peche.

Wallpapers were also produced for the Wiener Werkstätte by Salubra Werke and Flammersheim & Steinmann. Peche created a large selection of wallpaper designs in 1919 and again in 1922, one of which was selected for the catalogue cover to the Austrian design section of the

1925 Exposition. Peche's colleague, Maria Likarz–Strauss, created a portfolio of wallpaper designs in 1925, while examples of Mathilde Flögl's work were included in the workshop's collection in 1929, three years before it was forced to close through bankruptcy. During this period the Wiener Werkstätte's imaginative wallpaper patterns were enormously popular. Literally thousands were produced by Peche, Josef Hoffmann, Mathilde Flögl, Franz von Zülow, Ludwig Heinrich Jungnickel, Arnold Nechansky and the Rix sisters, Kitty and Felice. Hoffmann's designs in the mid-1920s simplified the enchanting herringbone and dash patterns of his prewar style.

In the light of the October Revolution Soviet designers took a fresh look at textile decoration and attempted to develop an entirely new aesthetic vernacular. Motifs symbolic of the Revolution – often of considerable charm despite such titles as Electrification, Industry and Waste Utilization – were used by designers such as Varvara Stefanova. Stefanova developed her artistic philosophy in her work with Alexander Rodchenko, and played an important role in the Inkhuk and Vkhutemas, designing simple, geometrically patterned fabrics for the first State textile factory in Moscow with Liubov Popova. Stefanova's later wallpaper designs were distinctly Constructivist.

In Germany, textiles were rescued from oblivion by the legacy of the Bauhaus. Weavers such as Gunta Stadler-Stölzl and Anni Albers, whose careers flourished in the post-Second World War period, helped early to implement change in the field of textile design and production. In fact, much of the postwar textile industry owed its success to the Bauhaus aim of developing 'prototypes for industry'. The focus was on materials, the decorative effect of each fiber judged both by its colour and texture and by its ability to convey tactility. Material was given preference over all other factors as the key to successful industrial production.

38 Gunta Stadler-Stölzl: tempera design for a runner, 1923

Stadler-Stölzl singlehandedly directed the Bauhaus weaving work-shop from 1926 to 1931, and it was through her talent and guidance that the mass production of Bauhaus designs became a reality. The workshop's early designs demonstrated an affinity for colour reminiscent of the work of Paul Klee, whose teachings helped free the Bauhaus artists from their lingering prewar notions concerning the application of conventional pattern and ornament. Klee espoused the belief that art should not merely be a superficial imitation of things found in nature, but an attempt to follow the actual process of their growth. Outside the Bauhaus, Modernist printed and handwoven fabrics were produced at the Kunstgewerbeschule, the industrial art school at Halle, and the Deutscher Werkbund. Notable individual designers were Bruno Paul, Fritz A. Brehaus and Richard Lesker.

Modernist Belgian fabric designers appear to have been inspired mostly by their German neighbours in their choice of a muted palette. Jaap Gidding and Paul Haesaerts, at the Studio de Saedeleer, produced linens and tapestries decorated with Peruvian Indian and tribal African motifs on geometric grounds. At the Vanderborght *frères* mill, Sylvie Féron created dynamic geometric patterns composed of overlapping triangles, zigzags and small squares. For the 1925 Exposition, Darcy designed roller-printed wallpaper with geometric and fanciful floral patterns on a pallid ground for the Société des Usines Peters-Lacroix.

Although the acid colours of early French Art Deco fabrics were initially perceived as too bold for the conservative American public, the inclusion of French textiles at exhibitions at the Metropolitan Museum of Art, New York, in 1926, and the department stores from 1928, led to the gradual understanding that Modernism was more than a passing fancy. American stores began to offer a modest selection from Aubusson, Cornille *frères*, Bianchini-Férier and others.

At the time there were only a handful of specialist textile designers of note in the United States: Ruth Reeves, Henriette Reiss, Zoltan Hecht and Loja Saarinen. Small firms which added Modernist lines to their traditional repertoire included Nancy McClelland and M.H. Birge & Co.

The work of American designers was shown at three exhibitions staged in New York in the late 1920s and early 1930s to promote the Modernist movement, at the American Designers Gallery, Contempora and the America Union of Artists and Craftsmen (AUDAC). Carpets were exhibited by Hermann Rosse, Wolfgang and Pola Hoffmann, Eugene Schoen, Joseph Urban, Henry Varnum Poor and Donald Deskey, as part of interiors by designers. Fabrics for these were

39 Ruth Reeves, seated beside one of her designs, late 1920s

40–43 *Opposite, above left* Donald Deskey: textile design of repeat pattern of Cubist forms; green, brown and cream opaque watercolours and graphite on board (Collection of Donald Deskey, courtesy of the Cooper-Hewitt Museum). *Above right* Süe et Mare: wool carpet for La Compagnie des Arts Français, late 1920s. *Below left* Fernand Nathan: hand-knotted carpet, 1920s. *Below right* Tcherniack: wool carpet for La Maîtrise, *c*.1930

executed for the most part in small rural weaving communities, such as the New England Guild, the Connecticut Handicraft Industry, the New Age Workers or the Contemporary American Artists Handhooked Rugs Guild.

The Hungarian emigrant sisters, Ilonka and Mariska Karasz, applied the exuberance of the new palette to traditional folk art motifs. The influence of Fauvism is apparent in the colours and patterns of their needlework. The work was executed by Mariska, to designs by Ilonka. Another folk-inspired American artist was Lydia Bush-Brown, who revived the batik technique in a blend of stylized Middle-Eastern and modern motifs. In tapestry wall hangings, Lorentz Kleiser and Marguerite Zorach emerged as America's pioneer Modernist designers.

The work of Ruth Reeves reflected the continuing search in America for a native vernacular appropriate to modern decoration. Reeves's association with Fernand Léger in the 1920s in Paris left the firm stamp of Cubism on both her woven and her printed designs. In 1930 the department store W. and J. Sloane exhibited twenty-nine of her designs – a sign of the confidence the American firms were beginning to show in the economic viability of the new style. 'Figures with Still Life',

48

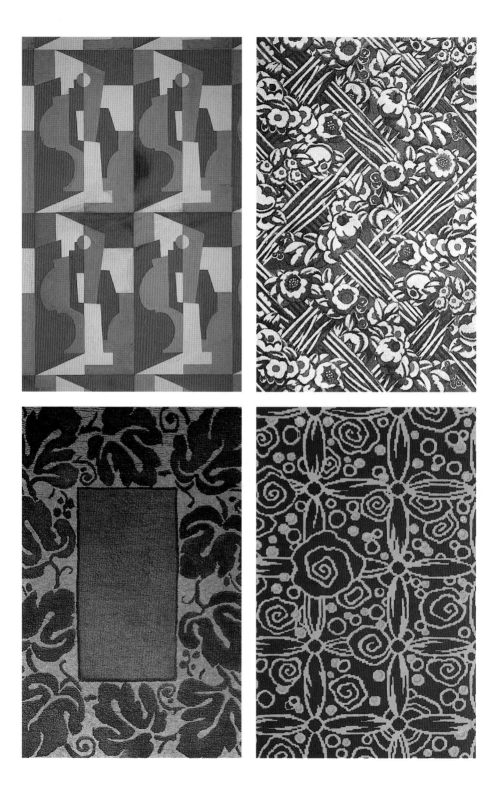

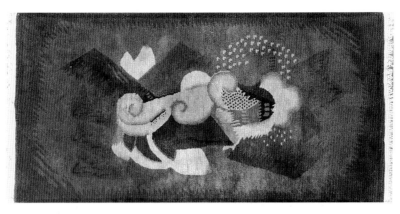

44 Jean Lurçat (attributed to): wool carpet, late 1920s

'Manhattan' and 'Electric' display Reeves's interest in the vigorous interrelationships of geometric forms. Among her most successful works was the repeating abstract design conceived for the carpets in Radio City Music Hall. Reeves translated her designs into roughly a dozen different types of fabric, including chintz, monk's cloth, voile, velvet and muslin.

40 Donald Deskey, America's foremost Modernist designer of the period, designed textiles which exhibit his fascination with asymmetrical geometric forms. The photographer Edward Steichen produced a unique range of silks for the Stehli Silk Corporation in which everyday objects lit from various angles were reproduced photographically in black and white to create powerful machine-age images.

By 1930, the modern textile movement had got into its stride in the United States, its tenet being simplicity of form and colour. No finer example of this simplicity was provided than 'Triptych', a printed linen fabric in three complementary hues of yellow, by Jules Bouy.

RUGS AND CARPETS

In the 1920s, rugs provided a decorative accent to the lavish interiors of
41 the Paris ensembliers. Maurice Dufrène, Paul Follot, Süe et Mare,
42 Emile-Jacques Ruhlmann, Jules Leleu, René Gabriel, Fernand Nathan, Francis Jourdain, Elise Djo-Bourgeois and André Groult, among others, designed carpets to complete their decorative schemes. Towards the end of the decade, rugs often provided the only element of warmth

and ambience in the austere metal-dominated interiors presented by Pierre Chareau, Djo-Bourgeois and René Herbst at the initial exhibitions of the Union des Artistes Modernes (U.A.M.).

Modernist rugs and carpets, like Modernist fabrics, displayed a selection of floral, abstract and geometric patterns. Designs were executed by Aubusson (Edouard Bénédictus, Paul Véra, Henri Rapin, Paul Deltombe and L. Valtat); Myrbor (Louis Marcoussis, Joseph Csaky, Fernand Léger and Jean Lurçat); La Maîtrise (Maurice Dufrène, Jacques Adnet, Suzanne Guiguichon, Marcelle Maisonnier, Raoul Harang, Jean Bonnet and Jacques Klein); Atelier Martine (Raoul Dufy); Pomone (Paul Follot); D.I.M. (Drésa, Boberman and Paul Follot); Primavera (S. Olesiewicz and Colette Guéden); Süe et Mare (Paul Véra and André Mare); and Pierre Chareau (Jean Lurçat and Jean Burkhalter). Other designers of merit appear to have worked independently: Marcel Coupe, Jacques Klein, Mlle Max Vibert, Maurice Matet, J. Bonnet, Mme S. Mazoyer and Mme Henri Favier.

French painters occasionally applied their talents to carpets, mixing abstract and Cubist styles. Noteworthy were the artists commissioned by Marie Cuttoli, and the painter Marie Laurencin, who translated her

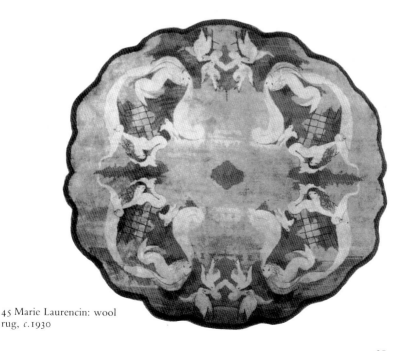

45 Marie Laurencin: wool
rug, c.1930

46–48 *Right* Ivan da Silva Bruhns: wool rug with a central geometric pattern, woven with artist's monogram, 1930s. *Opposite, above* Ivan da Silva Bruhns: hand-knotted carpet, 1920s. *Below* Francis Jourdain: hand-knotted carpet, 1920s

gay floral compositions into carpet designs for André Groult. The finest quality carpets were hand-knotted (*à la point noué*). As synthetic fibres made their entry into the medium, experimental pieces in cellulose and vegetable fibres, and new washable linen materials, were shown at the Paris Salons.

The most successful rug and carpet designs in Paris were those of Ivan da Silva Bruhns. Drawn to Berber and Moroccan textiles shown in the French capital during and immediately after the First World War, da Silva Bruhns also borrowed American Indian motifs for his early works. From the mid 1920s, however, his style evolved into a powerful Cubist-inspired geometry. His palette included beige, rust, ochre and grey tones. Cubism also played a role in the Modernistic designs of

53

Hélène Henri, who was retained by Francis Jourdain and the architects Robert Mallet-Stevens and Pierre Chareau.

Irish-born Modernist Eileen Gray used carpets to relieve the severity of her austere interiors. Her crisp, angular designs were displayed at annual Salons and through her gallery, Jean Désert. A notable example is her 'blackboard' rug of around 1927. Similar in design to those of Gray were the carpets introduced by La Maison Desny to complement its metal furniture and light fixtures.

In Britain, rugs and carpets were retailed by a number of decorating firms in the subdued and comfortable Modernism of the late 1930s. The geometrically designed rugs of graphics designer Edward McKnight Kauffer were used in interiors designed by David Pleydell Bouverie and Raymond McGrath. Betty Joel, who initially used rugs designed by Ivan da Silva Bruhns, later created her own models. These, woven in China, were an extension of her understated furnishings. Francis Bacon designed carpets to complement his own interior schemes.

In 1930, Sir Frank Brangwyn, who combined nineteenth-century and Modernist elements, designed carpets for James Templeton & Co. in a highly decorative style reminiscent of his panels symbolizing the riches of the British Empire for the Royal Gallery in the House of Lords.

The expatriate American Marion Dorn earned the nickname 'architect of floors'. Beginning in the early 1920s with designs for batik fabrics, her first collaborative efforts were with McKnight Kauffer and were executed by the Chelsea weaver, Jean Orage. In 1929, their designs for Wilton Royal were exhibited at the Arthur Tooth galleries. In 1934 Dorn established her own firm Marion Dorn Ltd, specializing in handmade and custom design rugs. Dorn's skillful integration of different piles added textural interest to Kauffer's brilliant geometric patterns. Her rugs echoed the decorative architectural features of the interiors that still grace Oswald Milne's Claridge's Hotel (1935), or added a dramatic note to subdued interiors created by Brian O'Rorke for the *R.M.S. Orion*.

In Germany, aside from the geometric patterned rugs of the Bauhaus's Gunta Stadler-Stölzl and Annie Albers, rugs in the Modernist idiom were also created by Edith Eberhart, in a style reminiscent of Stadler-Stölzl's; Marie Hannich, who designed rugs with powerful images of boats, cars and buildings in a rigid geometric manner; and Brehard Hesse and Hedwig Beckemann, who also worked in a geometric style.

In the United States, three specialized exhibitions helped to stimulate modern carpet design: at the Art Center, New York (1928), the

54

49 Francis Bacon: wool rug in geometric design, 1930s

Newark Museum (1930) and the Metropolitan Museum of Art, New York (1931). Here, avant-garde European textile designers were seen by the American public for the first time. The quiet symmetry of the German designers (Bruno Paul, Ernst Boehm and Wilhelm Poetter) was contrasted with the more spontaneous and colourful works of Edward McKnight Kauffer and Marion Dorn, the sophisticated and exotic geometrics of da Silva Bruhns, the tradition-bound florals of Süe et Mare and the naive florals of Atelier Martine.

The Cranbrook Academy played an important role in the dissemination of Scandinavian ideals to a generation of American weavers whose work came to prominence after the Second World War. Loja Saarinen's weaving studio was established in October 1928 to complete special commissions, and in 1929 a weaving department was founded, staffed by Scandinavian expatriates, to execute commissions by architects and designers such as Frank Lloyd Wright. Loja Saarinen's style, and indeed Cranbrook's weaving style in general, was marked by a restrained palette and an absence of either sharp geometry or purely representational motifs. When American mills such as Stephen Sanford & Sons and Bigelow Hartford finally became convinced that the modern idiom was more than a fad, they commissioned designers such as Ralph Pearson, T. Betor and Pola Hoffmann to work in a mode largely derivative of the European Modernists. There was also a market in America for rugs woven in China with subdued Art Deco patterns that were incorporated into both Modernist and traditional interiors.

Ironwork and Lighting

IRONWORK

The interwar years were a golden age for wrought-iron in France. The spare, clean lines of the new style in architecture lent themselves particularly well to decorative ironwork. Wrought-iron was used on the outsides of buildings for grilles, window guards and doors, and on the insides for elevator cages, balustrades, railings, fireplace furniture and a wide range of furnishings, including light fixtures, console tables and screens. Lift cages became the focal decorative point in lobbies, their ornamentation carefully matched to nearby railings and entrance doors. Only in their attempt to design traditional pieces of furniture, such as tables and room dividers, did Modernist wrought-iron artists sometimes apply too heavy a hand and produce a piece which over-powered other furnishings in an ensemble. Because of the metal's innate heaviness, it was often at its best when used only as an occasional, or accent, piece. One of its most effective uses was as a mount for light fixtures.

In wrought-iron, the Art Deco style divided itself chronologically into two broad categories. The first, following the lead of the *fin-de-siècle* designers, drew its inspiration from nature: birds, flowers, greyhounds, gazelles, clouds, fountains and sunbursts were translated into a high Art Deco style in which elongation and exaggeration of forms predominated. The second was a more architectural style which emerged after 1925 and in which the sleek lines of machinery, aeroplanes and steamships were increasingly evoked.

The period's preeminent ironworker was Edgar Brandt, who created grillwork and fixtures for numerous private homes and hotels, as well as for notable public commissions such as the First World War monument, *La Tranchée des baïonnettes*, near Verdun, in 1921. His fixtures for the oceanliners *Ile-de-France*, *Paris*, and *Normandie* brought him further prestige. Between commissions, Brandt exhibited regularly at both annual Salons, showing a seemingly limitless range of non-architectural metalware such as grilles, radiator covers, lamps and consoles.

The 1925 Exposition gave Brandt numerous opportunities to display

50 Edgar Brandt: detail of 'Oasis' screen, wrought-iron with brass applications, 1924 (Collection Robert Zehil)

his work, beginning with the exhibition's imposing point of entry, the Gate of Honour. His own stand on the Esplanade des Invalides included his celebrated 'Oasis' 5-panel screen in wrought-iron highlighted with brass accents. The latter displays the facility with which he interchanged materials: most frequently, in the 1920s, wrought-iron and bronze, but also gilt-copper, and later, steel, aluminium and the alloy 'Studal'.

Raymond Subes was second only to Brandt in the scope and quality of his work. As artistic director of Borderel et Robert, a prominent architectural construction company, he was responsible for a range of architectural commissions in the 1920s: churches, cemeteries, monuments, exhibition halls and hotels. He also displayed furnishings at the annual Salons, but his importance cannot be measured by these smaller items; most of his *tours de force* remain unidentified on building façades or survive in the bold sweep of a hotel's stairway balustrade. Many more were stripped and scrapped when the oceanliners *Ile-de-France*, *Atlantique*, *France* and *Normandie* met their ignominious ends.

Subes's displays at the Salons included commissions for other exhibitors: in 1927, for example, the steel frame for a Ruhlmann bookcase and a wrought-iron doorway for Michel Roux-Spitz. Later came work for Maurice Jallot and Alfred Porteneuve. For the 1925 Exposition he

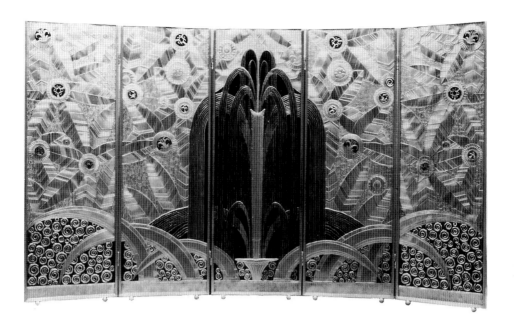

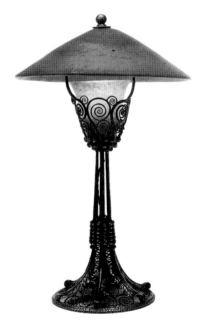

51–53 *Opposite* Edgar Brandt: 'Altesse',
wrought-iron console with marble top,
c.1925. *This page, above* Edgar Brandt:
model of the 'Oasis' screen, *repoussé*
copper on wood panelling *c*.1924. *Right*
Edgar Brandt and Daum: table lamp,
wrought-iron and glass, 1920s

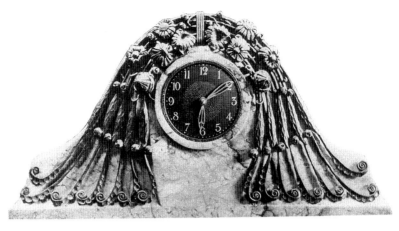

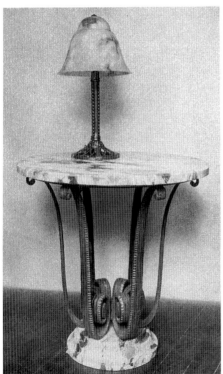

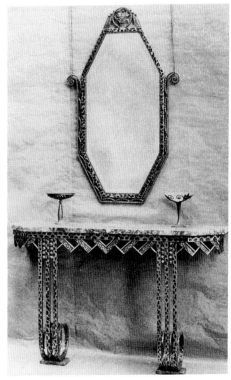

54–56 *Top* Raymond Subes: mantel clock in wrought-iron and marble. *Above left* Raymond Subes: table in wrought-iron and marble, the lamp with an alabaster shade. *Above right* Nics *frères*: wrought-iron console, mirror and compotes, all with hand-hammered *martelé* finish

created ironwork in the Ambassade Française, Hôtel du Collectionneur and the pavilion of La Société de L'Art Appliqué aux Métiers.

Subes's choice of metals matched Brandt's: a basic preference for wrought-iron interchanged occasionally with bronze, patinated copper and, in the 1930s, aluminium and steel, the latter either oxydized or lacquered.

Jules and Michel Nics were Hungarian-born brothers who worked in Paris under the name of Nics *frères*, producing a complete range of decorative ironwork from furniture to architectural decoration. Their work was characterized by a highly conspicuous *martelé* (hand-hammered) decorative finish and a rather excessive and passé use of naturalistic motifs. They rejected die-stamping and file work, and affirmed themselves instead as masters of the hammer, creating pieces by hand in a technique comparable to the finest artisans of the past.

The 1925 Paris Exposition was the testing ground for contemporary metalware designers and decorators. Among those to whom it brought success were Montagnac and Le Bourgeois. Pierre-Paul Montagnac, a painter, also designed tapestries, furniture and wrought-iron. His partner, Gaston-Etienne Le Bourgeois, was a well-known sculptor strongly influenced by Cubism. Together, they successfully allied modernity and tradition in a modest selection of metalware designs. The firm of Schwartz-Hautmont also exhibited work by its director Jean Schwartz in the metal section at the Exposition, including the grille designed by the architect M. Thomas for the Grand Palais des Beaux-Arts, the marquee for the façade of the Grand Magazin de la Samaritaine and the grille for the Hôtel Scribe.

The metalworker Richard Desvallières produced some extraordinary pieces in the 1920s, in a transitional style that carefully balanced the massive presence of Art Deco design and the sinuous lines of Art Nouveau.

Paul Kiss collaborated with Brandt early in his career, and his work 57 displays a similarly lyrical quality, though it differs in character. Kiss exhibited a comprehensive range of wrought-iron furniture and light fixtures at the Salons of La Société des Artistes Décorateurs and La Société des Artistes Français. Other serious and dedicated wrought-iron workers of the time included Edouard and Marcel Schneck, Adalbert Szabo, Louis Gigou, Charles Piguet, Fred Perret, Gilbert Poillerat, Edouard Delion, Robert Merceris and Paul Laffillée.

Metalwork in the late 1920s and 1930s was so closely associated with the names of individual artisans that it is easy to forget that the major decorating firms produced their own metalwork to ensure continuity

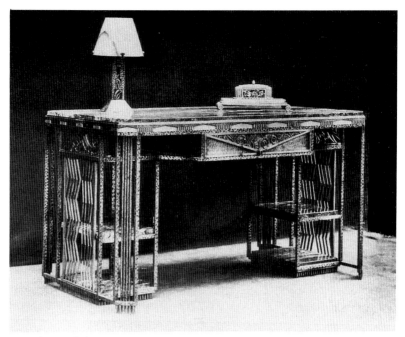

57 Paul Kiss: desk in wrought-iron, the lamp with alabaster shade

of design in their interiors. This was a labour born of necessity, as commercially produced decorative hardware of good design was virtually unavailable.

Almost all Parisian decorating firms worked with Fontaine et Cie, which had been creating decorative hardware for more than one hundred years. It was the only company willing to take the financial risks involved in making well-designed hardware in editions large enough to permit reasonable prices. One of the reasons for Fontaine's success was that it commissioned designs from prominent sculptors and decorators. From Süe et Mare, for example, came designs for wrought-iron furniture and decorative objects: mirror frames, fire screens, clocks, chandeliers, floor and table lamps, and a complete line of hardware. All displayed the firm's characteristically full-bodied, invariably beautiful, stylizations of natural forms, and *trompe l'oeil* depictions of pleated 'fabric' executed in gilded, silvered or bronzed copper and, somewhat later, polished aluminium. The sculptor Paul Véra was closely associated with their work.

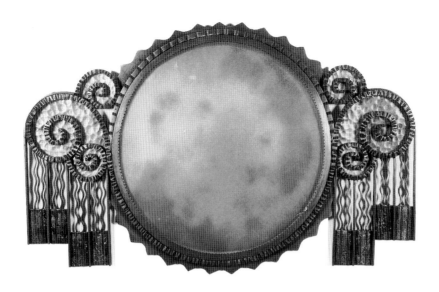

58 French (designer unknown): wall mirror, wrought-iron, 1920s

More Modernist than that of Süe et Mare was the work of the furniture designer René Prou, who also undertook commissions for Fontaine. His style was characterized by geometric motifs worked in variously finished metals that gave the surfaces an interesting play of light. Other notable designers and artists retained by the firm included Antoine Bourdelle, Aristide Maillol, Joseph Bernard, Paul Jouve and Pierre Poisson.

Although at first the United States lagged behind France in its adoption of metalwork for interiors, by the late 1920s, after the influence of the 1925 Paris Exposition and the opening of Edgar Brandt's New York office, Ferrobrandt, metalwork had become immensely popular. A number of American designers and craftsmen produced a great variety of both interior and exterior ironwork.

Oscar Bach was perhaps the only American ironworker who could match the technical mastery of the great French *ferronniers*. Born in Germany, he enjoyed a successful career before emigrating to the United States in 1914. He was proficient in many styles of metalwork

63

and metals, using copper, aluminium, bronze and chromed-nickel silver to provide colour and textural contrasts. His contribution to many of New York's most outstanding buildings was immeasurable. Bach is best known for the interior metalwork in the Chrysler and Empire State Buildings and in the Radio City Music Hall.

Wilhelm Hunt Diederich, an *émigré* from Hungary, was a successful designer in several areas, but was particularly attracted to metalwork. His simple, two-dimensional figures and animals seem snipped out of the iron, their sharp, jagged edges and minimal surface decoration giving them an engaging vitality.

Jules Bouy came from France to the United States. As manager of Ferrobrandt, he was no doubt strongly influenced by the work of Edgar Brandt. Columnar elements in many of his furniture designs show him to have been inspired also by the skyscraper.

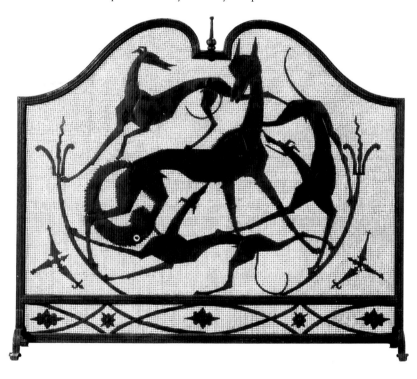

59 Wilhelm Hunt Diederich: 'Fox and Hounds' firescreen, wrought-iron and wire mesh, late 1920s (Collection de Lorenzo Gallery)

The difference in lighting between the Art Nouveau and Art Deco periods could hardly have been more pronounced. Gone, first, in the 1920s were the spectral delights of Art Nouveau lamps: the azure blues, moss greens, magentas and lavenders. In their place came achromatism: the new glass and metal models relying on factors other than colour for their effect. By etching, enamelling, or sandblasting the glass, the designer could orchestrate the light; by pressing or engraving it he could achieve sculptural effects; and, by combining such processes, he could obtain any number of nuances. In place of the spectrum there was milkiness and limpidity.

By the early 1920s, metal mounts had begun to replace the turn-of-the-century's favourite alloy, patinated bronze. Metal – whether nickel-plated chromium, aluminium, steel or silvered-bronze – represented far more effectively the aspirations of the new machine-age.

At the same time, there was considerable discussion about the role of illumination in the modern interior, much of which focused on the merits of indirect as against direct lighting, and function as against ornamentation. Although function grew in importance, the 1920s lamp survived as an *objet d'art*. Its designers had ample opportunity to display their creations: a Grand Competition of Light was arranged in Paris in 1924 by the Syndicate Union of Electricity, and, in 1925, the Exposition Universelle provided another excellent showcase. In the 1930s five Salons of Light were held in Paris: in 1933, 1934, 1935, 1937 (as part of that year's International Exposition) and 1939. There were, in addition to the above, the annual Salons, in which most decorative artists and designers participated.

Jean Perzel was Modernist lighting's foremost exponent in the 1920s. 60 Exclusively a designer and manufacturer of light fixtures, he had two main aims: first, to ensure that the light playing on diffusing surfaces did so evenly, and, secondly, to achieve maximum use of the light source's rays. To ensure the first, Perzel developed a specially frosted, sandblasted sheet of glass for the inner surface of his lampshades, adding an enamelled layer on the exterior for decorative effect. By this means he not only filtered the light equally, but met his own standards of opacity and milkiness. In later years, he used lightly tinted enamels to match the colour schemes in certain settings.

Damon, too, placed considerable importance on the correct type of glass for lighting purposes. He claimed that frosted glass was not perfectly translucent – the points of light formed by the bulbs were clearly visible through the glass – and he created instead a special glass,

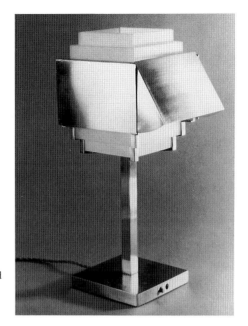

60 Jean Perzel: table lamp, silvered metal and glass, late 1920s (Collection Virginia Museum of Fine Arts)

verre émaille diffusant, housed in metal mounts. He himself designed and executed his lamp models, but drew for additional designs on the talents of others, including Boris LaCroix, Gorinthe and Daniel Stéphan.

Edgar Brandt worked with several glassmakers, but was best served by Daum. Early on, the shades created for him by Daum were smooth and silky in finish, and often heightened with swirling bands of colour. These gave way in the mid-1920s to the heavy glass, acid-etched with stylized floral or geometric motifs, that Daum favoured for his own production. This was well suited to the assertiveness of Brandt's iron, and the resulting torchères, ceiling fixtures and sconces were stylish and refined. Brandt used shades carved from alabaster with equal success. Other wrought-iron makers followed his example, Kiss, Nics *frères,* Szabo, Schenck and Subes all producing fixtures that incorporated glass and iron.

The Daum firm created some wonderful light fixtures of its own. Forms were simple. Glass shades, shaped like mushrooms, coolie hats, or of an elongated phallic form, rested on spherical or cylindrical bases. Models in frosted white glass, often etched with forceful linear designs, were particularly popular. Of equal importance to the glass fixtures by Daum were those by Lalique, in which flowers and fruit predominated.

66

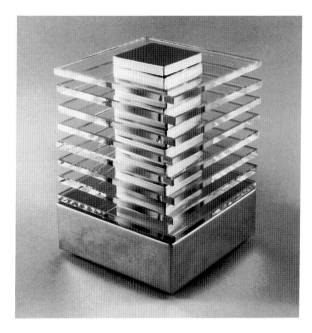

61 Maison Desny: table lamp, chromed metal and glass, late 1920s (Collection of Miles J. Lourie)

Lalique also produced an enchanting series of *luminaires* – panels and sculptural pieces with lighting housed inside their bronze bases – decorated with peacocks, jousting knights, swallows and so on.

Albert Simonet, of the firm of Simonet *frères*, one of the oldest bronze houses in Paris, was one of the first to realize that electricity required a new lighting aesthetic, not simply a reworking of gas and candle fixtures. By 1925 the firm had reduced its production of bronze and devoted its attention to the design of glass elements for lighting fixtures. The sculptor Henri Dieupart was commissioned to design sections of pressed glass, modern in concept, that would give off a flattering play of light from their surfaces.

Also pre-eminent in lamp design of the period was the Maison Desny. With a style and panache strongly echoing leading International Style architects, the firm produced carpets, *orfèvrerie*, and illuminated bibelots, in addition to a wide range of ultramodern light fixtures. Its fixtures for general interior illumination were designed specifically to do away with centralized points. Chromed wall-brackets, chandeliers and floor lamps had inverted reflecting bowls that concealed the naked bulbs and projected the light rays upwards. Where localized light was required – either for reading purposes or to illuminate a prized object or

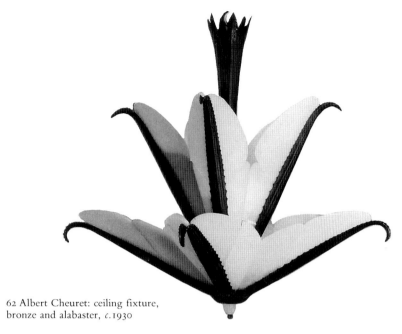

62 Albert Cheuret: ceiling fixture,
bronze and alabaster, *c.*1930

painting – the firm prescribed a range of 'genre' spotlights. One desk
lamp incorporated an anglepoise arm device which made the shade
adjustable to any desired height. Desny also designed a series of
illuminated bibelots, some in clear glass, others in metal, which had no
other function than to brighten a sombre corner.

Albert Cheuret designed a wide range of high-style Art Deco lamps
in which overlapping slices of alabaster were secured by bronze mounts
often cast as birds or animals. His distinctive style blended influences
from nature and antiquity in a sumptuous and exotic manner.

In the United States, the new philosophy on domestic illumination,
when it finally arrived in the late 1920s, was pursued with at least as
much zeal as in Europe. First, however, it had to wait for a change in
attitude towards Modernism to occur in the entire field of interior
decoration and it was not until 1926, when an exhibition of items from
the Paris Exposition travelled to eight United States cities that American
lamp fixtures began to show signs of Modernist influence. The exhibition
brought the nation's department stores into the drive towards a cont-
emporary style. Among the European participants were several lighting
designers – Brandt, Daum *frères*, Lalique, Chareau, Süe et Mare and the
Parisian department stores, Au Bon Marché and Primavera.

Two years later, leading Americans were provided with their own avenue to Modernism: the American Designers' Gallery exhibition of contemporary art in America. Now, finally, the Modernist movement in the United States had reached independence, its traditional reliance on European leadership largely severed by the impetus, ironically, of its immigrant designers. Those in the vanguard of lighting design included Donald Deskey, Ilonka Karasz, Walter von Nessen, Eugene Schoen, Wolfgang and Pola Hoffmann, and Robert Locher. Others participated beyond the formality of the annual exhibitions: for example, Walter Kantack, Kurt Versen, John Salterini, Paul Lobel, Maurice Heaton and, from the early 1930s, an emerging force in American contemporary design, Gilbert Rohde.

Walter von Nessen was the United States' premier Modernist lamp 63 designer. He emigrated from Germany in 1923, and set up the Nessen Studio in New York, where he designed and produced a wide range of contemporary light fixtures, principally for interior designers and architects. By the early 1930s, while most businesses were retrenching, he expanded to service orders from the retail trade. His lamps, especially, drew praise for their brazen modernity, both in form and in choice of brilliant metallic finishes. They were both functional and artistic, their bold linear contours matching the most avant-garde of Von Nessen's European counterparts. Angular shades in frosted glass or parchment were mounted in chromium-plated metal, brass or brushed aluminium. To soften this machine-age aestheticism, decorative accents were added in Formica, Bakelite and rubber discs. Both direct and indirect lighting requirements were accommodated by shades that could tilt, rotate or turn fully upwards. A particularly functional concept came to fruition in Von Nessen's 'Lighthouse' lamp model, which was made of two sections that could be lit together or independently.

Donald Deskey showed his versatility in several lamp designs which 64 rivalled those of Von Nessen in ingenuity. Some of his bases, especially, were astonishingly abstract. One was composed of a spiralling shaft of chromium-plated brass which led the eye to the light above. Another, in brushed aluminium, consisted of a series of square horizontal ribs echoing the boxlike structures of International Style architecture. A further example, with a serrated front inset with rectangles of frosted glass panels, appears to have been directly inspired by the work of Jean Perzel.

Walter Kantack, another leading lighting exponent, complemented his output of Modernist fixtures between 1928 and 1932 with monthly issues of his firm's magazine, *The Kaleidoscope*, in which he set out his

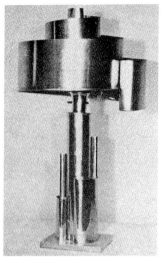

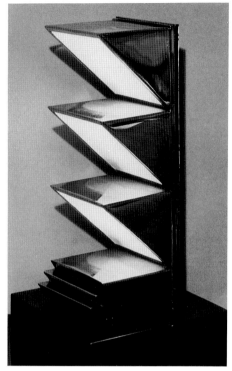

63, 64 *Above* Walter von Nessen:
table lamp, chromium-plated
metal, *c*.1928. *Right* Donald
Deskey: table lamp, brushed
aluminium and glass, exhibited
in Deskey's Man's Room at the
1928 American Designer's
Gallery, New York (Collection
of Miles J. Lourie)

tenets for contemporary domestic illumination. His lamps matched his concepts: they were crisply angular, bright and functional.

In the forefront of Modernist American lighting design, Kurt Versen created a range of table and floor models with polished chromed mounts. His lampshades incorporated a mix of opalescent glass, Bakelite, cellophane, Lumerith and, his favourite material, toyo paper. Versen's best-known models incorporate hinged shades which flip upwards to provide either direct or indirect illumination. Among the other metal craftsmen and small studios to turn their hands to contemporary lamp design were John Salterini and the Lansha Studios, both of whom produced wrought-iron fixtures with frosted glass shades in a manner distinctly similar to that of Parisian wrought-iron artisans such as Poillerat, Nics *frères* and Szabo. Paul Lobel – another metalworker – was also drawn to the medium, though his designs in copper and wrought-iron showed greater innovation in the sculptural bases than in the lamps *per se.*

Silver, Lacquer, and Metalware

SILVER

Silverware designers had to be more conservative than their counterparts in the other arts because they had a more traditional clientele. The Modernist philosophy of eliminating surface decoration could not be applied at once. What emerged was a traditional 'Modern Class' style, a marriage between new and old: dignified, understated, rational, and safe rather than bold.

By virtue of its colour, silver is a 'dry' material. To give it life without the use of surface ornament, the 1920s Modernist silversmith had to rely on an interplay of light, shadow, and reflection created by contrasting planes and curves. Another way to enrich its monotone colour was by incorporating semiprecious stones, rare woods, ivory and glass. Towards the 1930s, *vermeil* or gold panels were applied to the surface as an additional means of embellishment. When used with restraint, so as not to overwhelm the balance and purity of the design, these materials added warmth, sumptuousness and textural contrast.

Jean Puiforçat emerged as the doyen of Art Deco silversmiths. From 65-67 a very early stage, he concentrated on trying to unify design and function. Superfluous ornamentation was pared away in the pursuit of a purely functional form of design. This, he found, could be achieved largely by using three fundamental shapes; the sphere, cone or cylinder. Combining elegance and simplicity, he generated a formidable range of silverware tea services, flatware and hollow-ware, table-top objects, and liturgical pieces. Included were streamlined cruet dishes, *chocolatiers*, chalices and sword guards adorned with lapis lazuli, ivory, ebony and crystal. The term 'Cubist' was sometimes loosely applied to Puiforçat's style, but he (more accurately) preferred to call it 'mathematical'.

A latecomer to the field of silver, Jean Tétard abandoned simple geometric shapes for a combination of more complex flattened forms made of identical sections joined by flat conforming bars. Although these designs required a high degree of technical skill, they allowed him

71

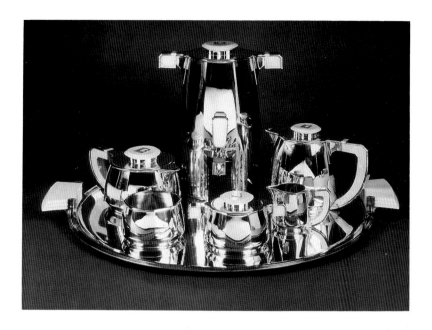

great freedom of expression. His only concessions to ornament were beautiful sculpted handles in rare woods that seemed to grow out of the silver. Tétard's development of serpentine surfaces, in which concave and convex planes were alternated to create the impression of spiralling movement, were particularly dramatic and elegant. He and his firm Tétard *frères* produced a wide range of silverware: table services, flatware, cigarette boxes, planters and mirrors, all in the intensely personal style that became Tétard's hallmark.

Silverplate, produced by electroplating, was virtually indistinguishable from real silver. Electroplating was developed in the 1840s and 1850s and is closely associated with the name of Charles Christofle, who purchased all existing French patents. In 1855, Pauline de Metternich, wife of the Viennese Ambassador in Paris, dined with Napoleon III. When she complimented him on the silver, he replied: 'Dear Ambassadrice, it is a luxury that everyone can now afford. I have on my table not one piece of sterling silver. It is all by Christofle.' Branches in London, Vienna and Philadelphia carried the firm's name to foreign markets.

The firm continued into the twentieth century and by the 1920s was producing a full range of utilitarian and decorative silverplate, including

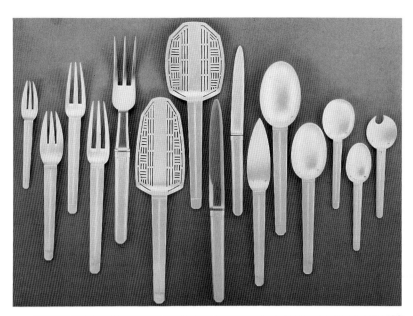

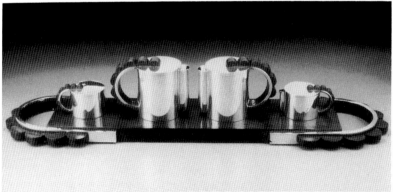

65–67 *Opposite* Jean Puiforcat: silver and ivory tea service, 1920s. *This page, top* Jean Puiforcat: silver flatware service, 1920s. *Above* Jean Puiforcat: tea set, silver and palisander, 1937 (Collection Virginia Museum of Fine Arts, gift of Sydney and Francis Lewis, photo courtesy of Primavera Gallery)

vases done in a *dinanderie* technique, in which inlays of patinated metals were applied commercially to machine-stamped blanks. Many of these pieces were designed by Gio Ponti, Maurice Daurat, Luc Lanel, Christian Fjerdlingstad and other noted artists.

Several individual jewelers and jewelry houses were drawn to silver as a means of extending their talents. Jean Desprès' silver and pewter bowls, *bonbonnières*, tureens and flatware were starkly simple and almost brutal in their Modernism, with heavily hammered surfaces and boldly hewn bolts and rivets. Gérard Sandoz also produced a limited number of distinctive objects of forceful design, in which lizard skin, *galuchat* and ivory added refinement. In the United States, the designer William Spratling created small silver objects with the same primitive elegance that characterized his jewelry.

Among the large houses, Cartier, Van Cleef & Arpels, Marchak, Mellerio and Tiffany & Co. followed suit with an amazing variety of objects which overstepped the traditional boundaries between jewelry and silver. Elaborate Art Deco objects of vertu were created in which elements made of semiprecious stones were mixed with silver and gold. Cartier's famous mystery clocks provided perhaps the most extreme example of this marriage of the two disciplines.

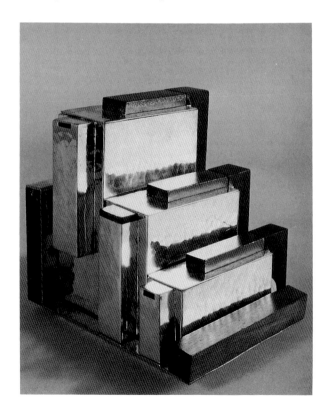

68 Jean Desprès: tea service, silver-plated metal and teak, *c.*1925 (Collection of Primavera Gallery)

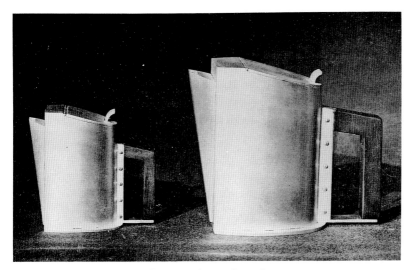

69 Gérard Sandoz: tea and coffee pots, silver and wood, 1920s

In Belgium, Germany and Denmark there were isolated exponents of the Art Deco style in silver. In Brussels, Marcel Wolfers, son of the famous Art Nouveau jeweler and silversmith, Philippe Wolfers, designed a range of angular and bulbous tea services and flatware in the Modernist idiom. While studying sculpture in his father's atelier, Wolfers mastered the related disciplines of enamelling and stone carving. He was fascinated by Chinese decorative techniques, and used them extensively in his work. In Germany, some of the period's most profoundly important and exciting designs in silver and metal were produced by Bauhaus designers. In Copenhagen, Georg Jensen emerged as a major figure in twentieth-century silver, despite the fact that he was not a great innovator. His major accomplishment lay in turning handcrafted modern silver into a successful commercial enterprise by producing it at a cost which made it available to the new bourgeoisie. Joined by the painter Johan Rohde, Jensen introduced a restrained brand of Modernism to Scandinavian silver, one which introduced the ideals of William Morris to twentieth-century Scandinavian art. Harald Nielsen, who joined the firm in 1909, brought with him a functional style derived from the Bauhaus. Sigvard Bernadotte, son of the King of Sweden, was their most influential designer in the 1930s, producing hard-edged pieces characterized by incised parallel lines.

70, 71 Erik Magnussen: covered chalice
designed for the Gorham Manufacturing
Company, silver and amethyst, c.1928
(Collection the Newark Museum). *Left*
Tiffany & Co.: silver coffee service
exhibited in The House of Jewels at the
1939 World's Fair (photo Tiffany & Co.)

Silver design in the United States was less receptive than other areas of the decorative arts to European, especially French, Modernist influences. To Americans, silver was still something passed down from generation to generation; it implied a certain snobbery and inherited wealth.

Tiffany & Co., the largest and most prestigious manufacturer of fine silver in the United States, executed very few pieces in the contemporary idiom, and even these did not make an appearance until the mid-1930s after Louis Comfort Tiffany, the firm's design director and a fierce antagonist of Modernism, had died.

Gorham, another important American silver manufacturer, was also reluctant to abandon traditional styles. Edward Mayo, who was appointed head of the firm in 1923, tried to bring new inspiration by hiring the Danish silversmith, Erik Magnussen, who worked for Gorham from 1925 until 1929. Magnussen produced designs that took their inspiration from a wide range of sources: Georg Jensen's lingering Art Nouveau style, Constructivism, Cubism and the skyscraper. His Cubist-inspired coffee set of 1927, entitled 'The Lights and Shadows of Manhattan', incorporated contrasting triangles of silver, gilt and burnished brown patina in a highly original composition which echoed the

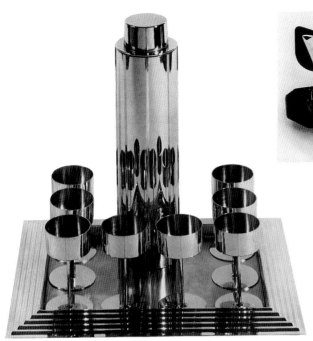

72, 73 *Above* Gene Theobald
(attributed to) for the International
Silver Company: tea service,
silver-plated pewter and Bakelite
(Collection Mitchell Wolfson, Jr.,
Miami-Dade Community
College). *Left* Norman Bel
Geddes: 'Skyscraper' cocktail
service with 'Manhattan' serving
tray, manufactured by the Revere
Brass & Copper Company,
chromium-plated metal
(Collection the Brooklyn
Museum, gift of Paul F. Walter)

silhouettes of New York's tallest new buildings. Today, no other piece of 1920s silver design captures as precisely the buoyant mood of late 1920s America. Among Magnussen's other audacious designs for Gorham was a similar set of flatware entitled 'Manhattan'. These designs elicited a good deal of imitation, most notably two 'Skyscraper' tea services in nickel-plate produced by Bernard Rice's Sons, Inc., for Apollo, and skyscraper-inspired tea services by the Middletown Silver Company and Wilcox Silver Plate Company. The industrial designer Norman Bel Geddes also designed a 'Skyscraper' cocktail service and a 'Manhattan' serving tray, but these were done in a restrained, linear style that was almost Scandinavian in feeling. In fact, Scandinavian design was more successful than French design in the United States.

The International Silver Company in Connecticut retained outside designers such as Gilbert Rohde, Eliel Saarinen and Gene Theobald to create a wide range of hollow and flatware in silver, silverplate and pewter that reflected new trends in the decorative arts. One of the most noteworthy silversmiths working independently in the United States during the 1930s and 1940s was the German-born Peter Müller-Munk. His designs were modern without being extreme, reflecting a European sophistication that attracted many private clients. But with the financial

77

crash of 1929 the silver market declined sharply, opening the way for a variety of imitation metals, such as silverplate, chrome and nickel.

The most successful manufacturer of mass-produced chrome and nickel accessories was the Chase Brass & Copper Co., of Waterbury, Connecticut, which hired such prominent designers as Walter von Nessen, Gilbert Rohde, Russel Wright and Rockwell Kent, to design Modernist-inspired cocktail and smoking accessories for the mass market.

The introduction of electricity inaugurated a revolution in the design of clocks. Now clocks were small enough to sit comfortably on tables with other objects, and to hang on inaccessible parts of walls where they would not require winding. Most French Art Deco designers abandoned the round clock in favour of strong vertical and horizontal shapes. Some modified, or even abolished, the traditional needle hands, replacing them with balls on moving metal plates or stationary points on a rotating dial of numbers. Great attention was also paid to the design of the numbers themselves. Both Roman and Arabic numerals became outmoded and were replaced by combinations of vertical and horizontal rectangles, circles and arcs.

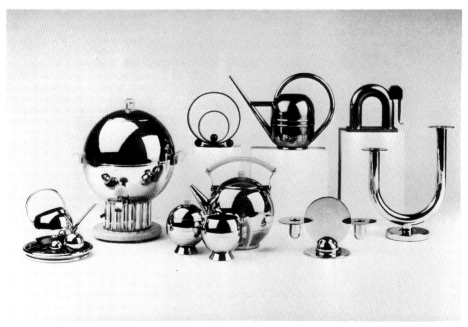

74 Chase Brass & Copper Co.: selection of 'Speciality' line items, chromed-metal with Bakelite, 1930s

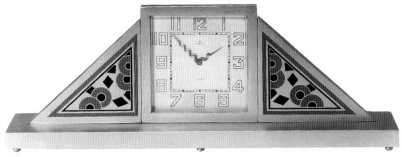

75 Omega: enamelled and chromed-metal clock, 1920s

LACQUER AND METALWARE

The huge interest in Japanese art spawned in the late nineteenth century contributed greatly to the resurgence of interest in lacquer in France. Jean Dunand, who developed into the most important artist to work in this technique, was introduced to the medium by a famous Japanese lacquer artisan and his mastery quickly led him to the forefront in Paris, and effectively changed his career. He was able to develop shades of yellow, green and coral lacquer that had always eluded Japanese artisans, and to produce top quality lacquer at a relatively low cost. To achieve white, a colour unobtainable with the vegetable dyes used to create lacquer, he developed the intensely laborious art of *coquille d'oeuf*, in which particles of crushed eggshell were inlaid into the uppermost layers of the lacquer.

Dunand applied lacquer to his metalwork vases in arresting geometric patterns that provided a series of vibrant new Art Deco images. He later extended its use into screens and panels, collaborating also with furniture designers such as Ruhlmann, Leleu and Printz on panels and doors for their cabinetry.

Dunand's earliest vases in the late Art Nouveau period derived their shape from gourds and other vegetal forms, but his vessels became simpler in form as his designs became more abstract. In addition to his own designs, Dunand commissioned the sculptor and painter Jean Lambert-Rucki to create a fanciful menagerie of animals in his bizarre Modernist style which Dunand could use to decorate his metalware and lacquer screens. Some of Dunand's small personal accessories and jewelry in silver and metal combined an Oriental influence with a powerful African inspiration that is readily apparent in his choice of colours, subjects and motifs.

79

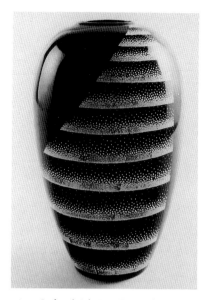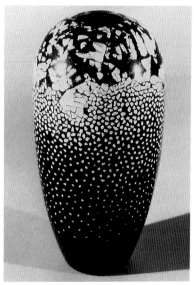

76, 77 *Left and right* Jean Dunand: metal vases, black lacquer and shaded eggshell, 1920s
(Collection Steven Greenberg)

One of Dunand's associates, Jean Goulden, became an outstanding
master of the art of champlevé enamelling. His highly sophisticated
objects are simple in shape with strong Cubist volumes and flat planes
painted with strongly contrasting enamels in abstract or represent-
ational designs. His preferred metals were gilt-copper, gilt-bronze,
silvered-bronze and sterling silver. Byzantine art was a continuing
influence on him, as it was on Claudius Linossier, whose work was
compared to the decor of Hagia Sophia in Istanbul or St Mark's in
Venice. His surfaces, it was said, 'seemed to shimmer with fire, with
the ferment of metal in fusion'. He also studied alloys, and his under-
standing of these enabled him to achieve the various tonalities of silver
that gave his pieces their understated richness. But the outstanding
element of Linossier's work was his use of metal incrustation. He
refused to use acids, as they did not produce permanent colours.
Instead, he used the flame, causing the inlays to expand and merge
slightly into one another, producing soft tones of faded rose, silvery
white, greys, pinks, yellows, mauves and deep, rich black. The finished
piece revealed the natural qualities of the metals, and also bore the subtle
traces of the hand that had formed it.

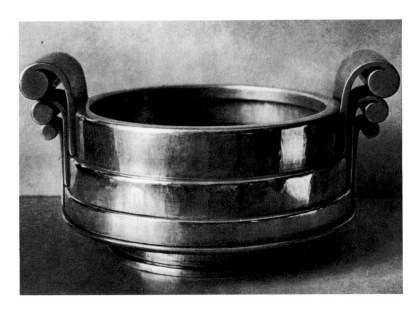

78 Maurice Daurat: centrepiece, pewter, 1920s

Maurice Daurat preferred to work in pewter, a soft metal, ductile and extremely supple. Daurat exploited its almost fleshlike surface, sombre shadows and the irregular reflections of light from random hammer marks. All of these imparted to the finished piece a warmth more appealing to Daurat than the cold gleam of silver. His designs became increasingly pared down, emerging finally as studies in form and simplicity. His only concession to ornament could be a ring of round beads at the base, or an interesting handle. Daurat intended his pieces to be admired rather than used, and indeed their weight often rendered them impractical. This was not as arrogant as it may seem. Compared with the price of fine silver or porcelain, Daurat's pieces were an affordable extravagance. In his hands, pewter achieved the status of a newfound material, and could stand without shame next to the finest silver.

Glass

Numerous new styles and techniques were developed in glass between 1900 and 1925. At the same time, distinction was increasingly made between glass as a medium of artistic expression and glass as a utility household item. With the advent of Modernism in the late 1920s, further uses for glass were found both in furniture design and in architecture. Glass became a fundamental component of the new design aesthetic that rejected traditional materials and modes of ornamentation and focused instead on functionalism.

FRENCH GLASS IN THE ART DECO STYLE

French designers in the Art Deco era produced the widest variety of forms and decoration in glass, under the leadership of Maurice Marinot and René Lalique, who jointly succeeded Emile Gallé as the leading *maître verriers* in France.

The work of Marinot is now considered to have been one of the major design sources for glass after the First World War. Marinot began his artistic training at the Ecole des Beaux-Arts in Paris from 1901 to 1905. His early painting style was similar to that of the Fauvists – Matisse, Derain and Van Dongen – whose canvases were shown alongside his at the 1905 Salon d'Automne. He exhibited his works at the Salon d'Automne and the Salon des Indépendants annually until 1913, by which time his interest had shifted entirely to glass. A visit two years earlier to the glassworks of his friends Eugène and Gabriel Viard at Bar-sur-Seine changed the course of his career. His early experimentation included models for vases and bottles executed by the Viard brothers under his direction. Using the surface of the glass as a canvas, he applied bold, stylized flowers, masks and nudes in bright blue, red, yellow and flesh-tinted enamels. Some of his earliest models achieved quick popularity when they were included in the 'Cubist House' exhibit conceived by his friend André Mare for the 1912 Salon d'Automne. In 1913, Adrien Hébrard, the noted Paris art dealer and bronze-founder,

became Marinot's exclusive agent, exhibiting examples of his glass in his rue Royal gallery.

Marinot acquired the technical skills of glassmaking quickly, and was soon executing his own designs. He worked virtually uninterrupted from 1914 to 1919, experimenting with translucent enamels as an alternative to the opaque varieties. This led to a transitional period in which he continued to employ enamelled figural decoration to the outside surface of the glass while experimenting with ways to apply the decoration internally. By 1923, he had rejected all types of extraneous decoration, including the use of enamels, in order to explore both hot and cold glass-making techniques. This allowed him to work with the glass mass itself. The glass objects of his mature years were extremely sculptural, while retaining the brute force of his early Fauvist paintings. An acid-etched vase in clear glass, dated 1934, now at the Corning Museum of Glass, New York State, provides a fine example.

In the 1920s and 1930s, Marinot's work divided itself roughly into four categories. First were the vessels he designed after his initial attempts at enamelling. These are characterized by heavy, thick walls which incorporate deeply etched or internal decoration, the latter consisting of air bubbles, smoky tints, streaks of muted colour, or a

79 Maurice Marinot: 3 bottles with stoppers, c.1925

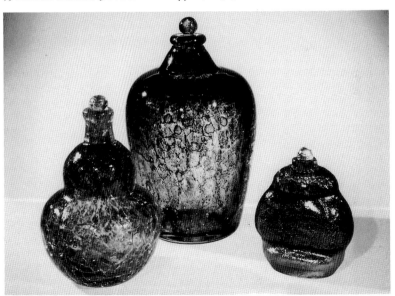

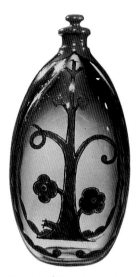

80, 81 *Left* Maurice Marinot: enamelled bottle and stopper, 1920. *Right* Henri Navarre: vase, pale sapphire blown glass, *c.*1927

'sandwich' effect in which a layer of speckled or spiralling colour was inserted between the inner and outer layers of clear glass. The second category comprises etched pieces that were very deeply acid-cut with powerful, almost brutal, abstract geometric motifs in which the acid-treated textured areas contrast with the polished and smoothed raised areas to maximize the refractive effects of the light. The third category includes glassware worked at the furnace, in which heavy applications of molten glass emphasize form. Marinot modelled some of these into formalized masks. The fourth category is made up of Marinot's bottles, either moulded or shaped at the kiln, which incorporate the artist's characteristic spherical or hemispherical stopper and internal decoration.

Marinot's work was published extensively and received wide recognition and critical acclaim. At the 1925 Exposition, he exhibited *hors concours* at various pavilions, including the Ambassade Française, Musée d'Art Contemporain and the Hébrard shop on the Alexandre III bridge. Praise for his glass soon became worldwide, and its influence extended beyond his French contemporaries to glassmakers outside France.

Of Marinot's many followers, Henri Navarre is probably the best known. Navarre began to experiment with glass in the mid-1920s after an earlier career as a sculptor, goldsmith and stained-glass artist. Most of his work is furnace-worked glass with heavy walls and internal decoration in the form of swirls and whirls of colour, internal granulations, and *intercalaire* (inter-layered) textures. These effects were

achieved by the use of powdered metal oxides patterned on the marver on to which a paraison of viscous clear glass was then rolled. The application of a second layer of clear glass encased the decoration. Navarre's palette is more sombre than Marinot's and his surfaces are more heavily adorned with applications pressed on to, or wrapped around, the body. One of his most important commissions was the execution of a large figure of Christ in moulded glass and a gilded bas-relief reredos representing Martha and Mary for the chapel of the *Ile-de-France* oceanliner in 1927.

Like Navarre, André Thuret began to experiment in glass in the 1920s after working as a glass technician for the Bagneux Glassworks. His work incorporated the same thick walls employed by Marinot, in clear glass enhanced with internal air bubbles. His style, however, was more adventurous in its range of shapes and colours; the semimolten glass was either pinched into contorted or undulating shapes or rolled on to metallic oxides on the marver to produce multicoloured swirls and patterns.

Georges Marcel Dumoulin received numerous awards for his paintings and ceramics before venturing into glassmaking. He made a series of waisted vessels with internal colour and bubble effects reminiscent of Marinot's works, in which trailing serpentine swirls were applied in spirals around the outside of the glass. Jean Sala, the son and disciple of Dominique Sala, also applied a bubbled *intercalaire* form of decoration to his *Malfin* series.

Daum *frères* of Nancy reopened in 1919 under the guidance of Paul Daum and grew in prestige as the town's other glass ateliers went into

82 Daum: selection of etched glass vases, 1920s/30s

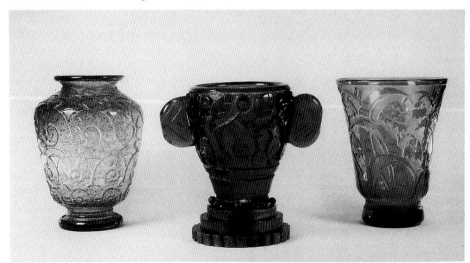

decline. Daum produced a line of thick-walled, large vases in transparent and opaque coloured glass. Among their most prominent works were a series of bowls, vases and lampshades with deeply etched bold, geometric motifs, some of which were blown into a bronze or wrought-iron armature. The backgrounds on these pieces were roughly finished to contrast with the polished relief sections, a technique borrowed from Marinot. After 1930, the walls on Daum's glass became thinner and the etching shallower. The firm also produced cameo vases and lamps in

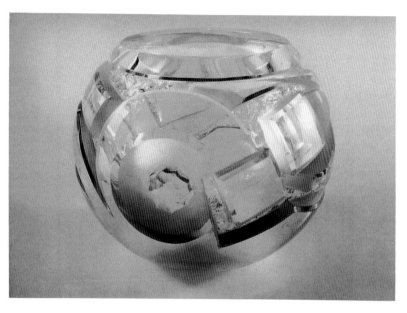

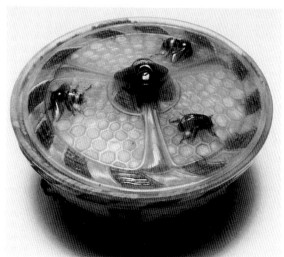

83, 84 *Above* Aristide Colotte: glass vase, carved and chiselled decoration, late 1920s (Collection of Miles J. Lourie). *Right* Daum and Alméric Walter: covered bowl in *pâte-de-verre*, late 1920s

crystal or single colours etched with stylized designs of animals, repeating floral patterns, sunbursts or swirls, invariably against a roughly etched background.

Aristide Colotte joined the rival firm Cristallerie de Nancy in the mid-1920s as a modeller. His early designs included moulded radiator mascots and statuettes, but experimentation soon led to enamelled and painted glassware enhanced with etched detailing. By 1928 Colotte's style had become distinctly unconventional, more suited to wood or metal in its choice of sculptural forms and techniques. Favourite themes included animals and birds – for example, rams, owls and swallows – and a considerable body of religious subjects, to which he often applied powerful geometric motifs such as bolts of lightning or spiralling bands engraved deeply into the freeform mass of crystal.

Ernest and Charles Schneider established their glassworks at Epinay-sur-Seine in 1913. They created large, colourful lamps and vases decorated with internal bubbles and mottled or marbleized colour effects.

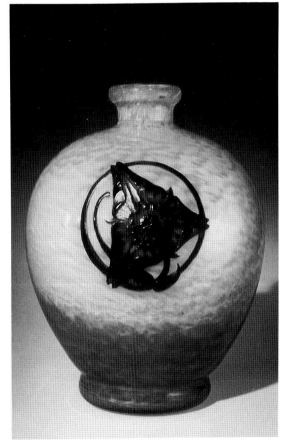

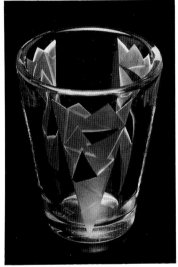

85, 86 *Above* Jean Luce: vase, etched glass, 1920s (Collection L. Mark Nelson). *Left* Schneider: mottled orange and amethyst vase, cased with colourless glass, *c.*1925

Some pieces were decorated with boldly coloured glass trailings fashioned into stylized flowers, others with engraved geometric whorls, stylized flora and portrait medallions. Some combined techniques to mimic realistic scenes from nature, such as painted goldfish on a translucent bubbled ground simulating an aquarium. Opaque black and orange were among the firm's most distinct Art Deco colours. Schneider glassware was also sold under the names Charder and Le Verre Français or, without a signature, with an embedded millefiore cane.

Marcel Goupy followed the enamelling style of Marinot's early work, designing a range of vessels in colourless or transparent coloured glass on which the decoration was rendered in bright enamels painted on both the inside and outside surfaces. His decorative motifs ranged from stylized birds, flowers and animals to landscapes, mythological figures and female nudes, in a style resembling that of Süe et Mare. He also created vessels in smoky or coloured glass that achieved new effects in their layering. Less known, but often equally high-style, were the enamelled commercial glasswares of Delvaux and André Delatte, the latter situated in Nancy.

Auguste-Claude Heiligenstein became proficient in enamelling under Goupy, for whom he worked for four years. His elaborately detailed and brilliantly coloured vessels reflected the 1920s revival of Neoclassical themes delineated in the Art Deco style. Draped women among flowers became a favourite theme, often rendered in a combination of enamelled, engraved and etched techniques.

Jean Luce, too, used enamelled stylized floral designs to decorate his early glassware, but shortly afterwards he rejected enamelling in favour of geometric abstract patterns engraved or sandblasted in contrasting mat and polished finishes. Other models in this period were thick-walled with mirrored or gilded surfaces engraved or sandblasted with geometric patterns.

René Lalique began his career as a graphic designer and then as a designer of Art Nouveau jewelry. His discovery of glass came in the course of his search for new and less expensive materials for his jewelry. He experimented with vitreous enamels and glass cast by the *cire perdue* method. It was in the latter technique that Lalique produced his first all-glass object, a tear-shaped vial with stopper, between 1893 and 1897. After this initial success, he made a limited number of glass items, which he displayed alongside his jewelry at his new atelier in the Place Vendôme.

It was here in 1906 that Lalique's glass vessels first caught the attention of the *parfumier* François Coty who commissioned him to

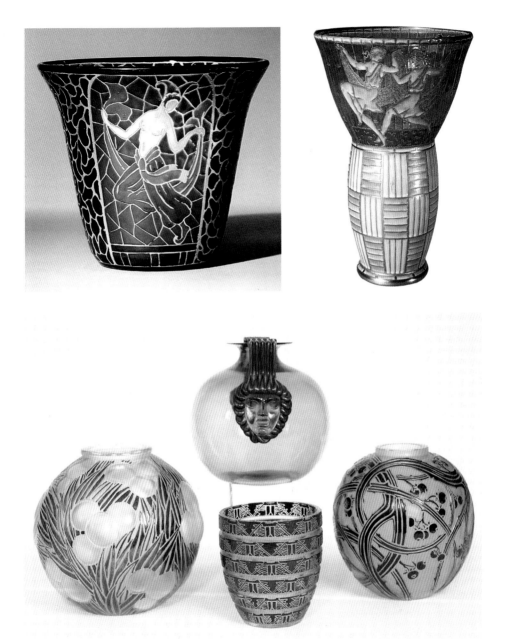

87–89 *Top left* Marcel Goupy: enamelled glass vase. *Top right* Auguste Heiligenstein: vase, mould-blown with gilt and enamel decoration, late 1920s. *Above* René Lalique: (left to right) *Oranges*, black-enamelled and frosted glass vase; *Cluny*, grey glass vase with bronze mounts; *Lagamar*, black enamelled and frosted glass vase; *Baies*, black-enamelled glass vase, 1920s/30s (photo courtesy of Christie's, New York)

create labels and *flaçons* for his various perfume lines. Lalique's first designs for Coty were produced at Legras et Cie, in crystal and mostly unsigned, but by 1908 Lalique had taken over the Combs-la-Ville glassworks and had begun to execute his own designs. More extensive premises, purchased in 1909, allowed him to go into serial production. By the outbreak of the First World War Lalique had almost ceased his jewelry production and in 1918 his emphasis on glass was consolidated with the purchase of a larger factory at Wingen-sur-Moder.

Lalique's vessels, which incorporated exceptionally high relief and finely detailed decoration, were made in three ways: by blowing glass into moulds by mouth, mechanically by an *aspirée soufflé* or *pressé soufflé* process, or by casting with a stamping press. The base material used was always *demi-cristal*, glass with a 50 percent lead content that was either left clear or coloured with metallic oxides, sulphides and chlorides, to produce an array of exquisite, jewel-like colours ranging from emerald green to ruby red. Opalescent effects were obtained by sandwiching a layer of opaque white glass between two layers of coloured glass. Other forms of decoration were achieved by painting or staining with enamels, frosting with acids, 'antiquing' or simulating the effects of aging, exposing the glass to metallic oxide fumes under a muffle, or by polishing with rouge or high-speed buffers.

Lalique's repertoire of decorative motifs was equally varied: naturalistic or stylized animals, flowers, human and mythical forms, and abstract geometric patterns. Relief patterns were heightened by the application of coloured enamel stains. A wide variety of items were offered: vases, tableware, *garnitures de toilette*, *flaçons*, *brûle-parfums*, jewelry, clock cases, sculpture, mirrors, desk sets, light fixtures, furniture, architectural fittings, fountains and even such novelty items as car mascots.

90, 91 *Left* René Lalique: box, black glass and silvered-bronze, c.1920. *Right* René Lalique: 'Victoire', frosted and polished glass car mascot, c.1928

Lalique was enormously successful throughout the 1920s, gaining wide acclaim at the 1925 Paris Exposition, where he had his own pavilion. He also designed a dining room in glass for Sèvres and a large fountain in the Cours des Métiers. In addition, his *flaçons* dominated the spectacular *fontaine des parfums* in the perfumery section, while other examples of his work were included in the exhibits of various ensembliers. Important commissions followed, including glass elements for transatlantic cruise liners such as the *Paris* (1920), the *Ile-de-France* (1927), and the *Normandie* (c.1935), for which he made decorative panels, light fixtures, illuminated ceilings and other accessories. He provided similar fixtures for luxury *wagons lits* (sleeper cars) in the French railway system, restaurants, theatres, hotels and churches, and he designed a series of public glass fountains at the Rond-Point on the Champs-Elysées.

Lalique's success prompted a similar line of glassware from several other designers, including Marius-Ernest Sabino, who exhibited at the 1925 Paris Exposition and subsequently at the Salon d'Automne and the Salon of the Société des Artistes Décorateurs. Sabino's blue-tinted opalescent glass vases and decorative accessories, though not as finely conceived and executed as Lalique's, were more colourful. His works included architectural elements, *electroliers*, floor and table lamps, chandeliers, tables, vases, wall *appliques*, fountains and statuettes in human and animal form. The elaborate bronze, brass and wrought-iron mounts for his lamps and decorative objects were made in his own workshops. Sabino's reputation rests primarily on his inventive designs for lighting fixtures, such as those for the oceanliner *Normandie*.

Edmond Etling et Cie produced a similar range of Lalique-inspired objects, including figurines of female nudes, animals and ships in opalescent glass with a bluish tint. The firm also made small chromed metal and crystal lamps, examples of which were displayed at the second Salon of Light in 1934 and at the 1937 International Exposition. Etling designers included Dunaime, Georges Beal, Jean-Théodore Delabasse, Geneviève Granger, Lucille Sevin, Geza Thiez, Bonnet, Laplanche and Guillard. Like Etling, the firm of Holophane in Andelys, forty kilometres from Rouen, produced a range of opaline glass bibelots and vases marketed under the name of Verlys.

The firm of Genet & Michon manufactured light fixtures, lighting schemes and custom-made illuminated panels inspired by Lalique. Their glass was slightly opaque, achieved by the application of hydrofluoric acid to its surface. This semi-opacity refracted and diffused the light in eye-catching patterns which the firm incorporated into

92 René Lalique: *Le Jour et la nuit*, clear and frosted blue glass clock, c.1932

architectural lighting commissions such as the Hôtel Splendid at Dax. Genet & Michon also produced a remarkable selection of small light fixtures, such as a globe lamp in pressed glass with a map of the world engraved on its surface, and a table lamp with a globular base and cylindrical pressed glass shade.

Albert Simonet, head of the bronze manufactory Simonet *frères*, was so inspired by Lalique's success that he relegated bronze to a secondary role, that of supporting the glass, and introduced pressed glass panels into his lighting fixtures. A remarkable work is an urn-shaped *torchère* in opalescent glass moulded in relief with stylized floral patterns, the shade of which rests on a bronze *guéridon*-type base cast with a Neoclassical frieze of satyr masks above a band of goats' hooves. This was one of several pieces shown by Simonet and Henri Dieupart at the 1925 Paris Exposition. The firm's most characteristic designs for light fixtures were globular, the individual sections of pressed glass mounted in a metal armature. The glass itself was moulded with a variety of naturalistic and abstract motifs.

Paul d'Avesn, a student of François-Emile Décorchemont, worked for Lalique between 1915 and 1926 before establishing himself at the Cristalleries de Saint-Rémy, where he produced moulded glass vessels

93 Argy-Rousseau and Alméric Walter: selection of *pâte-de-verre* wares, late 1920s

in various finishes. One of his best-known works is a vase with a frieze of alternating lions and lionesses stalking their way in an endless line around the squat bulbous vase. André Hunebelle also designed moulded vases *à la Lalique* which were more geometrical and stylized in shape and decoration than those of d'Avesn. Hunebelle shared with Sabino a liking for bluish opaline glass.

PATE–DE–VERRE

Although the revival of *pâte-de-verre* in France was initiated at the end of the nineteenth century, it did not peak until the 1920s and 1930s. *Pâte-de-verre* is made of finely crushed pieces of glass ground into a powder mixed with a fluxing medium that facilitates melting. Colouring is achieved by using coloured glass or by adding metallic oxides after the ground glass has been melted into a paste. In paste form, *pâte-de-verre* is as malleable as clay, and is modelled by being packed into a mould where it is fused by firing. It can likewise be moulded in several layers or refined by carving after firing. François-Emile Décorchemont brought the greatest recognition to *pâte-de-verre*. A ceramicist by training, he was inspired to experiment with the material in 1902, on seeing the *pâte-d'émail* works of the turn-of-the-century pioneer Albert Louis Dammouse. Décorchemont's first wares were typically Art Nouveau

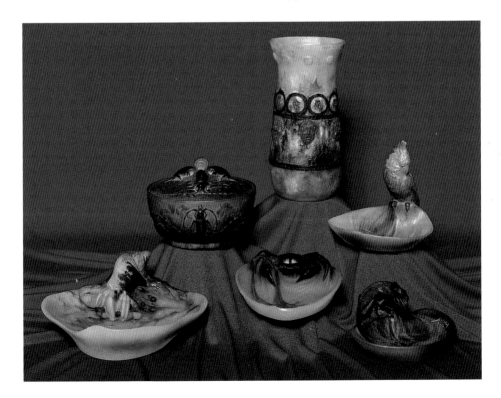

in style, with floral or symbolist motifs. Gradually, however, his style and technique changed. Around 1909, he began to work in the *cire perdue* method of casting, producing thin-walled vessels with decorative details cut into the surface. A year later he was working with *pâte-de-cristal*, having rejected the thin walls and ethereal decoration of his earlier models. His work in this period had thicker walls and was more richly coloured.

In the 1920s Décorchemont's style became increasingly bolder, progressing to the stylized asps and grotesque masks of the early to mid-1920s and, finally, to the highly geometric images of his mature style. Of restrained elegance, his works in this later period are characterized by rigid, often cubic, forms, with relief geometric decoration. Décorchemont developed a spectrum of jewel-like colours, using a variety of metallic oxides that rivalled Lalique's in brilliance and sumptuousness. Jade green, turquoise and sapphire blue were streaked with black or purple to simulate semiprecious stones. In the 1930s Décorchemont became increasingly involved in the production of decorative window panels, working from 1935 to 1939 almost exclusively on a window commission for the Sainte-Odile Church in Paris. In place of the traditional use of painted and leaded glass, Décorchemont used *pâte-de-verre* to create a rich and intimate effect.

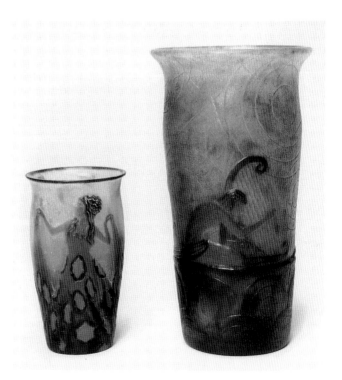

94 Argy-Rousseau:
pâte-de-verre vases, 1920s/30s

Joseph-Gabriel Rousseau employed several dozen workers and decorators in his firm (Les Pâtes-de-verre d'Argy Rousseau) to execute his designs. He manufactured a wide range of decorative objects, including vases, bowls, lamps, jars and panels in colourful, opaque *pâte-de-verre* of very light weight and a high grade of clarity. These were decorated with stylized flowers and animals in combination with geometric motifs. His more notable works, executed in *pâte-de-cristal*, had Neoclassical relief decoration. Other models were rigidly geometric in form. A waning public interest in *pâte-de-verre* from 1929 led to a gradual decline in production and, with the onset of the Depression, Les Pâtes-de-verre d'Argy Rousseau was dissolved. Argy-Rousseau turned to small-scale production, working on commissions for plaques and sharply angular vessels in jewelled colours streaked with black or deep burgundy. The geometry of these vessels gave them a refreshingly modern look.

Alméric Walter, a former ceramicist who had trained at the L'Ecole 84, 93 Nationale de la Manufacture Sèvres, first encountered *pâte-de-verre* as a student, experimenting with the medium under the direction of his teacher, Gabriel Lévy. In 1908, he moved to Nancy, where he found employment as a glassmaker at the Daum works, producing an array of *pâte-de-verre* vases, ashtrays, bowls and statuettes. His style was influenced by that of the firm's designer, Henri Bergé, and other well-known local artists, such as Victor Prouve and Jean Bernard Descomps. Most of Walter's works are highly sculptural, decorated with frogs, lizards, goldfish and beetles rendered naturalistically. He also designed *pâte-de-verre* medallions which could either be used as jewelry pendants or as decorative accents for furniture and lamps. Of merit, also, are his *pâte-de-verre* wall sconces and decorative panels, often in a dramatic palette of greens and reds. All items made prior to 1914 are marked *DAUM NANCY* with the Cross of Lorraine. Those after 1919 are signed *A. WALTER NANCY*, usually with the designer's signature added. Other *pâte-de-verre* modellers at Daum included Jules Cayette, André Houillon and Joseph Mougin.

OTHER EUROPEAN COUNTRIES

Glass produced in the rest of Europe was derivative of the styles and techniques developed in France in the 1910s, with one exception. In Scandinavia, and specifically at Orrefors in Sweden, glass designers brought a new creativity to the medium, which established them as world leaders. During the First World War, the Svenska Slojdforeningen (Swedish Society of Industrial Design), inspired by the ideas of the

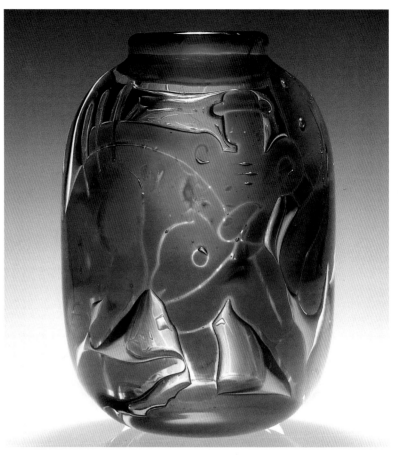

95 Edvin Ohrström for Orrefors: 'Toreador' glass vase in ariel technique, c.1937

German socialist critic and theorist, Hermann Muthesius, launched a campaign to introduce high standards of design into mass production. Every branch of the applied arts benefitted from the new union with industry, and Swedish glass manufacturers were the first to capitalize on the new movement. Orrefors' owner, Johan Ekman, decided to expand his production of domestic wares – ink and milk bottles, and window panes – with a line of artistic glass. In 1915 he applied to the Svenska Slojdforeningen for a glass designer, and was given the name of a promising young book illustrator and graphic artist, Simon Gate. With no prior experience in glass, Gate arrived at Orrefors in 1916 and was joined the next year by Edward Hald, an artist also new to the

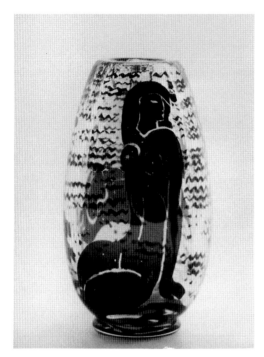
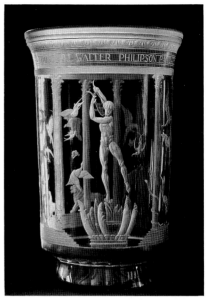

96, 97 *Left* Vicke Lindstrand for Orrefors: 'Europa and the Bull', Graal vase, 1937. *Right* Edward Hald for Orrefors: vase, engraved decoration, late 1920s

medium. The two made a formidable team, collaborating closely with the firm's glassblower, Knut Berkqvist, and engraver, Gustav Abels. A fresh and innovative style evolved, particularly in the firm's Graal technique, a modification of the French Art Nouveau cameo technique popularized by Emile Gallé, in which superimposed layers of coloured glass were etched or carved with relief decoration.

Until 1920 the firm's engraved glassware remained primarily Neo-classical, largely due to Gate's influence. It was left to Hald to introduce a series of Modernist designs, which he did in models such as *Ball Playing Girls* (1922), a delightful image which showed the influence of Henri Matisse, under whom Hald had studied briefly in Paris. Gate and Hald were joined in 1927 by Vicke Lindstrand, a gifted and vigorous disciple of the Modernist idiom, whose initial experiments included a series of vessels painted in enamels with Parisian high-style figures and animals. In the 1930s, when glassware became heavier and more massive following the move to functionalism introduced at the 1930 Nordiska Kompaniet (NK) exhibition in Stockholm, Lindstrand

engraved thick, undulating vessels with themes such as *The Shark Killer* and *Pearl Fisher* (both around 1937). The detailing in these evoked the Paris Art Deco style of the mid-1920s. At the same time, Edvin Ohrström, who had trained as a sculptor, joined Orrefors. He quickly developed the Ariel technique, a variation on Graal in which air bubbles are entrapped in deeply etched grooves or holes beneath the outer layer of crystal. Ohrström and Lindstrand developed a dynamic range of Graal and Ariel models decorated with Modernist images, often of tribal figures or abstract geometric patterns, which accentuated the refractive qualities of the embedded air bubbles. Before his death in 1945, Gate applied a quaint, somewhat exotic, Modernist style to models such as *King Solomon and the Queen of Sheba*, and a series of etched window panels.

In Belgium, the Val St Lambert glassworks, near Liège, reopened after the First World War. In the early 1920s the firm introduced a series of vases decorated by Léon Ledru and engraved by Joseph Simon with high-style motifs, entitled *Arts Décoratifs de Paris*, in which the crystal body was overlaid in transparent coloured layers cut with repeating geometric patterns. Other noted Val St Lambert designers included Modeste Denoël, Charles Graffart, Félix Matagne, René Delvenne and Lucien Petignot.

In Central Europe – Austria and Czechoslovakia, specifically – glass remained tradition-bound in the interwar years, despite occasional excursions into Modernist design by the Wiener Kunstgewerbeschule, J. & L. Lobmeyr, Moser and the technical schools of Steinschonau, Bor-Haida and Zwiesel, in Bavaria. At Bor-Haida, in particular, a vibrant Parisian high-style range of motifs was applied to glassware under the guidance of Professor Alexander Pfohl. Restraint, however, remained the catchword in commercial glass production.

In Britain, efforts at a contemporary idiom were similarly lacklustre except for the work of Keith Murray, a New Zealand architect who turned his hand to glass design in the late 1930s. Murray designed modern glass for Stevens & Williams in Brierley Hill, Staffordshire. In Stourbridge, Worcestershire, Irene M. Stevens applied a light Art Deco style to wares produced by Webb & Corbett.

THE UNITED STATES

The glass industry in the United States suffered a decline after the Art Nouveau flourishes of Louis Comfort Tiffany. But two companies did produce some successful designs based on the Art Deco style in France: the Steuben and Libbey Glass Companies.

98, 99 *Above* Steuben Glass: selection of vases, black over alabaster cameo vases, *c.*1930. *Left* Frederick Carder for Steuben Glass: architectural glass grille, 1930s

The Steuben Glass Company produced expensive, limited editions of art glass that included images and patterns derived from the 1925 Paris Exposition. Founded in 1903 by the Englishman Frederick Carder, the company was originally organized to produce crystal blanks for the Corning Glass Cutters, of which it became a division in 1918. An able craftsman, Carder created a line of coloured art glass that remained in production until 1933. His work of the 1920s and early 1930s was based on the French Art Deco style, as is readily seen in his hunting pattern vase, of around 1925. Made of acid-cut translucent glass decorated with leaping gazelles, the model incorporates stylized foliage and curved and zigzag motifs drawn from images popular at the Paris Salons some years earlier.

In 1933 Carder was replaced and a new principal designer was hired, the sculptor Sidney Waugh. The coloured glass line developed by Carder was eliminated, and only items in colourless crystal were made.

Waugh's style was drawn from the engraved designs of Simon Gate and Edward Hald a decade earlier. His elongated, highly stylized figures were crisply engraved to give the impression of bas-relief

100 Libbey Glass Company:
'Syncopation', novelty cocktail
glass, c.1933 (Collection Richard
Bohl, Custer Antiques)

sculpture. His first exhibition piece was the now famous Gazelle Vase of 1935. The frieze of twelve stylized leaping gazelles was a restatement of a popular motif of the 1920s seen not only in French design, but also in the sculpture of Paul Manship, and the ceramics and sculpture of Wilhelm Hunt Diederich.

In 1937 Steuben commissioned twenty-seven well-known painters and sculptors, including Henri Matisse, Jean Cocteau, Georgia O'Keeffe, Marie Laurencin, Pavel Tchelitchev, Salvador Dali, Thomas Benton and Eric Gill, to create designs for execution in crystal. In the same year, Steuben received a gold medal at the Paris Exposition. The firm participated also in the 1939 San Francisco and New York World Fairs.

The Libbey Glass Company was in the vanguard of 1930s American commercial glass design. Around 1933 it introduced a novelty cocktail glass, 'Syncopation', with an angular stem obviously inspired by Cubism. The firm's 'Embassy' pattern, designed by Walter Dorwin Teague and Edwin W. Fuerst in the late 1930s, was similarly Modernist, with slender fluted columnar stems that took their imagery from New York's skyscrapers.

THE INFLUENCE OF MODERNISM

Even before 1925, the style that would eventually eclipse the 1920s high style – Modernism – began to develop in France. In Paris, its arrival was heralded by L'Esprit Nouveau, a group of progressive designers and architects led by Amédée Ozenfant and Le Corbusier, whose radical

pavilion shocked the world at the 1925 Exposition. At the same Exposition the architect Robert Mallet-Stevens made revolutionary statements in his use of glass as a design medium in his Pavillon du Tourisme. This building, of rigidly austere geometric construction, had a flat glass ceiling and geometric leaded glass friezes by Louis Barillet which allowed natural light into the interior. Barillet also designed a wide selection of highly stylized leaded windows and screens in the 1920s, as did Jacques Gruber, Albert Guénot, and Paula and Max Ingrand in a contrasting black and opalescent white palette often applied by acid-etching or sandblasting.

One of the most extensive architectural applications of glass was that of the Maison de Verre, designed by Pierre Chareau as both a clinic and private residence. Wired glass was used for internal partitioning and slim square glass 'Nevada' bricks were used in the elevations to separate the interior spaces and to diffuse the daylight.

The formation of the Union des Artistes Modernes in 1930 helped to promote and unify the Modernist movement. Notable works in glass designed by U.A.M. members ranged from the bent chromed metal and glass furniture of Robert Mallet-Stevens to the luxurious glass bed and furniture created by Louis Sognot and Charlotte Alix for the Palace of the Maharajah of Indore.

Glass was also used extensively in Modernist British architecture. Erich Mendelsohn and Serge Chermayeff's De La Warr Pavilion at Bexhill-on-Sea (1935–36), Wells Coates's Embassy Court flats in Brighton (1935), and Ellis & Clarke's *Daily Express* building in London (1929–32) exemplified the gradual incorporation of glass into progressive British architecture. British designers also used glass in interiors, primarily in hotels and other public areas, such as Oliver Bernard's back-lit glass panelling for the entrance to the Strand Palace Hotel (1929–30), Oliver Milne's use of mirrored-glass panelling in the re-modelled Claridge's Hotel (1930) and Basil Ionides' all-glass Savoy Theatre foyer, which included spectacular illuminated glass columns executed by James Powell's Whitefriars glassworks.

The influence of the German Bauhaus was strongly felt in the United States, due primarily to the fact that many prominent German designers and architects emigrated to America in the interwar years, including Mies van der Rohe, Walter Gropius, Marcel Breuer, Josef Albers and Laszlo Moholy-Nagy. Under their influence, glass became a symbol of modernity for American designers. Mirrored and glass cocktail cabinets, frosted glass panelling, and glass panelled chairs became fashionable Modernist artefacts.

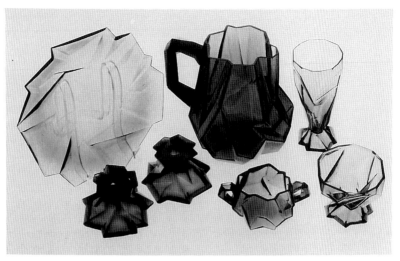

101 Consolidated Lamp & Glass Company: selection of 'Ruba Rombic' tableware; cased blown glass, 1931 (Collection W. M. Schwid, Jr.)

An inexpensive attempt to modernize the tradition-bound American home of the 1930s was made by the Consolidated Lamp and Glass Company in Coraopolis, Pennsylvania. They designed a Cubist line of glassware called Ruba Rombic, which was offered in pale hues such as grey, topaz and amber, and advertised in *Garden and Home Builder* as 'something entirely new in modern table glass . . . so ultra-smart that it is as modern as tomorrow's newspaper'.

Donald Deskey employed glass in a variety of ways: in architecture he used glass bricks to create indirect lighting, and in furniture he employed glass tops and shelves to achieve transparency and planarity. His table lamp of 1926–27 provides a fine example of how to combine several European influences to produce a unified whole. Its use of textured glass panels recalls the work of Louis Barillet which Deskey saw at the 1925 Paris Exposition.

Many other designers in the United States incorporated similar principles. Among them were Gilbert Rohde and Kem Weber, both of whom used glass in their furniture designs. An end table by Weber, for example, utilizes three circular panels of glass separated horizontally by vertical silvered-bronze supports to create multiple transparent spaces that can be compared to the Constructivist work of Naum Gabo and Antoine Pevsner.

Ceramics

It is tempting, in an examination of the ceramics of the Art Deco period, to limit the discussion to the high style which dominated the annual Paris Salons and the 1925 International Exposition. But this element of 1920s decoration – characterized by the mannered female form, accompanied by attenuated silhouettes of animals against a background of conventionalized flowers, volutes or geometric motifs – while certainly important, represented only one facet of the wealth of artistic talent found in the Modernist ceramics of the interwar period.

A clearer picture of the full range of Art Deco ceramics emerges if the ceramics of the 1919–39 period are divided into three more-or-less distinct categories. First, and most important, come the creations of the artist-potter, direct heir to the reform movements of the late nineteenth and early twentieth centuries; second, the wares of the more traditional manufactories, some of which had been in continuous production since the introduction of porcelain into Europe in the eighteenth century; third – and perhaps the era's most important contribution to the development of a distinct twentieth-century aesthetic – the birth of industrial ceramics, wares designed expressly for serial production, which were the offspring of a marriage between art and industry unknown in 1900.

ARTIST POTTERS

When John Ruskin and William Morris emphasized the virtue of handicraft, they were reacting in part to the poor quality, both artistic and technical, of ceramics of the late-Victorian period. The emergence of a large and prosperous bourgeoisie had encouraged the production of vast numbers of inexpensive, badly made wares. To counter this development, artistic reformers assigned a higher moral and artistic significance to handmade pieces, elevating the craftsman to the status of artist and thereby ennobling his creations. 'Art pottery' became a distinguished art form. The craftsman was seen as virtuous; the machine and its product as the root of evil.

Equally important at the time was Europe's gradual awareness of Orientalism. The beginnings of this cross-fertilization with the Far East were apparent in the 'Japanesque' wares introduced in England in the 1880s by firms such as the Worcester Royal Porcelain Company, and in the early twentieth-century's fascination with Oriental glazing techniques in the work of Ernst Seger in Berlin, Auguste Delaherche and Ernest Chaplet in Paris and Adelaide Robineau and the Rookwood Pottery in the United States.

After the First World War the market for handcrafted wares was revitalized as the public replenished its household goods. The potter was effectively involved in all phases of production – design, modelling and glazing – in a manner often hard to distinguish from that of his immediate forbears of the Arts and Crafts Movement. At no time were higher levels of technical virtuosity achieved than in French ceramics of the late 1910s and early 1920s. The mastery of the glaze became paramount. But this preoccupation with technical perfection came at the expense of artistic innovation, and it was left to the British and to Viennese-inspired Americans to breathe new life into this aspect of the medium in the period preceding the Second World War.

The work of the French potter André Metthey provided an important link between the reformers and the early modern period. Although the great body of his work was executed prior to the First World War, his wares incorporated many of the motifs which became the standard vernacular for Art Deco artisans. Working initially in stoneware and then in faience until his death in 1921, Metthey invited prominent artists of the School of Paris – Bonnard, Derain, Matisse, Redon, Denis, Renoir and Vuillard, among others – to decorate his wares.

More significant from a technical standpoint was the work of Emile Decoeur. His stoneware and porcelains were noted for a pronounced unity of form and decoration. Working at first in exquisite *flambé* glazes with incised decoration carved into rich layers of coloured slip, his style evolved gradually in the 1920s towards monochromatic glazes which by their brilliance effectively precluded the use of any further type of ornamentation.

Emile Lenoble's work was strongly reminiscent of Korean and Sung wares. Mixing kaolin to produce stonewares of exceptional lightness, Lenoble created geometric and conventionalized floral motifs suited to simple forms. Such decoration, incised into the vessel or its slip, was often used in conjunction with a refined celadon glaze.

The work of George Serré was profoundly influenced by a sojourn in the Orient where he taught and developed a fascination with Chinese

and Khmer art. He produced massive vessels incised with simple geometric motifs and glazed to resemble cut stone.

Henri-Paul Beyer was noted for his revival of salt-glaze for stoneware, drawing on native European traditions for vessels and figures of simple form. Jean Besnard was also inspired by native traditions for his distinct glazes, some of which he developed to resemble the delicacy of lace. Other models incorporated moulded or incised animals and birds in a more robust technique applied with a thick glaze. Séraphin Soudbinine, a Russian *émigré* and protégé of Rodin, worked in porcelain and stoneware, producing vessels which were predictably three-dimensional.

In Boulogne-sur-Seine, Edmond Lachenal began to work with *flambé* glazes in the early years of the century, gradually developing a technique in which the glaze was manipulated to mimic the geometric precision of *cloisonné* enamel. His choice of colours included a brilliant turquoise blue often imposed on a crackled ivory or beige ground. Henri Simmen, one of Lachenal's students, used incised symmetrical decoration to enhance his glazes. Simmen's Japanese wife, Mme O'Kin Simmen, sculpted stoppers and handles from ivory and horn to augment his pieces.

Jean Mayodon's faience wares were noted for their painted figural technique and crackled glazes, many designed for him in a high Art Deco style by Marianne Clouzot. Tiles were a Mayodon speciality, including the commission for many areas of the oceanliner *Normandie*. The simple, bulbous forms used by René Buthaud invited a similar type

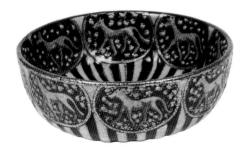

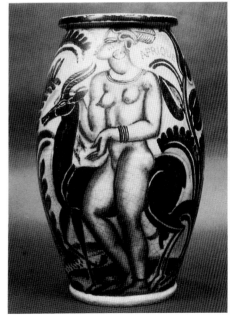

102, 103 *Above* André Metthey: pottery bowl, *c.*1920 (Courtesy of William Doyle Galleries). *Right* René Buthaud: earthenware vase, 1920s

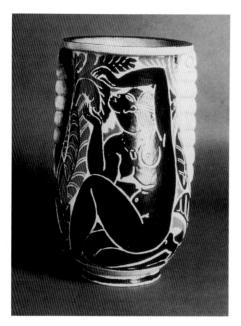

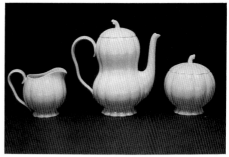

104, 105 *Above* Josef Hoffmann: 'Augarten', porcelain tea service, 1920s (Courtesy of Christie's, New York). *Left* René Buthaud: earthenware vase, exhibited at the Paris Exposition Coloniale Internationale, 1931

106, 107 *Opposite left* Vally Wieselthier: sculpture in lead-glazed earthenware, before 1929 (Collection Muriel Karasik, photo Charles Uht). *Right* Waylande Gregory: 3 glazed figures, late 1920s/30s (photo Cleveland Institute of Art)

of figural decoration. Buthaud worked in the provincial capital of Bordeaux, and his Modernist imagery has often been linked to the painting style of Jean Dupas, a friend and neighbour, who depicted a similar range of languorous maidens in lightly titillating poses. Stylistic qualities notwithstanding, Buthaud's technical capabilities were evident in the thick *craquelure* or *peau de serpent* glazes that he mastered in the 1930s. Also outside of the French capital, Félix Massoul, at Maisons-Alfort, worked with a bright palette of metallic glazes, often in collaboration with his wife, Madeleine.

The Wiener Werkstätte provided a forum for artisans in a variety of different fields. Founded in 1903, its aim was to provide a commercially viable enterprise true to the ideals of reformers everywhere – the union of artist with craftsman and the elevation of the decorative arts. The Wiener Werkstätte's early style was severe and uncompromising, but, perhaps in reaction to the deprivations of the First World War, a spontaneous style evolved in its ceramic workshop. Throughout the 1920s, Susi Singer, Gudrun Baudisch and Valerie (Vally) Wieselthier, among others, worked in a highly idiosyncratic style characterized by coarse modelling and bright, discordant drip-glaze effects. At the 1925 Exposition, Wieselthier exhibited both independently and through the

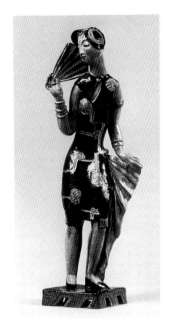
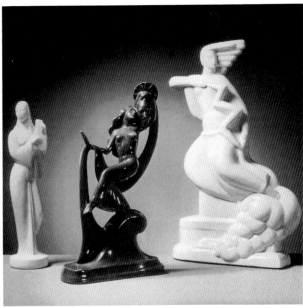

Wiener Werkstätte. Also at the Exposition, Michael Powolny and Josef Hoffmann displayed modern ceramics through the Wiener Keramik Workshops. In 1928 the Wiener Werkstätte potters participated in the International Exhibition of Ceramic Art which toured seven American cities, a seminal event which contributed to a later decision by Singer and Wieselthier to emigrate to the United States. Singer established herself on the West Coast in the 1930s, while Wieselthier, whose reputation grew rapidly in importance after she moved to Manhattan, was retained by both Contempora in New York and the Sebring Pottery in Ohio.

The impact of the Austrian school was felt in the United States through the teachings of Julius Mihalik, who emigrated to Cleveland. A number of his students found employment at the Cowan Pottery in Rocky River, west of Cleveland. Viktor Schreckengost, Waylande De Santis Gregory and Thelma Frazier Winter survived the economic reversals and demise of the Cowan Pottery in 1931 to pursue independent careers as studio potters.

Among Cowan's stock items were sleek Art Deco figurines designed by the artist Waylande Gregory after his return from Europe in 1928. After Cowan's closure, Gregory's sculptural style began to mature.

Sensual form, in biscuit or washed in a monochromatic glaze, became characteristic of his monumental works in the late 1930s, such as his 'Fountain of the Atoms' at the 1939 New York World's Fair. A sense of humour – another Viennese legacy – was evident in his lithe and sprightly figures. Similar wit was found in the work of Cleveland artist Thelma Frazier Winter, whose figures and groups expressed her search for a sculptural ceramic style expressive of metal or stone.

Viktor Schreckengost's exposure to Viennese ceramics was direct: he studied under Michael Powolny at the Wiener Keramik in 1929. His figures displayed a typically Austrian 'feel' for the material. A part-time jazz musician, he is best known for his series of 'Jazz' punchbowls. The first of these was executed in sgraffito for Eleanor Roosevelt, who was so delighted by his design that she commissioned a second example for the Roosevelts' impending move from the New York Governor's mansion to the White House. The studied vitality of the bowl's decorative motifs – champagne bubbles, gas lights, musical notes, neon signs, and so forth – recalls the spirit of artists such as Charles Sheeler and Charles Demuth. The 'Jazz Bowl' was one of the last productions of the Cowan Pottery. Fifty bowls, each a slight variation on the original, with carved sgraffito decoration in black slip over the white body with an Egyptian blue-green transparent overglaze, were sold through galleries and department stores at a suggested retail price of $50. Today the whereabouts of almost all of these is unknown.

Schreckengost had a profound impact on 1930s American ceramics.

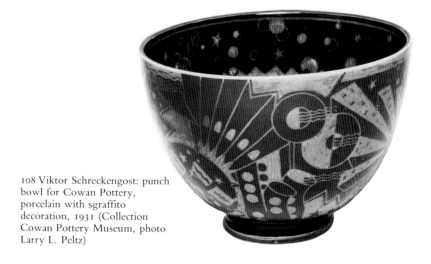

108 Viktor Schreckengost: punch bowl for Cowan Pottery, porcelain with sgraffito decoration, 1931 (Collection Cowan Pottery Museum, photo Larry L. Peltz)

His entries at both the Cleveland 'May Shows' and the National Ceramic Exhibitions drew repeated acclaim and awards. His designs, inspired always by his studies in Austria, were often strong and colourful, and always witty.

Trained as a painter, Carl Walters did not turn to ceramics until 1919. He produced models with glazes derived from sources as diverse as American folk art and Egyptian faience. His clever animal figures, produced in limited editions, relied on strong modelling techniques. Wilhelm Hunt Diederich, better known for his elegant metalwork, also executed pottery. Characteristic were animal forms in silhouette, reminiscent both in style and technique of the transparent washes found in early Mediterranean earthenwares.

Henry Varnum Poor, better known as a painter, turned to pottery in part from economic necessity. Inspired by primitive ceramics, he at first produced simple tableware items and though his emphasis gradually shifted toward more profitable architectural commissions, his style remained basically unchanged, relying on the decorative value of slip and sgraffito decoration.

The interwar period in America witnessed the growth and maturity of the Cranbrook Academy, founded in 1932 in Bloomfield Hills, Michigan. The Academy is best known as a catalyst of the post-Second World War studio movement. Remarkable are a cool and elegant dinner service by Eliel Saarinen for Lenox, and the serene and austere creations of Majlis ('Maija') Grotell, both distinctive contributions to Cranbrook's reputation for progressive design. Grotell's ceramics of this period exhibited a tactile quality and careful glaze manipulation which showed her mastery of Oriental kiln techniques.

MANUFACTORIES

The state manufactories of France and Germany experienced general artistic stagnation in the 1920s and 1930s. Throughout the nineteenth century such manufactories had become bastions of conservatism, creating expensive ornaments for the well-off, rather than trying to promote a Modernist audience. On the whole, the national manufactories never recovered the vitality which they lost by reproducing a seemingly endless repertoire of popular eighteenth-century forms. It was left in part to the Scandinavians, whose boundaries between art and craft were less rigid, to integrate the aesthetics of the potter's wheel with the grammar of Modernist ornament.

Other potteries, with widely varying capabilities, turned their attention to the possibilities of the modern style. These ranged from the

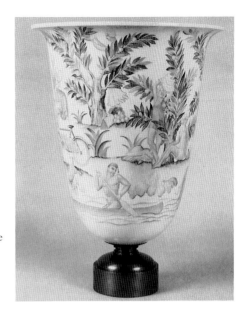

109–11 *Right* Jean Beaumont,
executed by Sèvres: earthenware
vase, bronze-mounted, 1920s.
Opposite, left Longwy: earthenware
plaque, retailed by Au Bon
Marché, 1920s. *Opposite, right*
Primavera: ceramic tea service,
Paris, 1920s (Collection Howard
Perry Rothberg)

French-inspired interpretations of Belgian firms, to the dichotomous efforts of the British, who produced both modern wares and period reproductions, and to various other European and American firms whose products revealed a thinly veiled attempt to capitalize on the 1925 style. Ironically, it was the last-mentioned which served most to popularize the Art Deco style and, by vulgarizing it, to precipitate its decline.

The 1920s and 1930s are generally conceded to have been artistically dry years for Sèvres despite the continuing efforts of the manufactory towards modernization. Under the direction of Georges LeChevallier-Chevignard from 1920, the factory participated in the 1925 Exposition, with items commissioned from artist-designers and architects whose principal expertise lay outside the field of ceramics: for example, Emile-Jacques Ruhlmann, Jean Dupas, Robert Bonfils, Félix Aubert, Jan and Joël Martel, Eric Bagge and Louis Jaulmes. The firm's pavilion and gardens at the Exposition were embellished with ceramic statuary and friezes by Henri Patout, Max Blondat, Le Bourgeois, Charles Hairon and Simon Lissim, the last-mentioned a stage designer and book illustrator who provided a sharply angular and Cubist imagery. Henri Rapin, in collaboration with Maurice Gensoli, the director of the newly formed faience department at Sèvres, designed a range of translucent porcelain light fixtures and lightly decorated tablewares for the pavilion's interior.

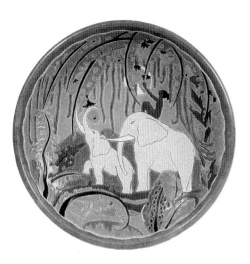
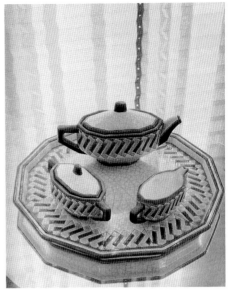

Rather more successful, in a Modernist context, were the stylish tablewares produced by Théodore Haviland et Cie, of Limoges. Commissioned from such artists as Suzanne Lalique, the *maître-verrier*'s daughter, and Jean Dufy, brother of Raoul, there was an obvious attempt to adapt a contemporary decorative vocabulary to traditional forms. Marcel Goupy, known more for his successful glass designs, created dining ensembles in porcelain and glass which displayed a fairly conservative mixture of floral decorations. Jean Luce, another artist whose designs in glass overshadowed his achievements in ceramics, designed tablewares for Haviland in a light Modernist style. A delightful selection of small *animalier* porcelain figurines, in glazed porcelain and biscuit, by Edouard M. Sandoz, was also issued by the firm.

In the 1920s, the large Paris department stores generated a wide range of household ceramics designed by their own studios. At Pomone, Charlotte Chaucet-Guillère (the director of the store's Primavera studio), Madeleine Sougez, Marcel Renard and Claude Lévy created lightly decorated tablewares and accessories to complement their furnishings. At the Galeries Lafayette, Maurice Dufrène (the director of the store's La Maîtrise studio), Jacques and Jean Adnet, Bonifas and Mlle Maisonée offered a similar line of household pieces executed for the store by André Fau & Guillard, and Keramis, in Belgium.

Louis Süe and André Mare's firm, La Compagnie des Arts Français, rivalled in prestige the department store pavilions at the 1925 Exposition.

For their dining-room ensembles, the pair designed heavily scrolled and floral tablewares, such as tureens and vegetable dishes, whose opulence evoked the Louis Philippe era. At the Exposition, Paul Véra and José Martin were retained to enhance the firm's pavilion with a series of ceramic friezes of recumbent nudes in bas-relief.

At the firm of Longwy, a vivid palette, outlined in black in a style derived from North African tiles, was successfully integrated in the 1920s with images such as leaping gazelles and formalized flora.

The potteries of Robert Lallemant, dating from the 1920s and early 1930s, reflected the vogue in France at the time for angular forms. These pieces were generally decorated with sporting scenes, stylized eighteenth-century vignettes, or quotations from popular verse. In 1929 Lallemant introduced a line of sporting figures. The large number of his wares fashioned as lamp bases attest to his purely decorative intent. A similar series of crisply angular forms and bird figures designed at the time by Jacques and Jean Adnet were produced by the Faiencerie de Montereau.

The Parisian retailer Robj sold figural decanters and other ornaments created by a variety of designers. Vaguely Cubist and often quite charming, these ceramic figurines were intended to be collected in series.

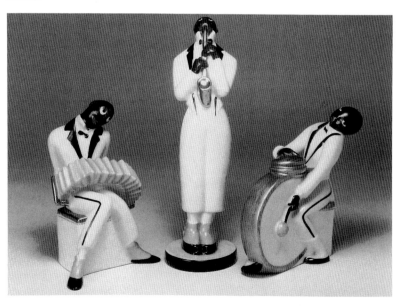

112 Robj: set of 3 porcelain figures of Jazz Musicians, c.1925 (Courtesy of Sotheby's, New York)

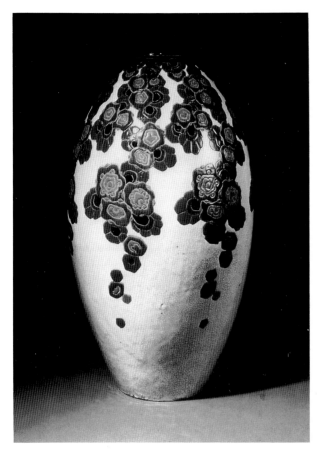

113 Charles Catteau, executed by Boch *frères*: earthenware vase, *c.*1925

With the closure of the famous Vienna manufactory in the nineteenth century, only the Augarten firm and the firm of Arthur Goldscheider remained to play a significant role in Austria's production of modern style porcelain wares. Augarten produced a limited selection of decorative wares designed by Josef Hoffmann and Ena Rottenberg. In the 1920s the Goldscheider factory's range of ballerinas and pierrettes, some from models by Lorenzl, achieved a certain gaiety and popularity. At the 1925 Exposition, the firm's Paris branch displayed a more stimulating range of ceramic dinner wares, statuettes, and lamp bases designed by Eric Bagge, Henri Cazaux and Sybille May.

In Belgium, the modern style was vigorously adopted by the firm of Keramis, owned by Boch *frères*, in La Louvrière. Charles Catteau 113, 114

designed a wide selection of Parisian high-style ceramic wares in which leaping gazelles and flowers predominated. His choice of brilliant blue turquoise glazes on crackled ivory grounds was reminiscent of Lachenal's earlier palette. The firm shared its success in this line of bright commercial wares with the Primavera department store in Paris.

In Germany only the Berlin manufactory espoused an interest in twentieth-century design. A survivor of the Jugendstil era, Max Lauger, created a small selection of Modernist stoneware and ceramic models.

At the Societa Ceramica Richard-Ginori factory, in Doccia, Italy, the architect Gio Ponti produced a traditional range of crisp, delicate ceramic forms with highly mannered decoration, but also created wares of strictly modern decoration – sporting scenes, grotesques, geometric forms, and so forth. In Turin, Eugenio Colmo turned to ceramics as a hobby and decorated white porcelain blanks with a forceful range of Art Deco images in vibrant colours.

The firm of Josiah Wedgwood & Sons in England was among the first in the nineteenth century to commission graphic artists to decorate

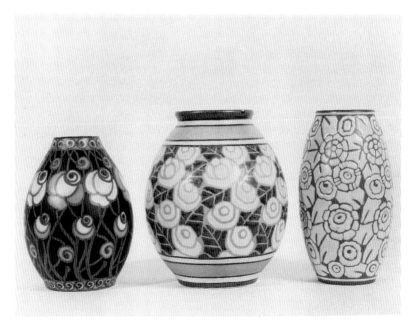

114 Charles Catteau: selection of stoneware and pottery vases, c.1925

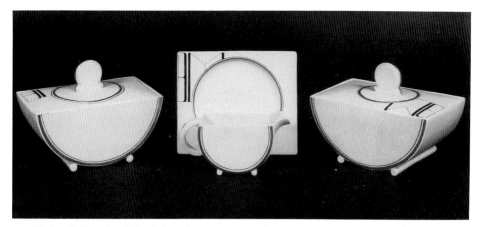

115 Clarice Cliff: 4-piece 'Biarritz' earthenware service, late 1920s

its wares, a technique which the firm again pursued from 1935 under the artistic directorship of Victor Skellern. The well-known engraver and painter Eric Ravilious was retained to decorate – through the transfer-printing process – blank ceramic vessels designed by the architect Keith Murray. Ravilious, who felt that only his least advent-urous designs were chosen, complained that the management 'think my beautiful designs [are] above the heads of their public and that something should be done that is safer and more understandable . . .' Nevertheless, his unique calligraphic style was shown to advantage in a coronation mug, a 'Boat Race' bowl and various tablewares, such as 'Harvest Moon', some of which were put into production only after his death during the Second World War.

Few British artists took the trouble to transpose the modern decorative idiom into manufactured wares. Two who did were Eric Slater, responsible for design and decoration of tablewares for Shelley Potteries, and Susie Cooper, who produced her own simply decorated services. In 1931 Cooper accepted an offer from Wood & Son's Crown Works to execute shapes of her own design. She produced dozens of tableware designs, decorated, in deference to the British consumer's innate conservatism, with subdued abstract or geometric 'Jazz style' patterns in muted tones. Her stringent attention to detail in both design and marketing brought her great success.

At the other end of the spectrum, Clarice Cliff's 'Bizarre' tablewares, produced by the Newport Pottery from 1928, have come to symbolize

the decorative exuberances and excesses of the Art Deco style in their use of colour, geometry and eccentric shapes. Clever marketing schemes – including editions with fanciful names such as Delicia, Biarritz and Fantasque – and moderate prices helped to popularize her wares. But her employment of artists such as Vanessa Bell and Duncan Grant, who were already engaged in pottery decoration, and others such as Sir Frank Brangwyn, Graham Sutherland and Laura Knight, was less successful. These artists were commissioned to design ceramics for A. J. Wilkinson & Company, the Newport Pottery's parent company, but their wares were not well received. Critics likened the idea to 'eating off pictures' and the project was quickly abandoned.

In Sweden, Wilhelm Kåge was artistic director at the Gustavsberg porcelain works. His Argenta stoneware has high-style Art Deco chased silver images applied to green-glazed grounds that resemble verdigris bronze. At the 1925 Exposition, Gustavsberg was joined in the Swedish pavilion by the Rorstrand Porcelain Manufactory, which displayed a line of understated floral designs. Kåge's Praktika tableware of 1933 showed the beginnings of the functionalist aesthetic while retaining elements of traditional design. In Norway, the geometry of Nora Gulbrandsen's designs for the Porselaensfabrik in Porsgrunn clearly reflected the modern aesthetic.

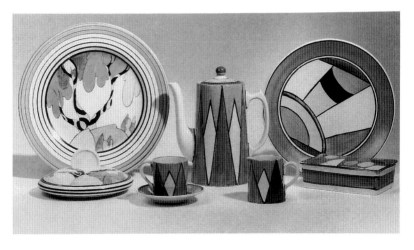

116 Clarice Cliff for Newport Pottery: selection of pottery wares, c.1930

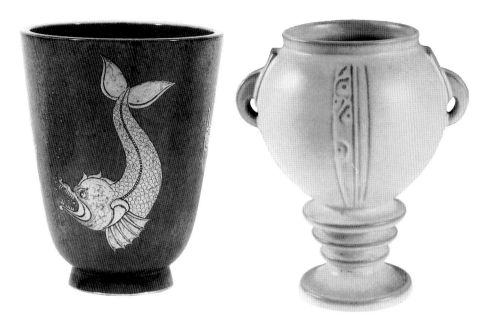

117, 118 *Left* Wilhelm Kåge for Gustavsberg: 'Argenta' ceramic vase with applied silver ornamentation on a green-mat glaze, 1930s. *Right* Roseville Pottery: 'Moderne' earthenware vase, 1930s

In the United States, the foremost Midwest potteries were too conservative to embrace the new idiom. Whereas the Rookwood Pottery encouraged individual decorators, such as Jens Jensen, Edward T. Hurley, William Hentschel, Elizabeth Barrett and Harriet E. Wilcox, to familiarize themselves with Paris's newest fashions through contemporary art reviews, its continuing financial vicissitudes from the mid-1920s prevented it from full commitment to anything new and risky. The same reticence applied to the Fulper, Newcomb, Van Briggle and Grueby potteries, all in various stages of decline since their celebrated 1900 years. Only Roseville had the temerity to produce a spirited line of new designs, entitled 'Futura', inspired by the terraced contours of New York's skyscrapers.

INDUSTRIAL DESIGN

Perhaps most significant to the development of a twentieth century aesthetic was the birth in the interwar period of the professional

industrial designer. That the profession is seen today as the inter-relation-ship between art and industry is the result of attempts in numerous fields – not the least of which is ceramic design – to prove that good design could be both economical and functional. The true industrial ceramics of the 1930s, non-derivative in form and generally devoid of decoration, lost none of their character through mass production. Throughout the decade, there occurred a gradual acceptance of functional forms coupled with modern industrial technique. The machine, seen decades earlier as the antithesis of good design, became the vehicle which facilitated the mass production of well-designed works.

The turning point in this development can be traced to the establish-ment of the Bauhaus in Weimar in 1919. Although today everything of functional form from the immediate postwar years – from teacups to seat furniture – is said to be 'Bauhaus', the school was not founded to create a style but to develop a new approach to the applied arts. Although no body of ceramic works evolved in the Bauhaus workshops to equal, for example, the metalware designs of Marianne Brandt or Mies van der Rohe, the Bauhaus ceramicists are noteworthy for their wholehearted rejection of tradition, and for their artistic creativity amid the chaos of the Weimar Republic after the defeat of the First World War. The initial lack of adequate facilities for pottery in Weimar was turned to advantage when the workshop was established at nearby Dornburg in 1921, under the technical supervision of Max Brehan. The Dornburg workshop came closest, among the School's different disciplines, to achieving the union of art and craft stated in Walter Gropius's original manifesto.

The only German manufactory to show a significant interest in functionalism was the Staatliche-Porzellan Fabrik, in Berlin. Its most direct link to industrial design occurred in the employment of ex-Bauhaus pupil Marguerite Friedlander-Wildenhain who designed the simple, classic shapes of the 'Halle' service of 1930, in which plain banding was the only form of decoration.

Trude Petri's 'Urbino' service of 1930 was more remarkable. In production for some forty years, the service was among the first to rely neither on colour nor ornament for commercial success. Also in the functionalist mode was Dr Hermann Gretch's 'Arzberg 1382' for the Arzberg Porcelain works. This form, again devoid of ornamentation, showed rather softer, more rounded, silhouettes than those of contem-porary Berlin wares. First shown at the 1930 Deutsche Werkbund Exhibition, 'Arzberg 1382' won a gold medal at the 1936 Trienniale in Milan and the Paris Exposition of 1937. These designs signified a

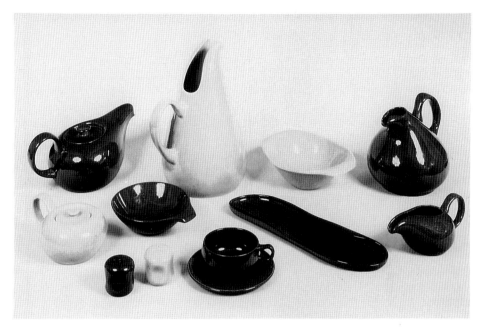

119 Russel Wright: selection of 'American Modern' dinnerware. *Top row, left to right:* teapot, water jug, sauce boat and wine carafe; *bottom row:* sugar, cereal bowl, salt and pepper, cup and saucer, celery dish, milk jug. Bean brown and coral glazes, designed 1937 (Collection William Straus)

growing interest in unornamented form, without neglecting porcelain as a costly and formal material.

Eva Stricker Zeisel is one of the most noted twentieth-century industrial designers, and although her most mature work generally belongs to the post-Second World War period, her designs for the Schramberger Majolika Fabrik in the 1920s incorporated several geometric motifs associated with Modernism. Throughout the 1930s her work in Berlin for Christian Carsten, in the Soviet Union for Lomanossova Porcelain and Doulevo Ceramics, and in the United States for Bay Ridge Specialty and Riverside China, reflected a somewhat softening geometry.

In Britain, Keith Murray's designs for Wedgwood were truly avant-garde. Trained as an architect, and experienced in Modernist glass design at Stevens & Williams, in Brierley Hill, Staffordshire, Murray joined Wedgwood in 1933. He designed large numbers of nonderivative shapes in which ornament consisted exclusively of turned or fluted motifs. Glazes provided textural interest. His wares were executed in black basalt, celadon, silken 'Moonstone' (1933), and mat green or straw (1935).

It was left primarily to the Americans to explore the phenomenal sales potential of mass production. The most accomplished, and one of the best-selling, tablewares was Frederick H. Rhead's 'Fiesta', designed for the Homer Laughlin Company, of which Rhead had become artistic director in 1927. Rhead, an *émigré* from Staffordshire, aimed at a mass-produced line of high-quality pottery free from derivative ornament, which would appeal to America's prosperous middle class. Introduced in 1936, Fiesta's simple geometric shapes were offered in five bright colours. In production for over thirty years, the line was an overwhelming success, helping to precipitate a revolution in industrial design. Through it, the ceramics industry was served notice that the American consumer was ready to embrace Modernism.

Russel Wright's ideas had a profound effect on the public perception of 'good design'. His 'American Modern' dinner service, conceived in 1937, introduced by Steubenville Pottery in 1939, and marketed by Baymor until around 1959, presaged in its biomorphic forms and subdued colours the work of post-Second World War organic designers. It was a logical extension of the 'good design' theory by which Wright's 'American Modern' became part of a larger scheme of decorative items entitled 'American Way'. Although the latter succumbed to the rigours of wartime restriction, over 80 million pieces of Wright's crockery were created during the twenty years in which it was produced.

Sculpture

Art Deco sculpture in Europe can be divided loosely into two categories: the commercial, often large-edition, statuary commissioned as decorative works for the domestic market by *éditeurs d'art* and foundries; and those created by avant-garde artist-sculptors, often as *pièces uniques* or in small editions, which fall in that indefinable grey area between the 'fine' and 'applied' arts.

ART DECO COMMERCIAL SCULPTURE

This category encompasses multiple-edition works in bronze, metal, or mixed-media materials, particularly bronze and ivory. These items, often small-scaled for placement on mantelpieces or in boudoirs, fulfilled much the same function that figurines in porcelain, *biscuit de Sèvres*, or terracotta had performed in the elegant interiors of the eighteenth century. Since they were purely decorative, they were sold by jewelers and department stores rather than by art galleries.

Despite the fact that these pieces were made for commercial purposes, they were often exquisitely crafted, and many today have enormous period charm, encapsulating the atmosphere of the Art Deco era more successfully than other, more serious, works.

The category of chryselephantine, or bronze and ivory sculpture, represents the pinnacle of commercial Art Deco sculpture. Chryseleph-antine sculptors worked primarily in Paris and Berlin, where two very distinct styles evolved: in Paris, the interpretation was on fashion and the theatre; in Germany on sport and classical themes. The word 'chryselephantine' derives from the Greek, and describes the overlay of gold and ivory used in classical statuary. In the late 1800s, the Belgian government promoted the use of ivory imported from its African colony, the Congo. At the 1894 International Exposition in Antwerp and later at the 1897 Brussels Exhibition in Tervuren, a group of sculptors used ivory as their main or sole material. By 1900 the word 'chryselephantine' covered any work combining ivory with another substance, such as bronze, wood, rock crystal or lapis lazuli.

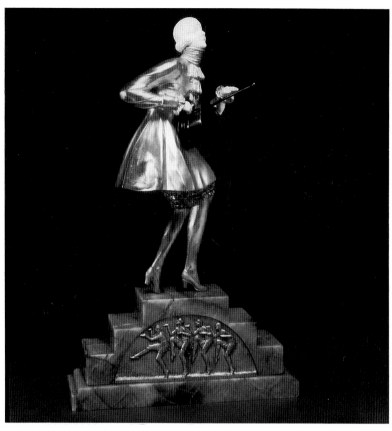

120 Demêtre Chiparus: gilt- and cold-painted bronze and ivory figure of a dancer with top hat and cane, c.1925

Demêtre Chiparus is considered the master of Art Deco chryseleph-antine sculpture. Romanian-born, he was based in Paris, where he generated a multitude of bronze and ivory statuettes and groups. Choosing as his subjects the idols of contemporary society, Chiparus provided today's Art Deco collector with a faithful depiction of con-temporary fashion, from Ida Rubenstein and Vaslav Nijinsky of the Ballets Russes ('Russian Dancers') to 'The Dolly Sisters', and a chorus line of cabaret dancers ('The Girls'). Many similar works by Chiparus reflect the interest in the French capital at the time in the Orient, Léon Bakst's costumes, Paul Poiret's dress designs, and the nightclubs and dance crazes of the new Jazz Age.

Chiparus's forte lay less in the quality of his ivory carving than in the jewel-like surface treatment applied to the bronze costumes of his figures. In his choice of ivory for limbs and faces, however, he was careful to ensure that its grain followed the natural line of the features, for a realistic effect. This attention to detail was applied also to the bronze. Dress details, such as the decorative trim on bodices and stockings, was carefully chased to ensure crisp definition. Figures were mounted on bases whose shapes became an integral part of the entire sculptural composition. Some of these were inset with bronze plaquettes cast with figures which echoed the main theme.

Very few, if any, of these figures were unique, though editions of the larger, more elaborate, models were probably limited. Chiparus's pieces were produced by foundries and manufacturing houses who also edited the work of his contemporaries. The Parisian firm of Etling is known to have edited his early pieces, and the LN & JL foundry his later ones. Models were produced in two or more sizes, or in a variety of materials, to accommodate a range of pockets. In the 1920s ivory was less expensive than bronze, so the more of it included in a model, the cheaper the finished piece was likely to be.

As the most important sculptor working with bronze and ivory, Chiparus produced few works in inferior materials. This was also true of Claire Jeanne Roberte Colinet, a Belgian sculptor active at the time in Paris, whose styling and choice of subject matter were similar to Chiparus's, but whose costumes and drapery were rendered far more fluidly. Her pieces depicted exotic figures and dancers associated with countries such as Egypt, Mexico and Russia.

Also impeccable was the quality of design of Alexandre Kéléty. He 1, 121 modelled smaller-scale works, mainly in bronze, specializing in unfamiliar techniques such as damascening, in which a precious metal is inlaid into the surface of the bronze (or base metal) in a decorative pattern; for example, flowers into the hem of a gown. Maurice Guiraud-Rivière and Marcel Bouraine worked both with bronze and ivory and with metal alone. The house of Etling, which edited most of the better quality models created by these artists, appears to have cornered the top end of the market for decorative sculpture.

The sculptor Max le Verrier also edited a wide selection of *objets d'art*, employing noted sculptors and designers to create models of inexpensive decorative items such as ashtrays, bookends and perfume burners made of cheap materials or alloys. These were then marketed through his shop at 100 rue du Théâtre. Sculptors working for the house of Le Verrier included Fayral, Janle, Laurent, Derenne, Marcel Bouraine,

Pierre le Faguays, Charles and Guerbe. Several, such as Bouraine, provided models for both Le Verrier and Etling.

In Berlin, Ferdinand Preiss and his company, Preiss-Kassler, formed in 1906, dominated the production of bronze and ivory sculpture. Preiss himself designed most of the models produced by his firm. Early works, small in scale, were of classical figures. The firm closed during the First World War, reopening in 1919, at which time its style began to shift away from the classical towards the depiction of contemporary children, acrobats, dancers and athletes, for which it is now best known. These figures, like their French counterparts, often represented theatrical and sporting personalities; for example, Preiss's dancer holding aloft a blown glass beach ball is Ada May, a member of C. B. Cochran's revue, 'Lighter Than Air'. Likewise, many of the athletes were modelled after Olympic stars, such as the ice skater Sonia Henie.

Among the artists who provided models for the Preiss-Kassler firm were Paul Philippe, Professor Otto Poertzel, R. W. Lange, Harders and the avant-garde artist Rudolf Belling. The styling of their work was in such harmony with the existing Preiss-Kassler mode that it is often virtually indistinguishable from it. This applies particularly to Poertzel's work. His models 'The Aristocrats' and 'Butterfly Dancers', for example,

121 Alexandre Kéléty:
'Modern Medusa', bronze on
black marble base, late 1920s

124

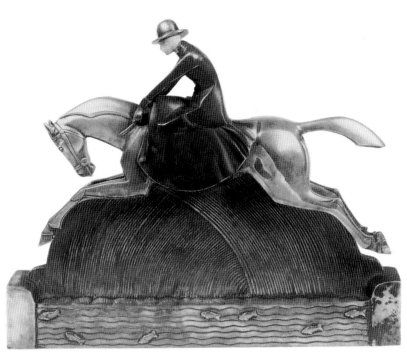

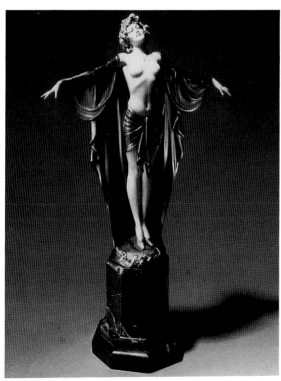

122, 123 *Above* Pierre le Faguays:
'Equestrienne', silvered and cold-
painted bronze and ivory group,
c.1926. *Left* Ferdinand Preiss:
'Spring Awakening', cold-painted
bronze and ivory, *c*.1925

have been known to carry both his and Preiss's signatures. Although there are slight differences between the two versions, these are so minor that it was assumed until recently that Preiss and Poertzel were one and the same person.

Whereas Chiparus concentrated mainly on the posture and the intricate finishing of the bronzework on his figures, the Berlin makers were concerned more with the quality of the ivory carving. An adaptation of Achille Collas's pantograph enabled carvers to duplicate almost exactly the ivory detailing on these figures, even down to the expression on a figure's face and the angle of its fingers. Figures were assembled like jigsaw puzzles along a central core pin. As in the French technique, the surface of the bronze was chased and then cold-painted, although the costumes on Preiss's figures required far less chasing; emphasis was provided, rather, by soft cold-painted metallic lacquers, often shaded to provide depth. The ivory faces of the models were also painted naturalistically and the hair stained. The most popular period for these bronze and ivory statuettes was from 1931 to 1936.

Austria, specifically Vienna, developed its own style of bronze and ivory statuettes and small decorative bronzes which combined the more theatrical poses of the French and the softer surface treatment and scale of the Germans. Viennese artists, such as K. Lorenzl, Gerdago and G. Schmidtcassel, provided representative examples.

The Austrian sculptor Bruno Zach was also active at the time. Zach's work was more openly erotic than that of his peers, though the overt sensuality of his cabaret girls and dancers from the *demi-monde* was softened by the tongue-in-cheek sense of humour and sophistication of his stylization. His cigarette-smoking women in leather suits are given a girlish air by the addition of enormous bows in their hair. Others, wearing teddies and garters and carrying whips, are wittily unthreatening. Zach also modelled ice skaters, skiers and ballerinas.

Many of the decorative bronzes produced in Austria were made by the Argentor and Bergman foundries in Vienna. The most important Austrian manufacturer of the period, however, was Friedrich Goldscheider, whose firm produced polychromed cast plaster and ceramic versions of the bronze and ivory dancers designed by sculptors such as Zach and Lorenzl. The latter, in particular, created a great many pieces for Goldscheider.

Goldscheider had established a branch in Paris in 1892 to 'commission, manufacture and sell bronze, plaster and terracotta sculpture'. The bronzes were made at an in-house foundry. Although the Austrian-based parent company was forced to close after the First World War, the Parisian

foundry survived and, under the guidance of Arthur Goldscheider, evolved into an *éditeur d'art* of considerable merit.

Arthur Goldscheider warranted his own pavilion at the 1925 Paris Exposition. The firm's roster of contributing artists read like a Who's Who of Art Deco design. Participants were divided into two groups: sculpture was listed under the heading *La Stèle*; other works of art, including glass and decorative objects, were listed as *L'Evolution*. Among the sculptors who exhibited under the *La Stèle* umbrella were Max Blondat, Bouraine, Fernand David, Pierre le Faguays, Raoul Lamourdedieu, Pierre Lenoir, Charles Malfray, Pierre Traverse and the Martel brothers. Artists such as Jean Verschneider exhibited in both groups.

One of Goldscheider's most highly stylized, and probably most successful, sculptures was Le Faguays's group of a lecherous satyr in pursuit of a voluptuous nymph. The zigzag tresses of the maiden's hair, trailing at right angles from her head, and the two-dimensional, almost Egyptian poses of the two figures have become trademarks of the Art Deco style.

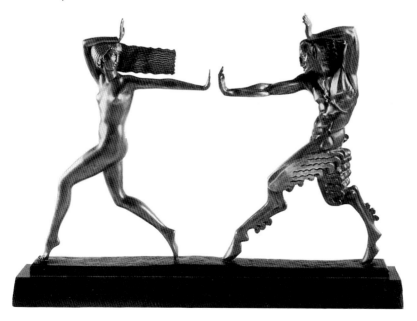

124 Pierre le Faguays: 'Faun and Nymph', bronze on marble base, 1924

In the 1910s, vanguard sculptors in France found themselves in a middle ground between the 'fine' and 'applied' arts. To compound this identification problem, modern art at the time was unpopular, sustained only by a handful of patrons and connoisseurs. For this reason, these sculptors were invariably too impoverished to have their works cast in bronze. Works were made in materials such as plaster, terracotta, wood or stone, and were often unique, limiting the recognition and income that bronze editions would have generated.

By the First World War, Modernist sculpture had broken with Victorian romanticism and naturalism. In their place was a spirited mix of three-dimensional abstract styles drawn from the parent movement in painting in which angular, faceted and simplified planes predominated. In Paris, many avant-garde sculptors exhibited at Léonce Rosenberg's Galérie de l'Effort Moderne. Today, the works of these sculptors continue to defy easy categorization. Some pieces by, for example, Archipenko, Brancusi, Modigliani and Laurens, are allied with the period's vanguard paintings. The work of others, such as Miklos, Csaky and Chauvin, is generally seen as 'decorative', more in style with the furnishings of the period. But the distinction is often arbitrary.

Gustav Miklos's style began to evolve towards Modernism in 1907, two years before he moved from Budapest to Paris. Recognized today as a major Art Deco sculptor, Miklos tried his hand at other disciplines – orfèvrerie (precious metalwork), champlevé enamels, carpets and jewelry – before settling on sculpture as his preferred medium around 1923. He displayed a pair of monumental polychromed wood columns at the 1925 Exposition and in 1928 held his only single artist exhibition at the Galérie de la Renaissance on the rue Royale.

In its simplification of mass and detailing, Miklos's style shows the influence of Cubism and Constructivism. His portrait heads of tribal women and birds are especially forceful; both dignity and sensuality find a place in their elongated, rounded features. Preferred materials were diorite, bronze, wood and copper, to which Miklos, like Brancusi, often applied a brilliant polished sheen.

In 1908, Joseph Csaky set off from Budapest for Paris, walking most of the way, as Brancusi had done four years earlier. A pioneer of three-dimensional Cubism, Csaky's first avant-garde works appeared in 1911 (all but three of these were later lost or destroyed). In 1914 he volunteered for army service, returning to sculpture in 1919 with a selection of Léger-like compositions comprising cones, cylinders, discs and spheres. These early essays followed Derain, Brancusi, Archipenko and

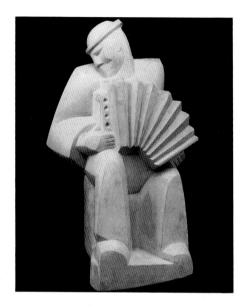

125 Jan and Joël Martel: terracotta
sculpture, late 1920s

Modigliani into rectilinear sculpture, in which the subject was modelled
out of a single block. Due to the prohibitive costs of bronze casting,
these works were usually *pièces uniques* in plaster or papier-mâché.

In the 1920s, Csaky varied his Modernist style repeatedly; in 1921 he
created perpendicular portrait busts in which certain features were
sliced off, as well as towering figural compositions. Details, where not
truncated, were broken down into angular planes. Raised and lowered
arms provided a fine contrapposto balance. From 1928 Csaky turned to
a more figural form of expression, moving away from the rectilinear to
full-bodied compositions.

Lambert-Rucki moved from Poland to Paris around 1911 and took a
studio with Miklos in the rue de la Grand-Chaumière. At times close to
poverty, Lambert-Rucki created his sculptural works in a cheap, some-
times curious mix of woods, polychromed terracotta, stucco and
mosaic glass. As in his paintings and decorative panels for Jean Dunand,
his sculpture showed a highly distinctive personal style in which
subjects – often top-hatted theatre-goers and their escorts in Paris's
Montparnasse and Montmartre bohemian quarters – were portrayed in
silhouette. Other favourite themes, including liturgical instruments,
African masks and modernistic animals, have an air of fantasy and lively
humor.

The style of Jan and Joël Martel was very similar to that of Csaky:
bold Cubist images predominate, often rendered in reinforced concrete,
reconstituted stone, cement, ceramics or hewn from slabs of granite.

129

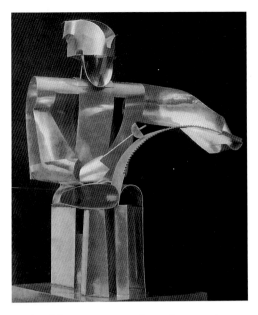

126 Jan and Joël Martel: musical saw player, sheet metal, late 1920s

Trained in monumental outdoor sculpture, the Martels responded to several important commissions at the 1925 Exposition; most notably, a set of concrete Cubist trees for a garden designed by Robert Mallet-Stevens, and bas-reliefs for the Porte de la Concorde and Mallet-Stevens's Pavillon du Tourisme.

Very few examples have survived of the work of Ossip Zadkine, another Cubist-inspired sculptor. Favourite themes included musicians, such as accordion players, and domestic animals. Pieces similar in style to Zadkine's are found in the oeuvre of Chana Orloff, who created a matching range of abstract figural and animal sculpture that showed an increasing machine influence after 1925.

The sculpture of Jean Gabriel Chauvin borders on Art Deco. Most of his subjects were reduced to a pure form of abstraction, similar in their simplification to the work of Arp and Brancusi, though some examples showed an understated angular definition.

Bela Voros is today known primarily for his bronze and granite groups of pigeons and musicians rendered in a bold and lightly abstract manner. His simplified forms show a slight Cubist influence in their distortion of the human body. Traces of African tribal art and primitivism are also evident.

Following on a long line of distinguished predecessors, such as Antoine-Louis Barye, Pierre-Jean Mêne and Emmanuel Frémiet, Art Deco *animalier* sculptors adopted the changes introduced in the 1910s by

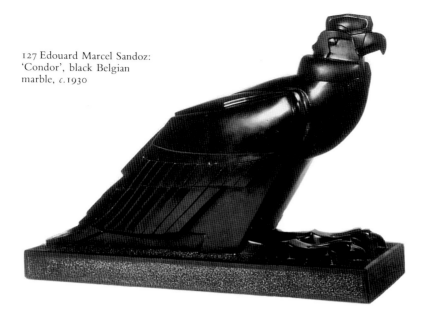

127 Edouard Marcel Sandoz:
'Condor', black Belgian
marble, c.1930

Rembrandt Bugatti and Paul Jouve. Although modelling from life at
zoos, both Bugatti and Jouve had preferred to portray animals impres-
sionistically, achieving their effects by kneading or scraping the clay
and leaving finger marks in it. Fur and feathers were suggested, rather
than actually being reproduced, as was more usual in the naturalistic
interpretations of the nineteenth century.

The *animalier* sculptor developed this concept in the 1920s by reducing
explicit detailing even further: images were given a bas-relief appearance
in an attempt to streamline and stylize shapes and surfaces. Features
were only hinted at in the overall form of the animal.

François Pompon emerged as the era's greatest *animalier*. He made his
reputation late, achieving his first success at the 1922 Salon d'Automne
when he was already in his late sixties. A student of Rodin, Pompon had
previously worked mainly on monumental outdoor sculpture. His
attempt to depict his subjects as a synthesis of observations made over
time, rather than as a momentary view, resulted in streamlined forms
emphasizing basic shapes, often highly polished to catch the light.
Edouard Sandoz, another noted *animalier*, created his wild and domestic
menagerie of birds, fish and animals with a deft and humorous touch.
The anthropomorphic expressions on the creatures' faces give each a
highly individualistic character. Paul Jouve was also successful, prefer-
ring a bas-relief interpretation of animals which evoked Assyrian
precedents.

131

In America, acceptance of an Art Deco sculptural style came only slowly. This was largely due to the enduring popularity of the Beaux-Arts traditions of the late nineteenth century, exemplified by the work of Augustus Saint-Gaudens and Frederick William MacMonnies, but it was also because the Art Deco style was only one of several interrelated avant-garde movements, spearheaded by immigrant sculptors, which occurred simultaneously in the fine arts in the United States between 1910 and 1930. Waves of talented sculptors arrived in America in those years, all hoping that twentieth-century avant-garde art would be afforded the same degree of tolerance in their adopted homeland that it had been given in Europe. Included, from France, were Gaston Lachaise and Robert Laurent; from Russia, William Zorach, Boris Lovet-Lorski, and Alexander Archipenko; from Poland, Elie Nadelman; from Germany, Wilhelm Hunt Diederich and the 17-year-old Carl Paul Jennewein; from Sweden, Carl Milles; and from Yugoslavia, Ivan Mestrovic. At the same time, the cream of America's young sculptors were crossing the Atlantic in the other direction to complete their training in Europe.

America's resistance to Modernism was deep-rooted, however. Her public was conservative, as was her academic community. Neither was prepared for the avant-garde movement in painting, let alone in sculpture. The National Sculpture Society, founded in response to the public's enthusiasm for the monumental outdoor statuary at the 1893 Columbian Exposition in Chicago, continued to represent the most conservative faction of American sculpture. The human figure, drawn from classical art, remained the medium's primary means of expression. Sculpture virtually missed the impact of the famed 1913 Armory Show which was so decisive for contemporary American painting. That form could exist independently of content, could express purely aesthetic or personal ideals without regard to representation, was a belief that progressed far more swiftly on canvas than in bronze or stone. Traditional American sculpture was simply not ready for the abstract Modernist art with which it was confronted from 1910: Cubism, Constructivism, Futurism, the machine aesthetic, and French 'Art Deco'.

Local sculptors who were tempted to explore the Modernist expression were often deterred by the fact that the National Sculpture Society continued to control the allocation of important public commissions, scholarships, prizes and appointments. Sculptors turned instead to private clients, for whom they were more free to carry out experiments in form, technique and expression. Garden sculpture, especially of

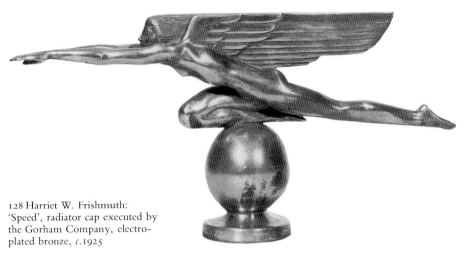

128 Harriet W. Frishmuth:
'Speed', radiator cap executed by
the Gorham Company, electro-
plated bronze, c.1925

animals, provided an important middle ground between the Modernist
and his customer because abstraction of the animal form was more
palatable to most than distortion of the human form. Growing demand
for such sculpture helped to develop a cohesive group of artists, many
of them women, whose style increasingly resisted traditional academic
strictures. Emphasis was still placed on a realistic interpretation of
form, but it was now more spontaneous and lightly humorous, in
many instances incorporating imagery employed by avant-garde artists
in Europe: the use of repeated pattern, streamlined form and mythological
subjects interpreted in a contemporary, and sometimes Art Deco, style.
Harriet Whitney Frishmuth, Edith Baretto Parson, Janet Scudder,
Edward McCarten, Wheeler Williams and John Gregory were among
those who became known for this type of transitional sculpture.

As noted, animal subjects – herons, storks, ant-eaters, and so forth –
became a natural theme for garden statuary. These pieces were often
given an Art Deco interpretation, with angular silhouettes and features.
Artists such as Eugénie Shonnard, Albert Laessle and Cornelia Chapin
modelled some of the most appealing of these. Others, including Bruce
Moore and Heinz Warneke, applied a highly personal and rigorous
Modernist style.

In the 1920s, three factors came together to facilitate the introduction
of a distinct twentieth-century style of American sculpture: the arrival
of avant-garde artists from Europe; the return of the most recent wave
of young American sculptors trained in Europe and keen to provide
their own (often watered down and cautious) interpretation of vanguard
European art; and the development of a new form of architecture: the
setback skyscraper.

133

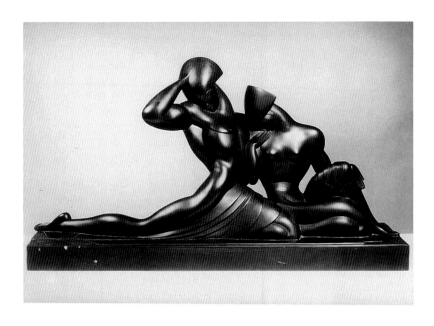

It is impossible to overemphasize the effect on Modernist American sculpture of the work of immigrant avant-garde sculptors. Only two of these – Lovet-Lorski and Hunt Diederich – worked consistently in the Art Deco idiom, but all in their different ways influenced and inspired younger artists. Elie Nadelman, in particular, whose monolithic talent dominated the medium in the United States from the moment he arrived after the First World War, produced work of an unclassifiably individual avant-garde style which encouraged a host of young sculptors to forgo their traditional training.

Most of Nadelman's work falls outside the scope of this book, but some pieces evoke the sleek French Modernism of the later Art Deco movement. Other immigrant sculptors, too, such as Lachaise and Robert Laurent, produced the occasional masterpiece in the 1920s style, among a larger body of more abstract avant-garde works. The human form and realism – the traditional means of sculptural expression – were embraced by these artists only to varying degrees. Their vision was of the new industrial age, and they looked for more contemporary symbols with which to express it, often turning for inspiration to the early works of such painters as Picasso and Braque.

No sculptor in America caught the prevailing Art Deco mood in Paris as effectively or poignantly as Lovet-Lorski, who arrived in New

129 *Opposite* Boris Lovet-Lorski: *Rhythm,* Belgian black marble, late 1920s (Collection of Hirschl & Adler Galleries, New York)

130 *Right* Boris Lovet-Lorski: bust of a young girl, white marble, *c.*1927

York from the Soviet Union in 1920. His style, like his choice of materials, was eclectic, an exciting mix of Modernist, Oriental, tribal, archaic and Teutonic influences.

By far the most original and interesting is his work in the modern style. At first a little stiff, it soon gave way to a more sophisticated, yet simplified, distribution of forms and mass, used to greatest advantage in his female nudes, in which the bold sweep of the body captures its innate rhythm and grace. His torsos, often cut off at the crown of the head, communicate the same feeling of movement and energy, in part due to the simplifying and streamlining of facial features and hair.

Wilhelm Hunt Diederich's sculpture reveals the same fascination with flatness and the silhouette that is evident in his metalwork. The bronze pieces which he created in the round show in their squared limbs a distinctly individual angularity and inner strength.

Known primarily for his rather formal classical style, Carl Paul Jennewein arrived in the United States from Germany in 1907 and began his studies at the Art Students League in New York. In 1916 he was awarded the Prix de Rome and returned to Europe for four years of advanced study. *Cupid and Gazelles* was created during this period, and five years later he produced its similarly endearing companion piece, *Cupid and Crane.* Although both have a lightly Art Deco quality, it was

131, 132 *Above* Carl Paul
Jennewein: *Cupid and Crane*,
bronze, 1924 (Collection the
Newark Museum, gift of Mr & Mrs
Felix Fuld, 1927) *Left* Carl Paul
Jennewein: 'Water', plaster study for
one of the 'Four Elements' figures
on the Department of Justice
Building, Washington, D.C.,
1932–34

not until a return trip to Rome in 1926, to formulate his design for the
pediment of the west wing of the Philadelphia Museum of Art, that
Jennewein created a truly enduring Art Deco classic, *Greek Dance*,
which was cast in an edition of twenty-five in gilt-bronze and a smaller
number in silver. Other freestanding works made at the time, including
studies of his children and small animals, show a similar intimacy and
sensitivity.

In the 1930s Jennewein continued to make his living from classically
inspired commissions, but he did also sculpt several powerful Modernist
works. Chief among these were his entrance to the British Empire
Building in the Rockefeller Center (1933); a charming Modernist frieze
for the entrance to an apartment building at 19 East 72nd Street, New
York (1937); and four stone pylons symbolizing the Four Elements for
the 1939 World's Fair in New York.

Gaston Lachaise is most famous for his series of large, buxom models
of his wife, Isabel Nagel. Less well known are the portrait busts and
animal group commissions which he undertook throughout his career
and in which he used a more marketable, popular style. The figure of a

136

133 Gaston Lachaise: *Dolphin Fountain*, bronze, 1924 (Collection The Whitney Museum of American Art, gift of Gertrude Vanderbilt Whitney)

seal and *Dolphin Fountain*, created for Gertrude Vanderbilt Whitney in 1924, show this style to full advantage. The *Dolphin Fountain*, in particular, reveals Lachaise at his most sensitive and alluring; the animals' characteristic playfulness and grace are caught precisely in the flow of their undulating bodies.

Carl Milles was a late immigrant to the United States, arriving in 1931 at the age of fifty-seven. His style showed considerable variations throughout an early career in Sweden and his later working years as director of the sculpture department at the Cranbrook Institute. The Institute's Triton Pool was designed by him in a vigorous Art Deco style. Steeped in classicism, he gave his mythological figures a light Modernist interpretation which distinguished him from most other traditionalists.

The immigrant Modernist sculptors brought with them to the United States a firm belief in the technique of direct carving, as opposed to bronze casting, as the main means of sculptural expression. Both Europe and America had always favoured bronze over other materials, so the preference for carving was partly a reaction against academic

tradition, a tradition which, in the 1920s, still limited the direct carver's success to a small audience, often courted through one-man exhibitions. Robert Laurent, William and Marguerite Zorach, José de Creeft, Heinz Warneke, John Flannagan, Chaim Gross and other sculptors promoted the use of primary materials such as stone, wood and alabaster in which the artist was involved in the entire creative process, finding inspiration in the material itself. Several direct carvers claimed to work in this manner, starting without preconceived ideas, and simply following their artistic instincts as they went along.

Second only to the far-reaching influence on American Modernist sculpture of the immigrant sculptors came the influence of young American artists themselves. By tradition they completed their training in Europe, ususally either in Rome or Paris. The education offered at both these centers was acceptable, despite the fact that it was fundamentally different. By the 1920s, Rome's emphasis on antiquity was increasingly seen as outmoded, whereas Paris offered a vibrant academic tradition spanning everything from the Ecole des Beaux-Arts to the annual Salons. Most importantly, the French system had developed a built-in tolerance for radical thought and expression.

Of the young American sculptors returning from Europe, Paul

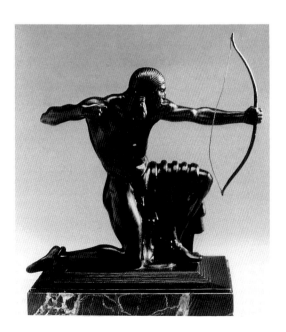

Manship was the best prepared. He had spent six years in Italy, studying the iconography and techniques of archaic and Greco-Roman sculpture and developing a style which was a highly personal interpretation of antiquity, one seen by academicians as both fresh and at the same time a proper continuation of the American tradition. On his return from Rome – a period during which he added Indian and European medieval influences to his archaism – he met with immediate success. By 1925 he was pre-eminent within the American sculpture establishment, and it was at this time that he achieved the highpoint of a supremely individual style, one seen in retrospect as exemplary Art Deco. Later commissions, in the 1930s, such as his 'Moods of Time' for the 1939 New York World's Fair, and his Celestial Sphere for the Woodrow Wilson Memorial in Geneva (1939), show a more streamlined, but equally vigorous, Modernism.

Manship's most endearing commission was a pair of gates for the main entrance to the New York Zoological Park in the Bronx. For this large project – approximately 36 feet high by 42 feet wide – he designed a double gateway in bronze with flanking columns and surmounting lunettes conceived as stylized trees and foliage populated by birds and animals. A lion crowned the central tree. Beneath, a menagerie of birds

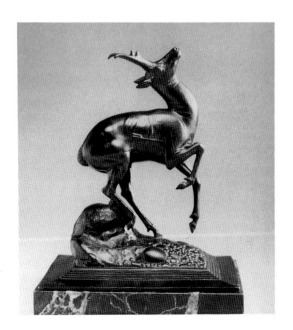

134, 135 *Opposite and right* Paul Manship: *Indian*, and *Pronghorn Antelope*, pair of bronze figures, *c.* 1914 (photos Christie's, New York)

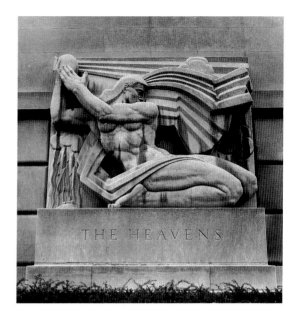

136, 137 *Right* Sidney Biehler Waugh: *The Heavens*, limestone carved by Joseph Geratti, the Buhl Planetarium and Institute of Popular Science (now the Buhl Science Centre), Allegheny Square, Pittsburgh, 1940. *Opposite* John Storrs: *Forms in Space*, aluminium, brass, copper and wood on a black marble base, *c*.1924 (Collection The Whitney Museum of Art, photo Robert Schoelkopf Gallery)

THE HEAVENS

and animals perched among the leaves. These creatures, subsequently issued in individual editions, were modelled in a most expressive manner. The birds, in particular, have a range of lightly humorous expressions which recall the work of the French *animalier* master, Edouard Sandoz.

The exoticism evident in the work of Allan Clark was the result of three years of study and travel in the Far East. *Bedaja* and *Study for a Garden Pool* show how elegantly he combined Oriental and Modernist influences. Particularly graceful was his treatment of garments, their folds simplified into curving lines.

Sidney Biehler Waugh's period of study abroad was more conventional than that of Clark. A four-year spell in Paris under Emile Bourdelle was followed by the Prix de Rome, which allowed him three further years of study. On his return home he concentrated on architectural sculpture, including the decoration of federal buildings in Washington, D.C., and by 1935 his early classicism had given way to a robust contemporary style. Characteristic of Waugh is the exaggerated musculatory emphasis accorded to the human body as well as the reduction to its basic geometric elements of secondary detailing, such as trailing drapery and background foliage. Waugh's style proved particularly effective in architectural reliefs, to which he applied deep carving to accentuate the bold bodily features of his subjects, but it was also suited to work in the round, of which his monumental group, *Manhattan*,

140

seen at the 1939 New York World's Fair, is a distinctive example. A Prix de Rome award also took Edmond Amateis to Europe, but he returned with a distinctly Parisian, rather than Italian, style. Back in New York, he undertook several substantial commissions, including architectural ornamentation for the Buffalo Historical Society and the Rochester Times-Union buildings. Amateis, like Jennewein, was capable of a range of historical and modern styles. His particularly successful modern designs include those for the Baltimore War Memorial, and his *Pastoral* group in Brookgreen Gardens, South Carolina.

John Storrs moved freely between figurative and abstract art, drawing both on classical iconography and on a blend of themes from twentieth-century abstract art: Cubism, French Modernism and the machine aesthetic.

Storrs launched his career in 1920 with a one-man show at the Folson Gallery in New York. In a highly distinctive non-representational style he explored the simplification of form into planes and volumes. One approach entailed his use of faceted surfaces to achieve a range of Cubist light and shadow effects in the manner of Picasso, Gris and Laurens; another reduced mass to its basic geometric components; another, still, arose out of his belief that architecture and sculpture were interdependent. In the 1920s Storrs created a series of thoroughgoing architectural pieces inspired by skyscrapers, including *Forms in Space No. 1* and *Study in Forms*. Alongside his interest in architecture grew a fascination with industrial art. Several later pieces took machine parts as their subject. In 1928 Storrs created a figure of Ceres for the top of the Chicago Board of Trade Building. Of all his pieces, this captures most successfully the Modernist spirit. He has transformed the features of the goddess of the harvest into a graceful 30-foot-high mass pared down to those elements visible in silhouette from the street.

The work of Storrs is but one example of the influence of architecture on modern sculptural expression in the United States. The coming of the skyscraper gave the avant-garde sculptor a new vehicle for his art. Architects rejected fussy traditional decoration, demanding fresh images and forms to accent their soaring new structures. Sculpture's interrelationship with architecture was analyzed, its function and relevance was discussed. Understatement was seen to be the key: sculpture's role was to soften the harsh transitions between a building's separate parts. Several sculptors responded imaginatively to this task, most notably René Paul Chambellan and Lee Lawrie, both of whom displayed a dynamic blend of Modernism in works for the Rockefeller Center.

Paintings, Graphics, Posters and Bookbinding

PAINTINGS

The paintings of the interwar years are difficult, if not impossible, to define in an Art Deco context. Most artists of the time employed a range of avant-garde techniques to solve traditional problems of design and composition. Almost every Modernist artist used, for example, abstraction by means of Cubism and elongation, or employed the bright colours of the Fauvists. Artists whose work falls beyond the scope of this book, such as Léger, Matisse, Vlaminck and Van Dongen, at times incorporated Art Deco motifs in their works.

All these factors blur the boundaries between painters who qualify as Art Deco artists and those who do not. There are, however, two main criteria by which individual painters can be judged to fall within the Art Deco movement. First, most Art Deco artists were not themselves innovative, but rather drew on themes introduced by other Modernist artists in the early years of the century. Second, their works on paper were *decorative*, designed to fit into and complement the fashionable ensembles of the period.

Jean Dupas is in this way typical of the true Art Deco artist. Many of his canvases were displayed at the decorative arts Salons – the Salon d'Automne and the Salon of the Société des Artistes Décorateurs – rather than at the Salons for painting alone. They were, in the final analysis, decorative rather than artistic compositions.

To most devotees, the pinnacle of the Art Deco style in painting is represented by Tamara de Lempicka. Born Tamara Gorska to a prosperous Polish family near Warsaw, she married a Russian, Thadeus Lempitzski, while still in her teens. The couple arrived in Paris towards the end of the First World War, fleeing the Russian revolution. Deserted by her husband in the 1920s, de Lempicka resolved to suppport herself and her daughter, Kisette, by painting. She enrolled at the Académie Ransom, where she studied with Maurice Denis, a disciple of Cezanne's, and with André Lhote, the theoretician of Cubism. She developed a highly personal, sometimes icy and enigmatic, style in which contrasting angular images and bright colours predominated. De Lempicka painted

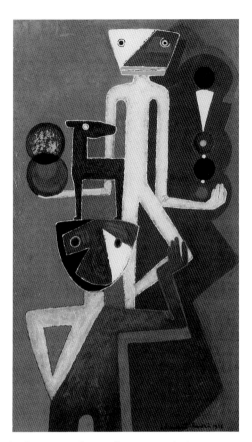

138 Jean Lambert-Rucki: *Two Masked Jugglers*, tempera on board, 1936

roughly one hundred portraits between the mid-1920s and the Second World War. Many were of nudes and several were set against a background of New York skyscrapers. The Cubist influence is obvious, as is her use of chiaroscuro to dramatize the impact. At the core of her finest works is an often highly charged sexuality.

Another Polish *émigré*, the artist-sculptor Jean Lambert-Rucki, moved in 1911 to Paris, where he likewise embraced the Cubist idiom in a diverse mix of materials, including wood, metal, painted plaster and mosaics. His preferred themes included African tribal imagery and Parisian street-walkers, which were often rendered in a lightly comical and primitive manner.

The City of Bordeaux contributed several distinguished artists to the Art Deco movement, including Jean Dupas, Robert Eugène Poughéon, René Buthaud, Jean Gabriel Domergue and Raphael Delorme, who together generated a wealth of decorative works on paper and canvas.

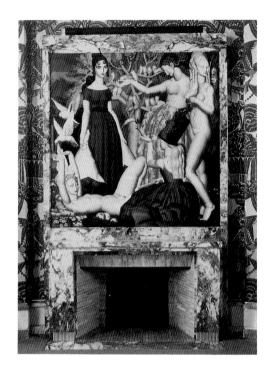

139 *Left* Jean Dupas: *Les Perruches*, oil on canvas, in the Grand Salon of Ruhlmann's Hôtel du Collectionneur at the 1925 Exposition, Paris

Dupas, in particular, developed a highly distinctive and abstract style which captured precisely in its elongations and dehumanizing expressions the mood of the period. Listed at the Salons from 1909, Dupas was awarded the Prix de Rome.

Poughéon studied at the Ecole des Beaux-Arts in both Bordeaux and Paris and developed an abstract style in which the subject's anatomy was given a pronounced angular muscularity, often of heroic proportions. Some of his works are quintessentially Art Deco in their high stylization; others portray allegorical figures in naturalistic settings. Domergue, a student of the Bordeaux Ecole des Beaux-Arts and also a recipient of the Prix de Rome, painted engaging portraits of Parisian socialites, theatre celebrities, and nudes. Delorme, perhaps the only artist of the era with independent means (his cousin, Mme Metalier, housed him in her castle at Valesnes), later claimed to have sold only one painting – to the Maharajah of Kapurthala – in his entire career. Mixing Neoclassical and Modernist images in strange, but appealing, compositions, Delorme

140, 141 *Above* Tamara de
Lempicka: *Portrait of Prince Eristoff*,
oil on canvas, 1925 (Collection
Barry Friedman Ltd) *Left* René
Buthaud: *Femme tenant une fleur*,
gouache on paper, 1924

142 Louis Icart: *Thaïs,* etching
and drypoint in colours, *c.*1927

141 placed many of his subjects in architectural settings. Buthaud, like
Dupas, switched media with great facility. His paintings, often rendered
initially as cartoons for his stained glass windows and *verre églomisé*
panels, incorporate all the softness and sensuality of his designs for
ceramics.

15 Marie Laurencin's portraits and floral compositions bordered on the
Art Deco style. Using a distinctly feminine pastel palette, Laurencin
worked closely with her brother-in-law, André Groult, supplying
paintings for his ensembles at the annual Salons. Sonia Delaunay and
Raoul Dufy, whose early work as textile designers can be placed within
an Art Deco context, were later to develop a more personal and less
classifiable style as painters.

A self-taught painter and print-maker, Louis Icart is today one of the
better-known Art Deco artists. He joined a postcard company in Paris
in 1907, branching out on his own the following year. In the 1920s Icart

146

generated a huge volume of lithographs and etchings, most depicting fashionable young women in languid poses attended by borzois and poodles, in a highly sentimental style which sometimes slipped into the realm of kitsch and high commercialism. He also painted a considerable number of oils and gouaches on the same theme, as well as a few erotic works.

In painting as in sculpture, some artists in the 1920s adopted a Modernist style in their portrayal of animals. The premier *animalier* painters were Paul Jouve, Jacques Nam and André Margat. Unlike their nineteenth-century predecessors, Delacroix and Géricault and, towards 1900, Barye and Rosa Bonheur, who depicted animals in their natural habitat, the 1920s artist chose to treat the subject in isolation, often silhouetted against a white ground. Felines – leopards and panthers, in particular – and snakes and elephants were popular, all painted in slightly abrupt or faceted brush strokes to reveal their innate power and rhythm. Jouve's output was the most diverse. He generated an important body of *animalier* etchings, drawings, watercolours, woodcuts and oils. He frequently worked with artists in other fields, such as Jean Dunand on the murals for the oceanliner, *L'Atlantique*; the binder Georges Cretté on bas-relief plaques for book covers; and Edgar Brandt, on monumental bronze doors for banks.

GRAPHICS
Book and fashion magazine illustrators of the 1910–14 years anticipated the Art Deco graphic style that evolved in Paris after the Great War. Inspired primarily by the 1909 arrival in Paris of Diaghilev's Ballets Russes and by Léon Bakst's vivid stage and costume designs, French

143 Paul Iribe: logo for Jeanne Lanvin, *c.*1930

Le Grand Décolletage.

commercial artists introduced the same orgy of colours and mélange of Russian, Persian and Oriental influences into their designs for book illustrations, fashion plates and theatre sets. Couturiers such as Paul Poiret provided further opportunities by commissioning artists to illustrate booklets on their latest fashions. By the outbreak of the First World War, Bakst-inspired pochoirs and aquatints dominated the pages of Paris's foremost fashion magazines: *Gazette du Bon Ton, L'Illustration,* and *La Vie Parisienne.* The *Gazette du Bon Ton,* in particular, drew on the talents of a myriad of commercial artists, including George Barbier, Edouard Garcia Benito, Georges Lepape, Robert Bonfils, Umberto Brunelleschi, Charles Martin, André Marty, Bernard Boutet de Monvel and Pierre Brissaud. These artists mixed eighteenth-century pierrots, columbines, powdered wigs, and crinolines with depictions of young women clad in the latest *haute monde* creations. From 1920, the lightly sensual maiden of these early years was abruptly transformed into a chic *garçonne,* coquettish, wilful, sporty and usually smoking.

Several illustrators warrant special mention. Lepape, Erté and Barbier, for example, used a colourful and engaging graphic style which now

148

appears perfectly suited to the Art Deco mood, providing today's reader with an exact record of contemporary fashions in the French capital.

Elsewhere in Europe, the French Art Deco graphic style received a sporadic and mixed reception. In Germany, the fashion magazine *Die Dame* followed the lead of its French counterparts in generating high-styled advertisements and illustrations, including work by the German-born illustrator Baron Hans Henning Voigt, who worked under the pseudonym Alastair and produced haunting images inspired by Edgar Allan Poe.

In the second half of the 1920s, the French Art Deco graphic style reached the United States. There it quickly evolved into a Modernist idiom in which the machine's influence was increasingly felt. Fashion magazines, such as *Vogue* and *Vanity Fair* (both owned by Condé Nast), *Harper's Bazaar* and *Woman's Home Companion*, included French styliza-tion in their advertisements. Editors commissioned European illustrators, including Erté, Lepape and Benito, to contribute cover designs. Other periodicals, such as *The New Yorker* and *Fortune*, tended to use a more geometric and industrial style, especially for their covers, a style that noted designers such as Joseph Binder and Vladimir V. Bobritsky, both

144, 145 *Opposite* George Barbier: *Le Grand Décolletage*, fashion illustration, 1921. *Right* Georges Lepape : *Vogue* cover, 15 March 1927

European *émigrés*, and the native-born William Welsh, John Held, Jr., and George Bolin also followed. In the 1920s, Rockwell Kent pursued a light Art Deco graphic style in his woodcuts for book illustrations. John Vassos, the country's premier Modernist book designer, gave his cover designs a powerful linearism.

POSTERS

The 1920s poster artist drew on the rich and enduring turn-of-the-century tradition of Toulouse-Lautrec, Théophile-Alexandre Steinlen, Jules Chéret and Alphonse Mucha. Works ranged from the transitional high-style interpretations of Leonetto Cappiello prior to the First World War, to the rigorous, geometric compositions of Cassandre a decade later. Most designers favoured as their point of departure the soft-edged, fanciful stylizations of Cappiello, who spanned the years 1900 to 1925. Jean Carlu, Charles Loupot, Charles Gesmar and Paul Colin, in Paris, for example, embraced a light and engaging graphic style which traced a clear progression from their *fin-de-siècle* forbears.

In the 1920s, commercial art became a bona fide profession which, in turn, gave birth to the graphic artist. In 1900 posters had been created largely to announce theatrical events: music hall, burlesque, and cabaret. After the First World War, their use was extended. They now promoted travel, sports meetings and art exhibitions, such as the annual Salons held in Paris at the Museé Galliera and the Grand Palais. In Germany and Italy, the poster also became a significant tool for Fascist propaganda.

New and improved manufacturing techniques created a surplus of consumer items in the 1920s. Supply exceeded demand. Dynamic design therefore became an essential means of persuading customers to buy a particular product. The poster, which reached the general public on Paris's ubiquitous *colonnes d'affiche*, became a major advertising medium, directly competing with radio. Powerful symbols and advertising techniques were sought. Poster designs were simplified, their images reduced to the essentials of product and brand name. Sharp linear compositions, floating on flat areas of background colour, quickly drew the eye. Other gimmicks helped to gain attention, such as aerial or diagonal perspectives. New sanserif type faces streamlined the message. 'The poster is only a means,' Cassandre noted, 'a means of communicating between tradesmen and public, something like a telegraph. The poster artist plays the part of the telegraphist; he does not emit messages, he transmits them.'

The Art Deco poster artist took inspiration from many of the

movements in avant-garde painting of the early years of the century. Cubism and Futurism, in particular, provided powerful new advertising tools. Cubism added fragmentation, abstraction and overlapping images and colour. Futurism contributed the new century's preoccupation with speed and power, translated brilliantly by poster artists into potent images of the era's new giant oceanliners and express locomotives. From the de Stijl and Constructivist movements came pure line, form and colour. By borrowing some of the concepts of these rather esoteric, intellectual movements, the poster artist helped not only to bring them to general notice, but also to make them more comprehensible to the public at large.

In Paris, several poster artists embraced the Art Deco style with vigour and innovation. Jean Carlu, for example, showed great diversity in designs ranging from the romantic (*Têtes de Paris*), to Cubism (*Havana Larrãnaga*), and a form of minimalism in which a broken white line traced the message (*Théâtre Pigalle*). His posters for Air France and Mon Savon, for both of which he served at some point as artistic director, remain among his most appealing.

Swiss-born Charles Loupot settled in Paris, where he worked as an illustrator for *Fémina*. His light, charming poster designs portrayed young women with a rather Icart-like sentimentality. In 1930, Loupot was invited by Cassandre to join his Alliance Graphique. His attractive style provided a spirited counterpoint to Cassandre's sharp imagery.

A designer of theatrical posters, Charles Gesmar linked his young career inextricably to that of Mistinguett, the 1920s music hall sensation. Gesmar designed Mistinguett's plumed costumes, stage sets and programme covers. His premature death in 1928, at the age of twenty-eight, deprived the French poster world of its most gifted young artist, though his style was continued by Zig on a lesser, but thoroughly enjoyable, plane.

Born in the provinces, Paul Colin settled in 1913 in the French capital, where he became proficient in paintings, posters, and set and costume design for the Opéra. His fame rests primarily on his long association with Josephine Baker, which began in 1925 with the publication of his La Revue Nègre poster, announcing Baker's first performance at the music hall Champs des Elysées. Colin's entertainment posters were invariably designed in a lively, angular style that after 1926 traced the emerging influence of the machine.

Cassandre emerged as the era's foremost poster artist. Born Adolphe Mouron in the Ukraine, he studied at the Académie Julian in Paris before launching his career across a broad spectrum of the graphic arts

146 Georges Favre: *Berger-Grillon*, advertising poster, 1930

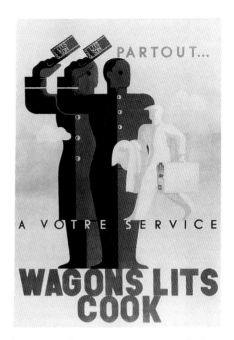

147 A.-M. Cassandre: *Wagons Lits
Cook*, lithographic poster, 1933

as a painter, theatre designer and typographer. It was in poster design,
however, that he made his most dramatic impact.

Cassandre comprehended fully the function of a poster; he knew that
the elimination of all superfluous detail would sharpen the message.
Simplification, translated into a vigorous interplay of geometric and
machine elements, became the vehicle by which he transformed poster
art into a dominant twentieth-century advertising phenomenon. Major
works followed on each other in rapid succession after the 1925 poster,
L'Intrans, for the Parisian newspaper *L'Intransigeant*, in which Marianne,
the symbol of the voice of France, was depicted as a defiant young
woman imparting the truth to the nation. His designs for the national
railways, *Nord Express* (1927), *Etoile du Nord* (1927) and *Chemin de Fer
du Nord* (1929), and those for the oceanliners *Statendam* (1928), *L'Atlant-
ique* (1931) and, the most celebrated, *Normandie* (1935), quickly entered
the realm of poster classics. In 1930, Cassandre founded the Alliance
Graphique with Maurice Moyrand, a printer's representative, but
Moyrand was killed four years later and the firm quickly slipped into
bankruptcy. From 1936 Cassandre made several trips to the United
States where, among other commissions, he designed covers for
Harper's Bazaar.

153

Another notable poster designer, René Vincent forsook his architectural studies at the Ecole des Beaux-Arts for a career in the graphic arts and, to a lesser degree, in ceramics. An illustrator for *La Vie Parisienne*, the *Saturday Evening Post* and *L'Illustration*, Vincent also designed posters for the giant Parisian department store, Au Bon Marché. His compositions, showing fashionable demoiselles playing golf (*Golf de Sarlabot*) or twirling parasols (*Au Bon Marché*) were in a crisp, illustrative style heightened with contrasting blocked colours.

Many other French painters and graphic artists provided the world of poster art with intermittent works. Jean Dupas, for example, turned his hand to a delightful series of advertisements for Saks Fifth Avenue, Constable, and so on, in a style which varied little from his canvases. René Buthaud transposed the lithesome maidens on his stoneware

148 René Buthaud: poster for the Salon of the Société des Artistes Décorateurs, gouache and ink, 1931 (Collection of Robert Zehil)

vessels on to paper, some to herald the annual Paris Salons and others as allegorical figures to promote Bordeaux's wine industry. The identity of the prolific artist, Orsi, whose name appears on more than one thousand Art Deco posters, including images of Josephine Baker at the Théâtre de l'Etoile, remains an enigma. From the world of fashion and theatre set design, Georges Lepape and Natalia Goncharova created posters in a predictably colourful and theatrical style which evoked an image of Paris as the pleasure capital of the world.

Outside of France, poster artists adopted the Art Deco style to varying degrees. In Belgium, the Swiss-born Léo Marfurt formed a fifty-year association with the tobacco firm, Van der Elst, for which he designed advertising materials, packaging and posters. In 1927 Marfurt formed his own studio, Les Créations Publicitaires, where he produced two masterpieces of travel poster art: *Flying Scotsman* (1928) and *Ostende-Douvres* (*c.* 1928). The former, consisting of overlapping diagonal images in sharply contrasting block colours to suggest the hustle and bustle of a railway station, has emerged as one of the most recognizable and popular images of the interwar years. René Magritte, who worked as a magazine and advertising illustrator before he turned to Surrealism, also created some vibrant Art Deco poster images in the mid-1920s. Two other Low Country artists, Willem Frederik Ten Broek and Kees van der Laan, produced posters for Dutch shipping lines in a Cassandre-like Modernist style.

In Switzerland, Otto Baumberger, Herbert Matter and Otto Morach designed for the fashionable men's clothing store PKZ, as did the German, Ludwig Hohlwein. Baumberger, trained as a lithographer and poster artist, worked principally in Zurich, where he helped to establish the Swiss School of Graphic Design. Matter is known principally for his pioneership of the photomontage technique, which he incorporated in his travel posters, *Winterverein* (1934) and *All Roads Lead to Switzerland* (1935). Much of his work appears today as overly romantic and sugary in comparison with his more forceful blocked Art Deco creations of the 1920s.

Hohlwein was Germany's most prolific, and popular, poster artist. His preference for virile, and notably Aryan, male images to advertise coffee (*Kaffee Hag*, 1913), cigarettes (*Die Grathnohl-Zigarette*, 1921) and beer (*Herkulas-Bier, c.*1925), later won him numerous commissions from the Nazi party for propaganda material. Hohlwein's real gift lay in his use of colour, which he employed in dramatically unexpected combinations. Other German poster artists, such as Walter Schnackenberg and Josef Fennecker, embraced a softer French-inspired style in

149

149 Herbert Matter: *All Roads Lead to Switzerland*, poster, 1935

their designs for theatre and ballet performances. The architect–designer Lucien Bernhard also created a range of Modernist posters incorporating hard–edged imagery.

The Hungarian Marcel Vertès established himself immediately after the First World War as a leading poster artist in Vienna. He moved in 1925 to Paris where, apart from the publication of two volumes of lithographs, *Maisons* and *Dancing*, and occasional work for the couturière, Elsa Schiaparelli, he lapsed into obscurity. His Viennese posters, however, were colourful, with a light, distinctly Parisian, mood.

Brilliant interpretations of the Art Deco poster were produced in other countries, but with less frequency. Marcello Dudovich and Marcello Nizzoli, in Italy; Maciej Nowichi and Stanislawa Sandecka, in Poland; and Edward McKnight Kauffer, Alexander Alexeieff, Austin Cooper, J. S. Anderson and Greiwirth, in Great Britain. In the United States, commercial artists such as Joseph Binder and Vladimir V. Bobritsky, both immigrants, likewise captured the buoyant interwar mood of Paris with verve and imagination.

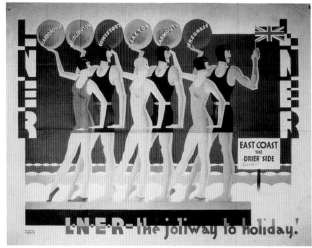

150, 151 *Top* Edward McKnight Kauffer: *Flight of Birds*, lithograph
for poster 'Daily Herald', 1919 (photo courtesy of Pat Kery Fine
Arts, Inc.) *Above* Austin Cooper: *Joliway to Holiday L.N.E.R.*
(photo courtesy of Pat Kery Fine Arts, Inc.)

BOOKBINDING

Not since the hand-illuminated manuscripts of the Middle Ages had
book design drawn such creativity as in the 1920s. Suddenly convention
was swept aside as first Pierre Legrain, and then a host of other French
binders, transformed the age-old craft into a vehicle for Modernist
design. Most observers were unaware, in fact, that binding had ever
attained a high degree of artisanship. The world of book collecting and

connoisseurship was a confidential one in which an exclusive group of bibliophiles commissioned works from binders in relative secrecy. By tradition, books in France at the outbreak of the First World War were published with flimsy paper covers (as they still largely are). To preserve his favourite volumes, the serious collector had to retain a binder to provide a more durable cover. Invariably in leather, this was lightly adorned with a gilt-tooled floral or arabesque design. The binding's primary function was to protect the text; it was not, in itself, considered as a means of artistic expression.

Credit goes to Pierre Legrain for revolutionizing the art. Without a patron since his employer Paul Iribe left Paris for New York in 1914, the young designer found it hard to secure commissions after he was wounded and demobilized in 1917. Fortunately, Jacques Doucet, for whom Legrain had worked with Iribe on the redecoration of his *hôtel particulier* on the avenue du Bois some years earlier, gave him employment. Doucet had disposed of his celebrated collection of antique furnishings at auction in 1912, and had simultaneously donated his library of eighteenth-century books to the University of Paris, retaining only his collection of works by contemporary authors, such as Gide and Suarès. Legrain was commissioned to design covers for some of these. Without prior experience, and largely self-taught, he introduced a vigorous blend of Modernist motifs and materials into his designs, to the delight of Doucet, who commissioned further bindings.

By the early 1920s, Legrain's abilities had drawn the attention at the annual Salons of other book collectors, including Baron Robert de Rothschild, Baron Gourgaud and Henri de Monbrison, who became clients. Suddenly, Legrain, whose career as a furniture designer and interior decorator had been gaining notice, was spearheading the resurgence of the craft of bookbinding. His ignorance of traditional techniques worked in his favour, allowing him to make free use of his creativity and to introduce into bookbinding materials used at the time only in the field of avant-garde cabinetmaking. Bookbinding became, in fact, an extension of the Art Deco cabinetmaking craft, as exotic skins and veneers were interchanged in the search for modernity. Hides such as snakeskin, *galuchat* and vellum were added to the basic material, Moroccan leather. Other decorative accents were provided in innumerable ways. The binding could be inlaid with a mosaic of coloured leather sections, or with gold, silver or platinum fillets, or it could be gilt-tooled, blind-stamped or painted. Further embellishment was afforded by the application of decorative plaques in sculpted or veneered wood, lacquered gold or silver, enamelled porcelain, or bas-relief

bronze or ivory. The encrustation of mother-of-pearl, cork, tortoise-shell or semiprecious cabochons provided further aesthetic possibilities. Books on the Orient were covered in Japanese prints or silk mounted on cardboard. Unique, or limited edition, works came with a matching sleeve (*chemise*) and slipcase (*étui*). Some binders, including Legrain, even donated the hand-tools used on each binding to the patron as an effective selling ploy. In short, the craft was totally revitalized. In a 1930 issue of *Creative Art*, the binder Georges Cretté recalled its rapid transformation following the First World War.

> Book collecting, which used to be the privilege of but a select few, for whom certain publishers, artists, printers, and binders worked in obscurity and silence, has since the war become so violently fashionable that one wonders how long it will last. . . . Editions de luxe are innumerable, and new ones are continually appearing. Authors, ancient and modern alike, are exquisitely printed on the finest papers in the world: the text is illustrated by the best artists. It is only a logical consequence that the production should be consistent throughout, and that the book designed in such a spirit of perfection should be worthily clothed in a beautiful binding.

When, as frequently occurred, a binder was commissioned by more than one client to bind the same book, each was provided with his own

153 François-Louis Schmied: book
cover plate executed by Jean Dunand
in eggshell lacquer for *Histoire de la
Princesse Boudour*, 1926

unique design. Ernest de Crauzat's book in two volumes on the
period's bindings, entitled *La Reliure française de 1900 à 1925*, for
example, illustrates three different book covers by Cretté (all with
plaques designed by Schmied executed in lacquer by Dunand) for
Le Cantique des cantiques, and a fourth example by Schmied alone. The
clients in this instance were all celebrated bibliophiles: the Art Nouveau
jeweler, Henri Vever; Charles Miquet, A. Bertraut and Louis Barthou.
Other noted binding collectors at the time were George and Florence
Blumenthal of New York, who were better known for their patronage
of the furniture designer Armand Rateau, and Carlos R. Scherrer, of
Buenos Aires, who established Paul Bonet's reputation. Municipal and
state libraries, such as those at the Bibliothèque Nationale and Sainte-
Geneviève, similarly commissioned bindings to preserve and enhance
their more important acquisitions.

It was not uncommon for a client to wait two years for a completed
commission, particularly after the First World War, when it became the
accepted thing for a cover's design to encompass all three of its
elements: the front, back and spine. Previously, attention had been paid
primarily to the front and, less importantly, to the spine.

Beyond Legrain, Paris was home to a multitude of premier binders
working in the Modernist idiom. Foremost among these was another
Doucet protégée, Rose Adler, and Georges Cretté (the successor to
Marius Michel, considered the last great traditional binder), René

Kieffer, Paul Bonet, François-Louis Schmied, Lucien and Henri Creuzevault, Georges Canape and Robert Bonfils. Less known were the works of Paul Gruel, André Bruel, Geneviève de Léotard, Charles Lanoë, Jeanne Langrand, Yseux, Louise Germain and Germaine Schroeder, whose creations in many instances matched those of their more celebrated colleagues.

Enrollment at Paris's Ecole Robert-Estienne, a technical school devoted entirely to the art and craft of the book – printing, type cutting, binding, typography and so on – swelled in the excitement generated by the craft's revival. Exhibitions, such as the 1925 Arts du Livre Français, provided further prestige and exposure.

The medium's new vogue also attracted graphic artists. Maurice Denis, George Barbier, Georges Lepape and Raphael Drouart all designed covers for volumes by some of the era's most popular writers: Colette, Anatole France, Guillaume Apollinaire, Jean Cocteau, André Gide and Oscar Wilde. The artist-turned-decorator André Mare incorporated a pair of turtle doves, on painted and engraved parchment, in his cover design for Robert de Rothschild's copy of Verlaine's *Amour*.

154

Many binders collaborated on commissions with artist-designers, even, on occasion, with other binders. Schmied, in particular, was so versatile that he participated on commissions as binder, artist or artisan, with Cretté and Canape. Jean Dunand was likewise active, creating lacquered and *coquille d'oeuf* plaques for these and other binders. The *animalier* artist Paul Jouve contributed designs for ivory and bronze panels.

For the most part, the 1920s binder drew on the same repertoire of Modernist motifs employed in other disciplines. Combinations of lines, dots, overlapping circles and centripetal or radiating bands were used to create symmetrical or asymmetrical compositions. Raised panels, achieved by the use of thick boards, introduced a sculptural element, and vortex and spiral designs provided a three-dimensional perspective. Towards 1930, the influence of the machine and new technology became increasingly felt, particularly by Bonet, who emerged after Legrain's death in 1929 as the medium's most brilliant exponent. His sculptural and all-metal bindings of 1931-32 were followed shortly by an even more revolutionary technique: Surrealist photographic images transposed on to leather covers.

Beyond France, bookbinding remained conservative. Very few examples in the Art Deco style were produced in other countries. In the United States, John Vassos designed a few starkly modern bindings in which bright enamels replaced the coloured leather mosaics used in France.

161

Jewelry

The 1920/1930s Art Deco style in jewelry traced its origins to the period before the First World War when the Art Nouveau movement freed jewelry from its Victorian straitjacket. By 1900, the diamond's long reign was brought to an end by jewelers such as René Lalique, Georges Fouquet and Henri Vever, who introduced semiprecious and even valueless materials into Belle Epoque jewelry designs. Horn, tortoise-shell, ivory, enamel and mother-of-pearl replaced diamonds, rubies and sapphires. And although Art Nouveau jewelry was too ornamental and exuberant to retain the public's interest for long (by 1905 it was outmoded), the world of fashion continued to embrace its use of the semiprecious.

JEWELRY AND FASHION

The great influence on Art Deco jewelry was Paris fashion prior to the First World War, so much so that a study of contemporary fashion is a prerequisite to an understanding of why certain types of jewelry evolved in the interwar years.

More than any other couturier, Paul Poiret transformed dress design, freeing the female figure from the constricting bustles and whalebone corsets of the Victorian era: 'It is unthinkable', he wrote, 'for the breasts to be sealed up in solitary confinement in a fortress-castle like the corset, as if to punish them.' His revolutionary designs, rejecting all superfluous ornamentation, transformed the female silhouette. Suddenly, dresses were long, tubular and relatively unadorned.

In 1917 a line of low-waisted models replace Poiret's slim, high-waisted dresses. Hemlines fluctuated for the first five years of the 1920s, ranging from the ankle to the calf. Then, in 1925, skirt lengths shot up to just below the knee – the length now generally associated with the 1920s – dropping back to mid-calf in 1929. The silhouette became longer and flatter, suppressing all curves. This long, lean look necessitated a similarly simple, minimal line of jewelry.

Not only hemlines fluctuated. The neckline and the back of the dress also moved up and down, the latter plunging almost obscenely low. To

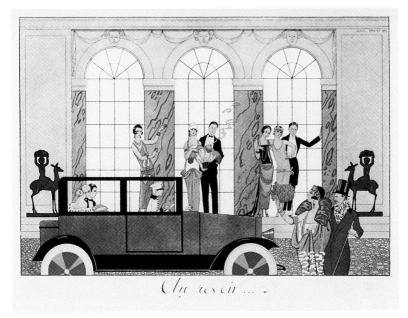

154 George Barbier: *Au Revoir*, fashion illustration, 1924

accentuate the vertical line of the tubular dress, jewelry designers introduced long, dangling necklaces. Sautoirs of pearls and strings of beads were worn down the back, over one shoulder, or wrapped around an arm. Necklaces, suspended with pendants and tassels, hung as far as the stomach or, on occasion, even to the knees. In the 'Roaring Twenties' a long necklace and short tunic dress were *de rigueur* for dancing.

The First World War introduced women into the workforce. Certain types of work, such as assembly line production in armaments factories, speeded up women's liberation from constrictive clothing, giving them a freedom which they would not surrender after the war. There was also a need to conserve heavy fabrics for the troops, which hastened women's acceptance of a softer, slimmer silhouette. The introduction of light materials such as rayon and muslin had an impact on the design of jewelry. New, lighter designs, often mounted in platinum, replaced heavy jewelry, which lightweight fabrics could not support.

To match the sleek new look, hairstyles were shortened, ushering in the boyish *garçonne* look. These changes in hair fashions also directly influenced jewelry design. Closely coiffed hair, for example, exposed the ears and neck, allowing the introduction of pendant earrings which by 1929 had grown so long that they touched the shoulder. The cloche

163

hat, which made its entry in the winter of 1923, was another symbol of the Art Deco period. It completely covered the head from the eyebrows to the nape of the neck, and was secured with a brooch-buckle or hat dart. Because long hair or hair pinned back in a bun or chignon distorted its shape, women cut their hair into the new bobs and shingles. This, in turn, eliminated the need for the large combs and formal tiaras and diadems of the Belle Epoque. When venturing forth without her cloche, the fashionable new woman enhanced her short hair with clips of stones worn flat against the head or with a bandeau. The latter, for evening wear, was worn on the hairline or set back on the crown of the head, like a halo.

The typical dress of the period was sleeveless, allowing the jewelry designer free rein to decorate the wrist and upper arm. Several types of bracelets evolved. Most popular were flat, flexible narrow bands decorated with compact stylized designs of flowers, geometric patterns, or exotic motifs. Four of five of these could be worn together. Towards the end of the 1920s, these bands became wider. Large square links of coral, rock crystal, onyx and *pavé* diamonds were accentuated with emeralds, rubies, sapphires and other cabochon gems. Bangles or slave bracelets were worn on the upper arm or just above the elbow. Like the flexible bracelets, several of these were worn at a time. A variation for evening wear consisted of loose strands of pearls held together by a large pearl-studded medallion from which additional strings of pearls were suspended. This, too, was worn above the elbow.

The sleeveless dress and the craze for sports which evolved in the 1920s helped popularize the watch bracelet. Jean Patou introduced the *garçonne* look into high fashion when he outfitted the tennis star Suzanne Lenglen, who was to typify the chic new mode. By day, the wristwatch was plain, with a leather or ribbon strap. The evening variety resembled a richly jeweled bracelet set with pearls and diamonds, mounted either in enamelled or bi-coloured gold. An example from the period by Tiffany & Company was set with diamonds and onyx mounted in platinum.

The pendant and chatelaine watch, suspended from a ribbon or silk cord, became popular between 1925 and 1930. An example by Van Cleef & Arpels shows the Eastern influence, with jade, enamelling and Oriental motifs. A version for evening wear was suspended from a sautoir chain. The latter was studded with pearls, diamonds and coloured gems, and the case embellished with diamonds.

The new couture also did away with muffs and gloves, leaving fingers and wrists free to display a dazzling new array of matching ring

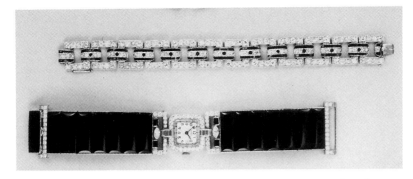

155 Designers unknown: *top* Black onyx and diamond bracelet mounted in platinum, 1920s. *Above* Black onyx and diamond wrist watch, mounted in platinum, 1920s

and bracelet models. Rings tended to be massive, signet-style designs, composed of a single central stone bordered by a band of small *pavé* diamonds or cabochons or semiprecious stones. The popularity of the fan for evening wear provided an additional opportunity to show off the latest in ring fashions. A large ring by Suzanne Belperron, in carved chalcedony set with a single Oriental pearl, captured the new mood precisely. Other designers offered widely different solutions: Jean Desprès, for example, combined crystal, gold and silver in abstract geometric patterns influenced by Cubism and African masks.

The most versatile jewelry accessory of the Art Deco period was the brooch, used not only as a corsage ornament, but also to adorn belts, hats and shoulders. Almost every jeweler offered brooches designed on the theme of the bouquet of stylized flowers or basket of fruit, and the fountain motif.

OTHER INFLUENCES

The riot of colors which burst on to the Parisian scene before the First World War provided another inspiration for the Art Deco jewelry designer. Léon Bakst's stage sets and costumes for the Ballets Russes, which opened in the French capital in 1909, were a kaleidoscope of oranges, bright blues and greens which eclipsed the diaphanous, rather évanescent, *fin-de-siècle* palette. The world of fashion was also seduced by the Ballets Russes' emphasis on Persian and Oriental motifs. In avant-garde painting, the Fauvists, who had first exhibited as a group at the 1905 Salon d'Automne, similarly promoted the use of vibrant colors. The period's preoccupation with brightness manifested itself in jewelry design in the search for a matching palette in stones, many of which were exotic: coral, jade, amber and onyx, for example.

156 Van Cleef & Arpels:
bracelet and shoulder clip,
rubies, emeralds, sapphires,
onyx, diamonds and
platinum, 1924 (Collection of
Van Cleef & Arpels)

ART DECO JEWELRY MOTIFS

Art Deco jewelry drew primarily on the vanguard painting movements
in the first decade of the twentieth century for its decorative vocabulary.
The Cubist and Constructivist movements, in particular, in their
division of form into flat and overlapping geometric images, provided a
major source of inspiration. Superfluous details were eliminated in the
pursuit of simplification. In 1909, the Italian poet Marinetti published
the *Futurist Manifesto*, which heralded the machine, urban life and
speed as the visual expressions of a new reality. The Dutch de Stijl
painter, Mondrian, took Cubism a step further, into Neo-Plasticism.
Through abstraction, he freed forms from any suggestion of objective
reality. As early as 1913, several of these new concepts were evident in
jewelry design, particularly in France. In the United States, where
Modernism in jewelry design was resisted fiercely for many years, a

critic for *The Jewelers' Circular Weekly* asked in 1913, 'Will the new movement in painting and sculpture be reflected in the forthcoming jewelry?' and went on to conclude that a 'vital impulse toward something new and simple is apparent on every hand . . .' This impulse reached its peak at the Exposition des Arts Décoratifs in 1925.

The principal motifs in Art Deco jewelry design were simple geometric forms – the square, circle, rectangle, triangle and so on. These were often juxtaposed or overlapped to create complex linear configurations. Abstract patterns, derived from the architecture of ancient civilizations, such as Babylonian ziggurats and stepped Mayan and Aztec temples, likewise found their way into the contours of jewelry design. Sir Flinders Petrie's archaeological excavations in the first decade of the century started an Egyptian craze which was accelerated by Howard Carter's hugely publicized discovery of Tutankhamun's tomb in 1922. The clean lines in hieroglyphic calligraphy reiterated the linear concepts which had begun to emerge before the war. Van Cleef & Arpels, among others, introduced stylized Egyptian motifs, such as the lotus, scarab and sphinx, in a series of matching bracelets, shoulder clips and brooches. Stripped of their symbolic significance, these images brought a light femininity and exoticism to jewelry design. Diamonds, rubies, emeralds and sapphires were interchanged with neutral stones such as onyx.

Further exotic influences were drawn from France's African colonies. Tribal masks and statuettes were translated into brooches by designers such as Jean Fouquet and Raymond Templier. Josephine Baker's Revue Nègre on the Champs Elysées helped to popularize this interest, which was promoted further in the jewelry exhibition Les Arts Précieux at the 1931 Exposition Coloniale. Jewelers also turned to Persia for inspiration in their creation of jewelry designed as turbans and aigrettes in a characteristic palette of rose-pinks, jonquil-yellows, mauves and cherry-reds. From China, designer houses such as Cartier and Van Cleef & Arpels borrowed the pagoda and dragon for brooch designs.

COSTUME JEWELRY

Costume jewelry differs from fine jewelry in that it is made out of base metals or silver set with marcasite, paste or imitation stones. In the 1920s, the introduction of synthetic substances brought the price of artificial jewelry within the reach of the general population. Since it was inexpensive, it had the advantage over precious jewelry that when styles changed it could be discarded. The French dress designer Coco Chanel championed the use of costume jewelry from the early 1920s.

Between 1925 and 1930 there was a rapid development in the manufacture of Bakelite, a synthetic plastic resin. Considered at first to be only a substitute for materials such as wood, marble, horn and amber, Bakelite gradually became appreciated in its own right as a major component in costume jewelry.

ACCESSORIES

Van Cleef & Arpels and Cartier, among others, produced exquisite accessories for the well-dressed woman of the period. Influenced by Chinese, Japanese, Persian and medieval art, these *objets d'art* combined coloured gemstones, precious stones, marcasite, enamel and lacquer. The small cigarette cases designed by Gérard Sandoz, Jean Dunand and Paul Brandt introduced a further type of decoration in their incorporation of crushed *coquille d'oeuf*. Whether vanity case, cigarette case, compact, lighter, lipstick case, mirror or handbag, each item was intended to be a miniature work of art.

The *nécessaire*, or vanity case, took its form from the Japanese *inro* (a small case divided into several compartments). Although small, it accommodated all the essential accoutrements: mirror, compact, lipstick and comb. Vanities were mostly rectangular, oblong or oval, and hung from a silk cord. In 1930, the vanity case was enlarged into the *minaudière* by Alfred Van Cleef, who gave it the name after witnessing his wife simper (*minauder*) into the mirror. The *minaudière* replaced the evening bag, *pochette*, and daytime dress bag. Cigarette, lipstick and card cases were decorated with the same mix of materials as vanities.

The Art Deco handbag was made of luxurious fabrics or exotic skins with gold or platinum frames and clasps. Gemstones, embellished with faceted or cabochon rubies, emeralds, sapphires and diamonds studded the frames. Semiprecious stones, carved with Egyptian and Oriental motifs, were used for the clasps. Evening bags by LaCloche and Chaumet were embroidered with sequins sewn on to the fabric. Mauboussin designed elaborate evening bags with diamond and emerald clasps to match brooches and bracelets.

The Art Deco style was applied also to men's jewelry, but with less flare. Pocket watches were given geometric dials and were mounted in platinum set with onyx, diamonds, pearls, emeralds, rubies and topazes. Watch chains consisted of cylindrical links enhanced with polished or faceted stones. Cufflinks incorporated the same general shapes. Jean Fouquet designed a notable pair of cufflinks with enamelled Cubist motifs and Black, Starr & Frost's selection included onyx cufflinks with diamond borders.

157, 158 *Top* LaCloche: vanity case, gold, frosted crystal and lapis lazuli, 1920s (photo courtesy of Christie's, Geneva). *Right* Designers unknown: evening bag, diamonds, emeralds, sapphires, ivory, enamel, gold, black suede, silk lining, *c.*1924; evening bag, diamonds, jade, gold, enamel, brocade, silk lining, *c.*1924 (courtesy of Christie's, Geneva)

As in most disciplines of the decorative arts, the 1925 Exposition Internationale des Arts Décoratifs et Industriels Modernes represented the culmination of the high Art Deco style in French jewelry. Beyond France, however, the style had few adherents and the foreign entries did not on the whole reflect the geometric style which had dominated modern taste in Paris since the First World War.

Georges Fouquet of the Maison Fouquet was elected Chairman of the Selection Committee for the *Parure* section. Under his leadership the committee decided that only works of new inspiration and originality would be accepted. Objects had to be submitted anonymously; names of designers and firms whose works were chosen were omitted from the showcases. Of the nearly four hundred firms which submitted entries, only thirty were accepted.

The principal exhibitors were Boucheron, Chaumet, Dusausoy, Fouquet, LaCloche, Linzeler, Mauboussin, Mellerio and Van Cleef & Arpels. Cartier chose to exhibit with the fashion designers in the Pavillon de l'Elégance. The house of Boucheron was represented with creations by M. Hirtz, M. Masse and M. Rubel, which included two remarkable corsage ornaments characteristic of the Art Deco style. Scalloped lapis lazuli, jade and onyx were combined with mat coral and turquoise within diamond-studded borders in geometric patterns resembling miniature mosaics.

160 The artist-jewelers Raymond Templier, Paul Brandt and Gérard Sandoz contributed outstanding examples in new and original materials. La Maison Fouquet was represented by the architect, Eric Bagge; the graphic artist, André Mouron (Cassandre); the painter, André Léveillé;
161 Louis Fertey; and Georges Fouquet's son, Jean, who had joined the family firm in 1919. André Léveillé and Louis Fertey received Grand Prix awards, and Cassandre and Jean Fouquet honorable mentions. Léveillé's designs recalled the overlapping images in Picasso and Braque collages, while Cassandre adapted the mandolin, a motif popularized by Picasso, into the design for a brooch.

INTO THE 1930S

By 1929 the abstract creations of the 1925 Exposition had evolved into mechanistic forms based on industrial design and machine parts. The design principles inherent in motor car and aeroplane construction inspired a new decorative vocabulary for jewelry. A remote but real influence could now be traced to the Bauhaus. In the vanguard of the new aestheticism were the designers Jean Fouquet, Raymond Templier,

Jean Desprès, Paul Brandt, Gérard Sandoz and Suzanne Belperron. Jewelry design evolved from the thin, delicate creations of the early 1920s into bolder, larger designs with sharp outlines. Bright colours gave way to muted tones. Stark contrast was achieved with black and white, epitomized by onyx and diamonds. Earrings became longer. A bangle bracelet and matching ring designed by Jean Fouquet for his wife was made out of frosted rock crystal set with amethysts and moonstones. In place of the uniformly narrow band bracelet of the early 1920s, new models became thicker toward the center. Overlapping forms gave way to clean, simple lines.

In 1929, the Exposition des Arts de la Bijouterie, Joaillerie, Orfèvrerie was held at the Musée Galliera in Paris. Only one truly novel piece of jewelry was displayed – a large diamond-studded tie by Van Cleef & Arpels.

The diamond now once again reigned supreme, cut in the new baguette style and placed next to contrasting stones. Boucheron introduced a baguette-cut diamond bracelet, edged with sapphires. Mauboussin incorporated diamonds on to the tassel of a large sapphire collar. The coloured diamond, out of fashion since the late nineteenth century, also returned to favour. LaCloche displayed a brooch and bracelet set with canary diamonds.

159 Oscar Heyman & Bros.: sketches for bracelets; (top) diamonds, emeralds and platinum; (centre) diamonds, onyx and platinum; (bottom) diamonds, emeralds and platinum; all *c.*1929 (courtesy of Oscar Heyman & Bros.)

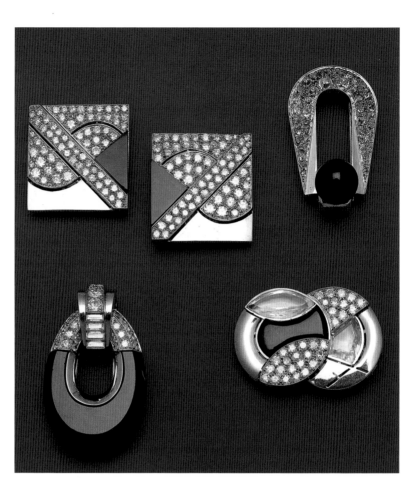

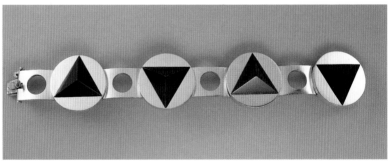

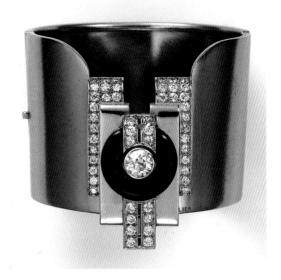

160, 161 *Opposite, top, clockwise* Paul
Brandt: pair of clips, diamonds, onyx,
white gold and platinum, c.1925;
Raymond Templier: brooch, pavé
diamonds, onyx and platinum, c.1925;
Mauboussin: brooch, diamonds, onyx,
white gold, c.1925; Paul Brandt: brooch,
faceted rock crystal, onyx, white gold,
c.1930 (Collection of Primavera Gallery).
Bottom Jean Fouquet: bracelet, white gold,
yellow gold and onyx, c.1925 (Collection
of Primavera Gallery)

162 Raymond Templier: bracelet with
applied brooch, diamonds, onyx, silver,
platinum and gold, c.1929 (Collection
Virginia Museum of Fine Arts)

The Depression struck a fatal blow to luxury items. After the Crash
of 1929, multiple-use jewelry (made of two or more components which
could be dismantled and used separately) became popular. Pendants
could double as brooches or be attached to lapels. A double barrette was
constructed from two linked parts which could be worn separately.
Tiffany & Co. designed a necklace which came apart either to form a
pendant and two bracelets, or a pendant and a choker.

As the economic effects of the Depression deepened, firms were
hesitant to produce new items which might prove difficult to sell. In
1931, when entries were solicited for the Exposition Coloniale in the
Bois de Vincennes outside Paris, only twenty-three firms participated.
Although some exhibited jewelry embellished with colonial themes
such as Negro masks, most contributed objects from existing inventory.
Throughout the 1930s, major jewelry houses cut back their staff or
closed. In 1935, Art Deco's grand master, Georges Fouquet, ceased
major production. In the United States, Tiffany's remained open, but
with a skeleton staff.

As noted, Art Deco was principally a French movement. In America,
the Art Deco style was only reluctantly assimilated into jewelry design.
Tiffany's in New York, the leading American jewelry establishment in
the nineteenth century, created traditional objects in the new style, but

173

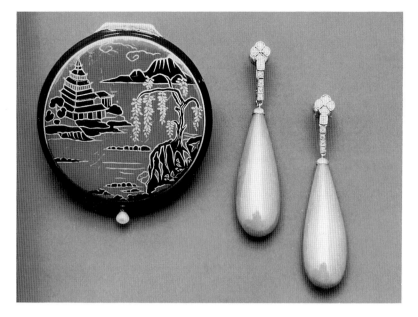

163 Charlton: compact, gold, enamel and pearl, 1923; Black, Starr & Frost: earrings, diamonds and coral in platinum, c.1923 (Collection of Primavera Gallery)

without the crisp angularity of Boucheron or Mauboussin. Other jewelry firms such as Black, Starr & Frost, and Udall & Ballou in New York; J. E. Caldwell & Co. and Bailey, Banks & Biddle in Philadelphia; and C.D. Peacock and Spaulding-Gorham, Inc. in Chicago, produced jewelry in the new idiom, but, again, without the panache of their French counterparts.

Within these limitations, Art Deco jewelry in the United States followed a similar path to that taken in France: lightness and economy in the early part of the decade; massiveness worn in quantity towards the end. In 1924, the major French houses of Boucheron, Cartier, Mauboussin, Sandoz and Van Cleef & Arpels displayed their most up-to-date creations at the French Exhibition at the Grand Central Palace in New York, and though American jewelry design did not derive direct models from this exhibition, it did later become more geometric.

One genuinely new stylistic development can be discerned in American jewelry at the time. The stepped outline made its debut on a few pieces of jewelry, coinciding with the emergence of the skyscraper which was transforming major cities across the country. The image first appeared in jewelry when the Chrysler Building and Empire State Building in New York were under construction.

Architecture

In France, the Parisian 'Art Deco' high style, which dominated the annual decorative arts Salons from the end of the First World War until the 1925 International Exposition, was applied only infrequently to buildings. Examination of contemporary reviews reveals a random selection of boutiques – typically perfumeries, bakeries and shoe stores – adorned in the new idiom. Süe et Mare applied an opulent array of bas-relief baskets of fruit and swagged flower garlands to the façades of the *parfumerie d'Orsay*, the Robert Linzeler jewelry shop and the Pinet shoe store, among others. Materials echoed the firm's interiors: yellow marble ornamented with *ormolu*, blue stucco, wrought-iron and sculpted gilt-wood. Similarly colourful façades appeared in the heart of Paris's most fashionable boulevards on the Right Bank, executed by the decorating firms of Siègel and Martine, while the architects, René Prou, Djo-Bourgeois and Jean Burkhalter produced a more restrained and angular form of shop-front decoration.

The best French Art Deco architecture was designed for the 1925 International Exposition and was destined to last only six months. The fact that the entire site would be razed on the Exposition's closure stimulated experimentation with radical architectural forms and untried materials. Stone and brick yielded to laminates and plastics. The Exposition's charter made radicalism a prerequisite, 'Works admitted to the Exposition must show new inspiration and real originality. They must be executed and presented by artisans, artists, manufacturers, who have created the models, and by editors, whose work belongs to modern decorative and industrial art. Reproductions, imitations, and counterfeits of ancient styles will be strictly prohibited'. There was an exhilarating mix of avant-garde structures, primarily along the Esplanade des Invalides and, perched like a cramped mediaeval Italian town, along the Alexander III bridge. Poiret's three flower-painted barges, moored beneath the bridge, continued the theatrical impact. Banished to the Right Bank among the foreign exhibits was Le Corbusier's starkly perpendicular Pavillon de l'Esprit Nouveau.

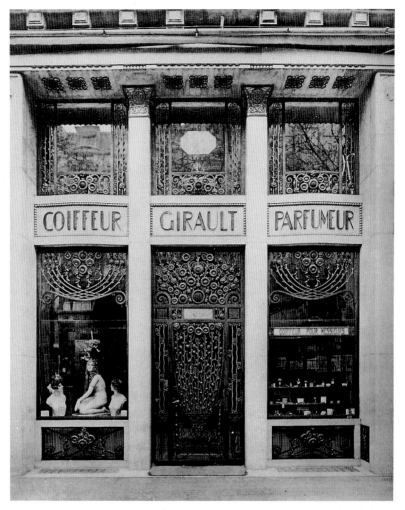

164–66 *Above* Azema, Edrei and Hardy (architects): façade, Girault, boulevard des Capucines, Paris, stone and wrought-iron, *c.*1925. *Opposite above* F. Chanut (chief architect), in collaboration with Maurice Dufrène (decorator): Maîtrise Pavilion, International Exposition, Paris, 1925. *Opposite below* Henri Sauvage & Wybo (architects): Primavera Pavilion, International Exposition, Paris, 1925

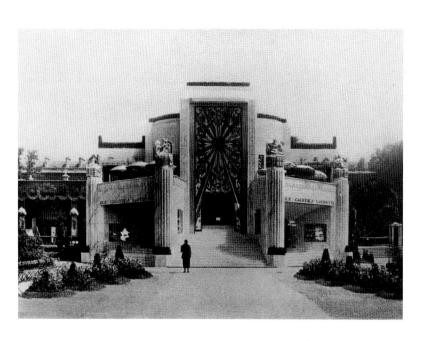

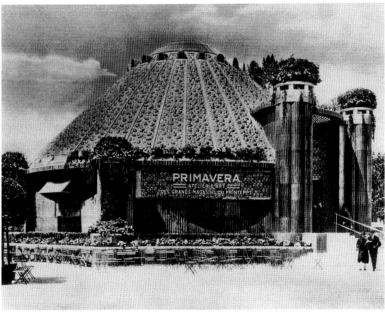

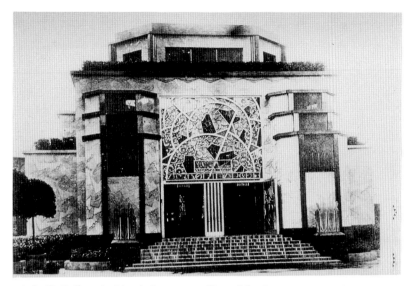

167 L.-H. Boileau (architect): Pomone pavilion of the department store Au Bon
Marché, International Exposition, Paris, 1925

An American critic compared the exhibition's rhapsody of colours
and abstract shapes to a giant Coney Island. The four leading Parisian
department stores set the mood in the designs for their pavilions:
Pomone, of the Magasins au Bon Marché (L–H. Boileau, architect);
166 Primavera, of the Magasins du Printemps (Sauvage & Wybo, architects),
165 La Maîtrise, of the Magasins des Galeries Lafayette (F. Chanut, chief
architect, with J. Hiriat, G. Tribout, G. Beau and Maurice Dufrene,
decorator); and Studium-Louvre, of Grands Magasins du Louvre (A.
Laprade, architect). Other pavilions were equally eye-catching: the
pavilion of Information and Tourism (R. Mallet-Stevens), the shops of
the Place Clichy (C. Siclis), the National Manufactory of Sèvres (P.
Patout & A. Ventre, in association with H. Rapin) and Ruhlmann's
Hôtel du Collectionneur (P. Patout).

At every turn the visitor was exposed to a bizarre mix of terraced
structures, Cubism, overlapping arcs, and chevrons. This did not
please everyone. One critic called the Exposition's architecture a
conglomeration of ill-proportioned rectangles and triangles and noted
with irony that the silhouettes of the Louvre, Tuileries and Invalides
stood in the distance 'like silent disapproving ghosts'.

Art Deco architectural ornamentation did not extend far beyond the French capital. Unlike America, which experienced a building boom in the 1920s, Europe was in a quiet period of retrenchment following the devastation of the Great War. In addition, its rich architectural tradition leaned heavily towards renovation rather than demolition.

Britain has some claim to be one of the pioneers of Art Deco in the late style of Charles Rennie Mackintosh. His 1916 designs for Derngate, a house in Northampton, are a consistent exercise in typical Art Deco motifs – zigzag lines, arrow shapes, overlapping squares and flat geometrical patterns.

In Britain in the 1920s, as elsewhere, the new style was a favourite for building types that had no tradition behind them: garages, power-stations, airport buildings, cinemas and swimming pools. All these tried to be self-consciously modern (or *moderne*), and it is not always easy to separate elements derived from the early International Style in the Continent from Art Deco in the strict sense.

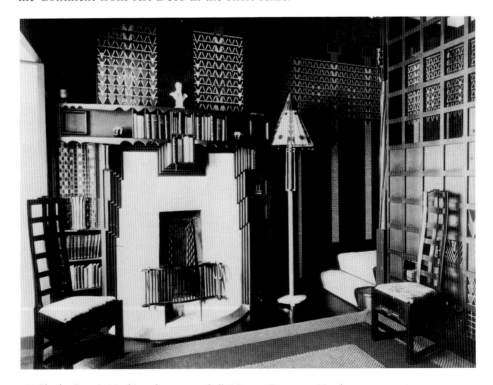

168 Charles Rennie Mackintosh: entrance hall, No. 74, Derngate, Northampton, 1916

At one end of the scale is the blatant populism of cinemas and hotels, where Art Deco attained its most exuberant expression: the numerous provincial Odeons designed in the office, if not by the hand, of Harry Weedon, or the New Victoria Cinema, London, by E. Wamsley-Lewis of 1930. Among hotels, the foyer of the Strand Palace, London, by Oliver Bernard, which seemed to be built of luminous glass panels, was the most striking. R. Atkinson's foyer to the *Daily Express* Building in Fleet Street of 1932 was its rival and now survives it.

Commercial and industrial buildings were necessarily more restrained, but their decoration could sometimes be unexpectedly lavish – for instance, Battersea Power Station, London, by Halliday and Agate (exterior by Giles Gilbert Scott), 1929–34; the Hoover and Firestone Factories in West London; Ideal House, London, by Gordon Jeeves and Raymond Hood, 1928; H.S. Goodhart-Rendel's Hay's Wharf, London, of 1927; or Gray Warnum's headquarters of the Royal Institute of British Architects of 1932. In all these cases the expensive materials, the quality of the craftsmanship and the attention given to detail entitle them to rank with comparable works in France and the United States.

There is also a whole range of attractive buildings whose shapes are part of the vocabulary of Art Deco, and which are still memorable parts of the British architectural scene, but where the decorative element is muted or absent – Mendelsohn and Chermayeff's De La Warr Pavilion, Bexhill; the Senate House, London University, by Charles Holden; Broadcasting House, London; Crabtree's Peter Jones store in London; or Wells Coates' Embassy Court flats, Brighton.

In the years 1923–25, when the American skyscraper boom began in earnest, the United States did not have its own Modernist style. The only decidedly modern decorative style which the American architect could use was the style flourishing in Paris. For this reason, Art Deco ornamentation is to be found in the United States on a host of buildings under construction from the early 1920s and is most strongly associated with the skyscraper.

Of course American architects could have continued in the Gothic manner of Cass Gilbert's Woolworth Building in New York, or Hood and Howell's Gothic-inspired Chicago Tribune Tower. But this historicism no longer seemed suited to the twentieth-century structure. It was replaced by up-to-date colourful geometric and floral designs drawn directly from Paris – chevrons, arcs, sunbursts, maidens, flower sprays, and so on. In the 1920s these Art Deco appropriations were to become America's most readily identifiable decorative vernacular for Modernist buildings under construction. They continued to be used

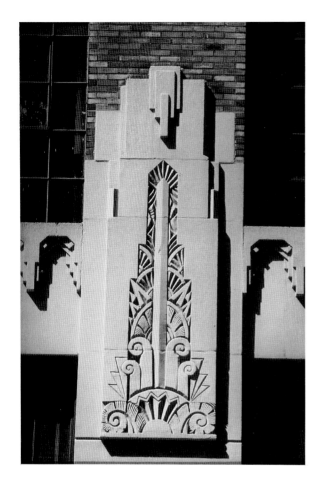

169 Unidentified architect: terracotta frieze, 345 Hudson Street, New York

long after the style had become a cliché in France.

As in traditional architecture, Modernist decoration served as a transitional device to alert the eye to a change in the contour of a building. Stepped vertical decoration accentuated a skyscraper's height, horizontal decorative bands emphasized the rhythmic ascent of its setbacks. Art Deco ornamentation was also concentrated heavily on a building's entranceway – exterior grillework, doors, vestibule and bank of elevators. A sumptuous combination of stone, brick, terracotta and metal often transformed an otherwise bland structure into a source of great civic pride.

In a great many instances, a building's decorative elements were not designed by its architect. Countless commercial buildings, factories and shops across the United States have identical terracotta and bronze ornamental friezes, spandrels and entranceways, all stock items obtained from manufacturers such as the Northwestern Terra Cotta Company, the National Terra Cotta Society, and the Atlantic Terra Cotta Company. The American Brass Company offered 'limitless possibilities for the creation of original design by utilizing the 2313 shapes for which dies are maintained'. These decidedly Parisian shapes – stylized fountains, cloud patterns, sunbursts, tightly packed fields of flowers, and so on – could be mixed to produce an 'original' border. Most architects left the initial selection of decorative trim to their draftsmen.

170 McKenzie, Voorhees & Gmelin: façade over entrance, cast concrete, New York Telephone Company, West Street, between Barclay and Vesey Streets, New York, 1923–26

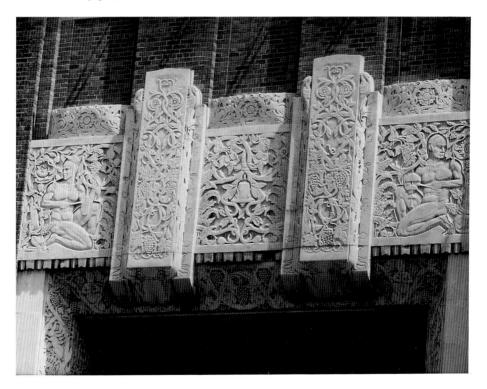

171 Unidentified architect: frieze, Health Department Building, corner Center and Worth Streets, New York

In the 1920s, architects began increasingly to turn from traditional building materials to newer materials – specifically metal and glass – which they found to be more in harmony with the new architecture. Science's most up-to-date building aid – steel – with its enormous tensile strength and brilliant sheen captured the modern imagination. In architecture, as in the decorative arts, the age of metal began to phase out the terracotta and stone age.

From 1925, Modernist architectural decoration slowly spread into every part of the United States. In small urban communities Manhattan-type skyscrapers (with their ornamentation) sprung up, despite protests from Frank Lloyd Wright and many others at the impracticality of positioning such huge structures in lightly populated areas. But there

were surprisingly few regional variants on the Art Deco style: the same Parisian sunbursts and chevrons are found on factory buildings in San Diego as on shops and banks in northern Michigan and Seattle. A rare example of a direct regional influence is provided by the KiMo Theatre in Albuquerque, New Mexico, which has a colourful terracotta frieze fusing Pueblo and Navajo motifs on a Spanish Mission-style building. Elsewhere, little effort was made to draw inspiration for Modernist decoration from local traditions. Only in southern Florida, and in particular Miami Beach, was there a consistent community style of identifiable modern architecture that set itself fully apart from New York.

The following nationwide survey of American Art Deco architectural ornamentation provides a summary of the movement's finest examples, beginning with the largest area of concentration, New York City.

In Manhattan, the New York Telephone Company was the first to align itself with Modernist architectural decoration. In 1923 it retained the firm of McKenzie, Voorhees & Gmelin (later, Voorhees, Gmelin & Walker) to design its corporate offices on the lower West side. The setback skyscraper building, now known as the Barclay-Vesey, was completed in 1926 and received considerable attention for its massing and ornamentation. These were thought at the time to be without any trace of historical influence and to be very modern and American, but to today's eyes the design looks distinctly Renaissance and its profuse application Victorian. A beige cast stone was chosen to offset the building's darker brick façade and a compact design of grape vines, fruit, plants and game covers every cornice, arch, window sill and lintel.

Not surprisingly, this design did not become the wellspring of a subsequent American architectural Modernist movement. The possibilities for a modern corporate style are more effectively suggested by the terrazzo mural panel in the lobby of the Telephone Company's later Newark building. There, stylized bolts of electricity radiate from Alfred E. Floegel's central figure, representing mankind's control of worldwide communications.

Ely Jacques Kahn established himself in the late 1920s both as a brilliant architect and as America's foremost exponent of Modernist architectural design. Kahn's importance lies in his distinctly individual Modernist style of decoration. It is impossible to mistake the interplay of geometric motifs which recur in his entrance lobbies, elevator doors and mailboxes, each a new rendering of a common angular theme. The Film Center, Squibb Building, Holland-Plaza Building, 2 Park Avenue,

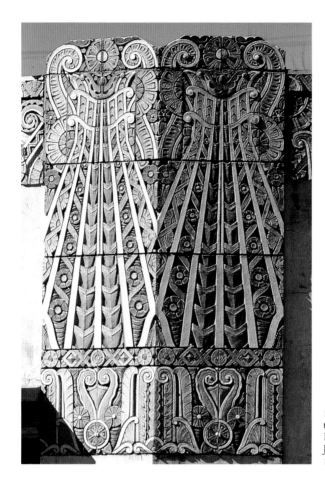

172 Ritter & Shay (architects): terracotta detail, National Bank Building, corner Market and Juniper Streets, Philadelphia, 1929 (photo Randy Juster)

the Lefcourt Clothing Center, 120 Wall Street, the Bricken Building, 111 John Street, and 1410 Broadway are all superb examples of his spectacular entrances and vestibules. The undeviating quality of Kahn's design is due partly to the fact that he worked for only two principal clients, both of whom allowed him freedom to develop his vigorous personal style.

Manhattan's most lavish Art Deco façade was constructed in 1929 by the architects Warren and Wetmore on the Stewart & Company Building on the East side of Fifth Avenue at 56th Street. Its monumental entrance, consisting of six doors, stood beneath a vast rectangular frieze flanked by two matching panels. The building housed a series of women's speciality shops and the decorative theme was lifted from

185

1920s Paris: stylized draped nudes bordered by tiered fountains, baskets of flowers, flights of birds, and so on. A combination of *repoussé* aluminium, polychromed faience and verdigris bronze brought the images sharply into low relief. This effect was heightened by the sun's rays, or, at night, by the rays of a lower row of concealed lights.

Eight months later, a faceless substitute had replaced the extravagant Stewart & Co. façade. The building had been bought by Bonwit Teller and, presumably to erase such a dominant image, they had retained Ely Jacques Kahn to redesign it.

If one building could be said to symbolize the romance of the period, it would of course be the exhilarating Chrysler Building designed by William Van Alen. For a brief moment in the early 1930s, it was Manhattan's tallest structure, towering over all others. Without its decoration, the Chrysler Building is typical of late 1920s commercial architecture. Its massing, studied use of fenestration as an element of design, and surface treatment are similar to many other buildings of the time. But its ornamentation makes it an Art Deco classic. The excitement lies primarily in the seven floors which make up the elongated dome, each of tiered arched form with triangular dormer windows encased in shimmering nickel chromed steel. Even in today's Manhattan, surrounded by taller buildings, the dome still draws the eye.

The eagle gargoyles at the corners of the setbacks on the 59th floor and the winged radiator caps at the 31st level give the building an impressive profile, although neither amounts to more than a decorative fillip to the dome. Van Alen's most striking feat of showmanship was of course the building's 27-ton steel spire, which pushed its height to 1,046 feet, beyond that of the Eiffel Tower. The spire, secretly assembled inside the building, was hoisted through the top aperture to the amazement of onlookers.

The Chrysler was soon overtaken by the Empire State Building, which rose on the West side of Fifth Avenue between 33rd and 34th Streets. William F. Lamb, of the firm of Shreve, Lamb & Harmon, presented sixteen plans to the consortium of owners before consensus was reached and a public announcement made on 30 August 1929. Within twenty-one months the building was complete, having grown at a rate of roughly four and a half storeys per week.

The building achieves more than just height. It is an immensely skillful piece of massing, dignified and serene, almost as much a natural wonder as a building, and one that passed quickly into popular folklore. It is not, though, as is generally believed, a classic Art Deco structure. Its Modernist ornamentation is restrained, even cautious,

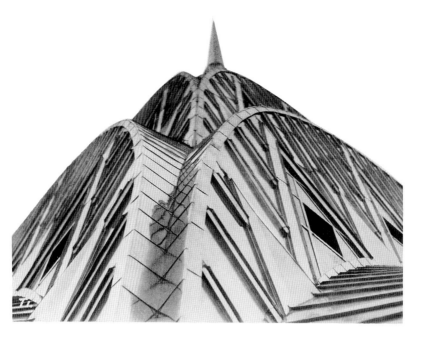

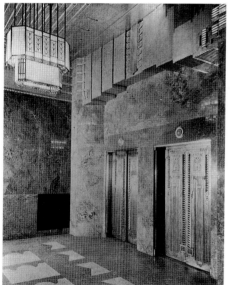 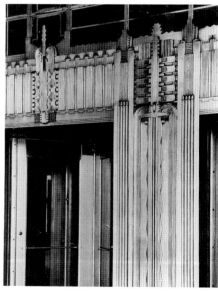

173–75 *Top* William van Alen (architect): view from the 67th floor to the spire of the Chrysler Building, 1046 ft (318.8m.) above Lexington Avenue at 42nd Street, New York, showing the construction of the stainless steel dome, 1930 (photo collection of David and Amy Stravitz). *Above left* Ely Jacques Kahn (architect): lobby, office building, S.E. corner 29th Street and Fifth Avenue, New York, *c.*1929 (photo Fischer archives, Museum of the City of New York). *Above right* Ely Jacques Kahn (Buchman & Kahn, architects): gilt-bronze detail, lobby, 2 Park Avenue, New York, *c.*1930 (photo courtesy of the Museum of the City of New York)

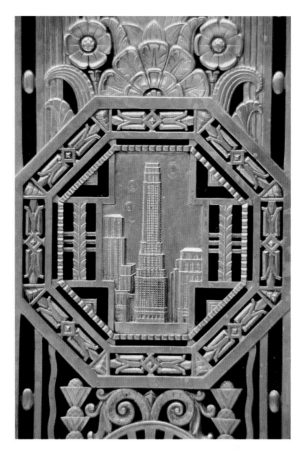

176 Cross & Cross
(architects): detail of
grille, City Bank
Farmers Trust
Building, Exchange
Place and William,
Hanover and Beaver
Streets, New York,
1929–31 (photo
Randy Juster)

both in the lobby and, on the exterior, in the selection of cast metal spandrels and overlapping fan-shaped motifs at each corner of the aluminium mast (intended as a dock for dirigibles to land their passengers on the upper observation platform), which crowns it. The architects' brief was entrepreneurial: a profit-making building whose size was carefully weighted against its optimum amount of rentable space. Ornamentation was not a priority, perhaps in part because it could not compete on a structure of such monumentality.

In the skyscraper which they designed at the time at 500 Fifth Avenue, Shreve, Lamb & Harmon were allowed far greater decorative latitude. A spirited French Modernism invests both the pair of stylized Parisian female figures which surmount the entrance, and the forceful geometric tracery in the vestibule (now replaced).

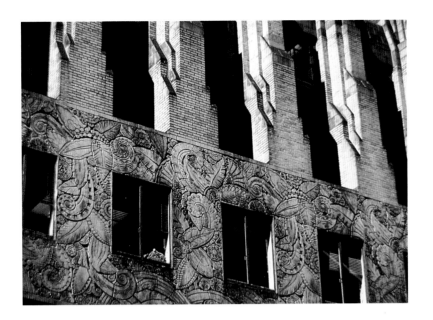

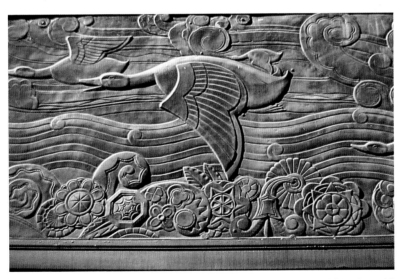

177, 178 *Top and above* Sloan & Robertson (architects), probably in collaboration with Jacques Delamarre: terracotta frieze and bronze frieze, Chanin Building, 42nd Street and Lexington Avenue, New York, 1927–29 (photos Randy Juster)

A rather more conservative range of contemporary French motifs ornamented the new Waldorf-Astoria Hotel (Schultze & Weaver, architects) on Park Avenue. The entrance frieze, by the French artist Louis Rigal, underwent several refinements before the final, more simple, version was chosen. The restrained Modernist theme continued in the public areas inside.

177, 178 The Chanin Building (Sloan & Robertson, architects), situated diagonally across Lexington Avenue from the Chrysler Building on 42nd Street, 'topped out' at fifty-four floors in just 205 days between 3 January and 8 August 1928. The façade of the lower four floors and the interior, decorated by the Chanin design department headed by Jacques L. Delamarre in collaboration with the sculptor René Chambellan, was based on the theme of the 'City of Opportunity'. Chambellan's bas-relief panels and radiator grilles in the building's lobby are perhaps the most impressive example there is of Modernist ornamentation.

Following his 1923 triumph in the Chicago Tribune Tower competition with John M. Howells, Raymond Hood turned his attention to a host of New York commissions, four of which bore distinct Modernist ornamentation. The first, the American Radiator Building at 40 West 40th Street, opposite Bryant Park, incorporated a bold black and gold brick colour scheme which emphasized the strong silhouette of the building's tower and craggy crown. Despite its lingering Gothicism, the building was hailed as a commercial breakthrough, in part because of the battery of floodlights which caused the crown to light up at night.

A more mature Hood is evident in the *Daily News* Building on East 42nd Street. Here, too, he seems well in touch with contemporary architecture, dressing what was to be simply a factory to house the *Daily News*'s printing plant in the fashionable modern idiom. In a simple, yet elegant, terraced structure, Hood emphasized height by the use of recessed vertical bands of windows and spandrels. The lobby was panelled dramatically in black glass with a recessed central globe.

For the McGraw-Hill Building (1930), Hood, now in partnership with André Fouilhoux, borrowed a technique that Walter Gropius had used in his Pagus factory twenty years earlier, creating a horizontal emphasis by the use of lateral windows. The McGraw-Hill Building brought Hood full circle from the historicism of the Chicago Tribune Tower and the American Radiator Building, through the Modernism of the *Daily News* Building, to a modified version of the International Style. Only his use of colour, and the publisher's name in bold capital lettering along the crown set the slab-shaped building fully apart from the Internationalists.

The fourth significant Modernist project from this versatile architect was Rockefeller Center, which Hood and Fouilhoux shared with two other architectural firms: Morris, Reinhard & Hofmeister; and Corbett, Harrison & MacMurray. Hood's main contribution was the final draft of the Center's focal point, the 70-storey RCA Building, in which he pared down the simple slab proposed by Reinhard and Hofmeister into a series of graceful, knife-edged and, in this case, since no zoning requirements needed to be met, purely decorative setbacks.

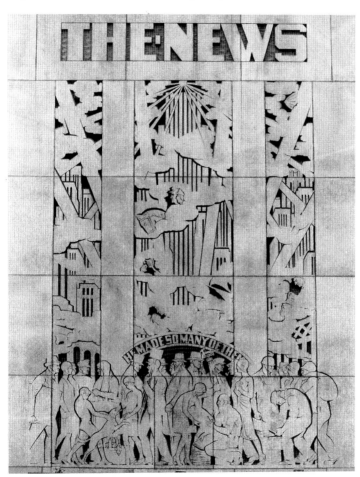

179 Raymond M. Hood and John Mead Howells (architects): façade of the *Daily News* Building, 220 East 42nd Street at 2nd Avenue, New York, 1929–30 (photo Randy Juster)

For the Art Deco enthusiast, Rockefeller Center provides a treasure-house of 1930s Modernist oramentation, including bronze sculptural friezes by Alfred Janniot and Paul Jennewein; bronze statuary by René Chambellan and Paul Manship (including the latter's 'Prometheus'); and work by Lee Lawrie, Leo Friedlander and Hildreth Meiere. The Center's interior decoration is dominated by Radio City Music Hall, coordinated by Donald Deskey. Here, too, are works by the period's foremost avant-garde artists: Witold Gordon, Louis Bouché, William Zorach, Ruth Reeves, Stuart Davis, Yasuo Kuniyoshi, Edward Buk Ulreich, Henry Varnum Poor, Henry Billings, Ezra Winter and, most importantly, Donald Deskey himself.

Just south of Rockefeller Center, New York's most exuberant Modernist decoration is to be found in the little-known Goelet Building (now the Swiss Center Building) at 608 Fifth Avenue. The original unabashedly French Art Deco entrance lintel has now gone, but the lobby and lift cages survive.

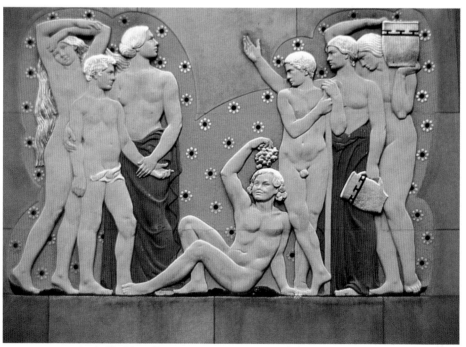

180 Attilio Piccirilli: 'The Joy of Life', polychromed limestone panel, One Rockefeller Plaza Building, 15 West 48th Street entrance, Rockefeller Center, New York, 1937 (photo Randy Juster)

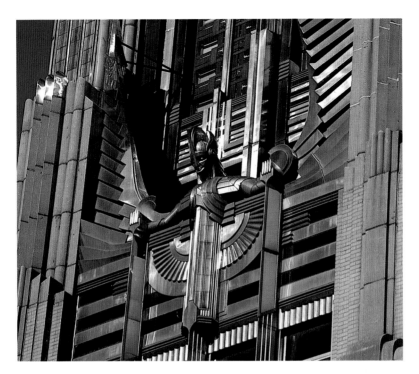

181 Bley & Lyman (architects): 'Spirit of Light', stainless steel figure on the front façade of the Niagara Mohawk Power Corporation Building, 28ft (8.5m) high (photo Niagara Mohawk Power Corporation)

Upstate New York boasts one major Art Deco monument, the Niagara Mohawk Building in Syracuse (Bley & Lyman, architects), 181, 182 inaugurated in 1932. Its exterior incorporates the entire Modernist vernacular: a symmetrical ziggurat form terminating in a stepped tower, a façade sheathed in sharply contrasting materials (brick ornamented with stainless steel and black glass), a strong sense of verticality throughout, all rounded off with an arresting sculptural figure which surmounts the entrance. The interior decoration is limited largely to the lobby.

In Los Angeles, the finest building in the Art Deco style used to be the Richfield Oil Building (known now as the Atlantic Richfield Building) 183, 184 at 6th and Flower Streets. Begun in 1928 by Morgan, Walls & Clements, the 13-storey structure was surmounted by a double setback tower, itself topped by a 130-foot Beacon Tower. The building's novel aesthetic impact lay in its sheath of glazed black terracotta intersected by vertical terracotta gold ribbing. A band of gold winged figures along

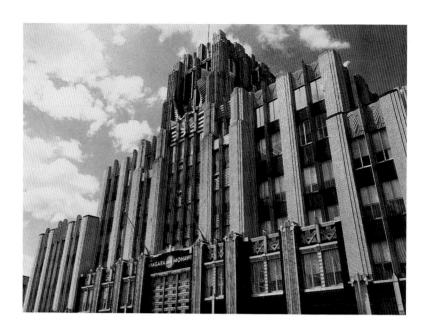

182–84 *Opposite, top* Bley & Lyman (architects): Niagara Mohawk Power Corporation, 300 Erie Boulevard, West Syracuse, 1930–32 (photo Niagara Mohawk Power Corporation). *Below left* Morgan, Walls & Clements (architects): entrance, Richfield Oil Company Building, with terracotta figures by Haig Patigian. *Right* Morgan, Walls & Clements (architects): Richfield Oil Company Building, Los Angeles, glazed black and gold terracotta tiling, 1928–29 (demolished 1968)

185 S. Charles Lee (architect): aluminium front entrance and ticket booth, Wiltern Theatre, 8440 Wilshire Boulevard, Los Angeles, 1929–31

the parapet, symbolizing motive power, by the sculptor Haig Patigian, and a matching stepped frieze above the entrance rounded off the contrasting and opulent effect. In the lobby a bank of decorated bronze elevators alternated with Belgian black marble walls trimmed in Cardiff green under a colourful ceiling composition.

In the late 1960s the original structure was replaced by a pair of 52-storey towers (one for the Atlantic Richfield Company, the other for the Bank of America). Some of the original decoration, such as the elevator doors, is now installed at the foot of the new buildings.

Los Angeles's other Art Deco masterpieces can be divided into two broad categories: the 'zigzag moderne' of the 1920s and the 'streamline moderne' of the 1930s. The former covers the modern, largely vertical, building with setbacks, which had originated on the East Coast; the latter a horizontal structure with rounded corners and curved projecting wings and parapets, to which glass bricks and portholes were often added to give an increased sense of movement and aerodynamics.

Notable zigzag moderne structures include the Los Angeles City Hall, the Central Library, the Selig Retail Store, the Eastern-Columbia Building, the Pantages and Wiltern Theatres (discussed below), the Guaranty and Loan Association Buildings, the Oviatt Building, and the Bullocks Wilshire department store. The last two took their inspiration

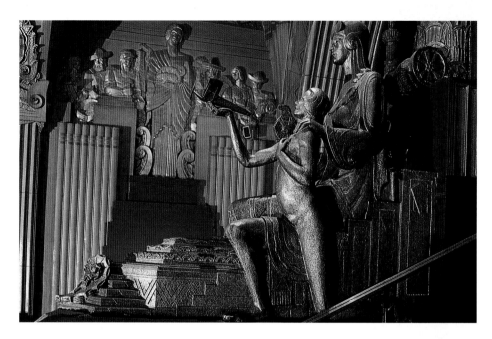

186, 187 *Above* B. Marcus Priteca
(architect): side view of auditorium,
Pantages Theatre, Los Angeles, 1929–30.
Right Façade, black and silver terracotta,
Florist Shop, Oakland, California

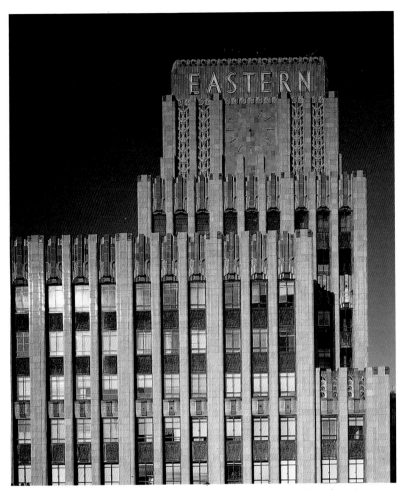

188 Claude Beelman (architect): Eastern Columbia Building, 849 S. Broadway, Los Angeles; glazed aquamarine and gold terracotta tiling with recessed copper spandrels, 1930 (photo Randall Michelson)

directly from Paris. The Oviatt Building, erected in 1928, is notable for its decoration by René Lalique and the decorating firm of Saddier et fils. Lalique is responsible for the designs for the entrance lobby – grill work, elevator doors, mailbox and an illuminated glass ceiling. The decoration of the Bullocks Wilshire department store is the work of both American and European artists. It has survived in its original condition and provides today's historian with a rare encyclopedic record of 1920s avant-garde art.

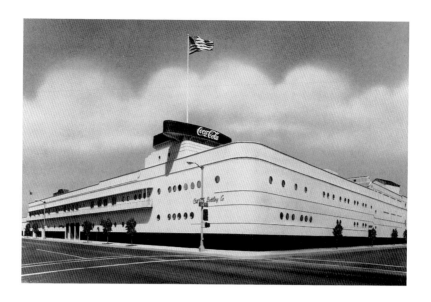

Examples of 1930s streamline moderne in Los Angeles include the Pan-Pacific Auditorium, the Coca-Cola Bottling Company Plant, the California Petroleum Service Station (on Wilshire Boulevard) and a host of now forgotten roadside diners. The Union Railroad Terminal provides an unusual blend of streamlined modernism with Spanish Colonialism.

In San Francisco, Modernism's most gifted disciple was Timothy L. Pflueger, of the firm of J.R. Miller & T.L. Pflueger. Although, in the Medical and Dental Building at 450 Sutter Street, Pflueger's choice of a stylized Mayan theme of decoration may seem inappropriate today, it was unremarked at the time. More newsworthy was his use of broad bands of incised hieroglyphics to span the building between its rows of windows. These give the effect of a huge tapestry. The theme was repeated in the entrance and lobby in golden brown tones.

Pflueger also designed the Luncheon Club in the San Francisco Stock Exchange, but this time the effect was strongly Parisian: furniture and pilasters, incorporating broad reeded supports and capitals terminating in scrolls, were reminiscent of certain earlier pieces by Süe et Mare. Pflueger's most celebrated architectural achievement, however, was the Oakland Paramount Theatre, which he designed for Paramount-Publix, a giant studio-theatre chain, and which matched, in its scale and spendour, any movie palace built.

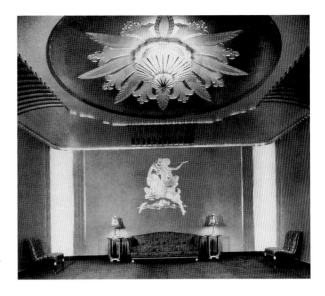

189 Robert V. Derrah
(architect): the Coca-Cola
Bottling Company Plant, 1334
S. Central Avenue, Los Angeles,
1936

190 Timothy L. Pflueger
(architect): women's lounge,
lower level, Oakland Paramount
Theatre, 2025 Broadway,
Oakland, 1931 (photo Library of
Congress, Washington, D.C.)

In Chicago, the leading practitioners of the Art Deco style were John A. Holabird and John Wellborn Root, Jr., who broke with Chicago's Beaux-Arts and Gothic classicism and dressed a number of buildings between 1928 and 1930 in Modernist ornamentation, including the Palmolive Building, 333 North Michigan, the *Chicago Daily News* Building, the Chicago Board of Trade Building and the Michigan Square Building.

Directly across the Chicago River from the *Daily News* Building is the 44-storey Chicago Civic Opera Building, completed by the firm of Graham, Anderson, Probst & White in 1929. The exterior is decorated at the setbacks with rows of circular windows and balustrades. Elsewhere, the façade is decorated with charming pairs of stylized theatrical masks depicting 'Comedy' and 'Tragedy'.

America's premier Art Deco bank building is unquestionably the new Union Trust Building in Detroit, designed by Wirt Rowland. The theme and scale of its Modernist decoration fully justified the name it acquired when it opened in 1929, the 'Cathedral of Finance'. The Union Trust Company, a new banking group, gave Rowland broad latitude to develop a decorative theme which would project for the bank a concerned and public-spirited image. Rowland took up the challenge, decorating the front door with a central figure symbolizing progress, flanked by three medallions representing agriculture, transportation and industry.

191

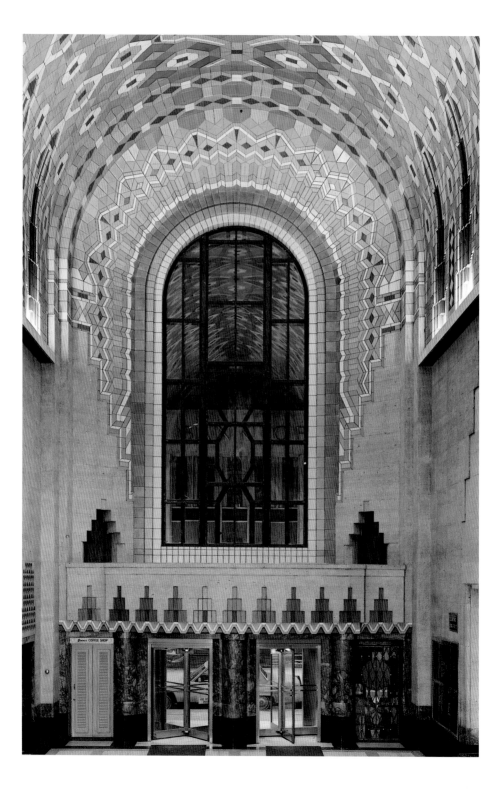

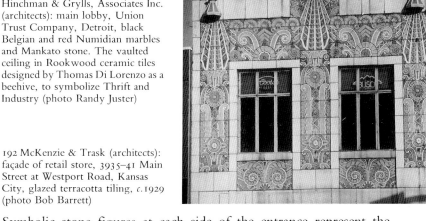

191 *Opposite* Wirt Rowland, in collaboration with Smith, Hinchman & Grylls, Associates Inc. (architects): main lobby, Union Trust Company, Detroit, black Belgian and red Numidian marbles and Mankato stone. The vaulted ceiling in Rookwood ceramic tiles designed by Thomas Di Lorenzo as a beehive, to symbolize Thrift and Industry (photo Randy Juster)

192 McKenzie & Trask (architects): façade of retail store, 3935–41 Main Street at Westport Road, Kansas City, glazed terracotta tiling, *c.*1929 (photo Bob Barrett)

Symbolic stone figures at each side of the entrance represent the banking institution's power, and its security (which was not to last). The arch above the side entrance continued the theme with a tiled beehive (to symbolize thrift and industry), an eagle (representing money), and a caduceus (representing authority and commerce).

The main lobby's vast vaulted ceiling repeated the beehive theme in bright Rookwood ceramic tiles. A combination of imported Travertine marble columns, Mankato stone, Belgian black marble and red Numidian marble walls produced a kaleidoscopic effect, set off by the glistening Monel metal elevator doors, check desks and trim.

Despite the stock market crash, later financial vicissitudes, and transfers of ownership – most of which entailed remodelling of the building's upper floors – the exterior and lower floors have remained relatively unchanged. Its admirers consider the building's rich imagery to surpass even that of the Chrysler Building.

Until very recently, Kansas City has been America's unheralded Art Deco mecca. Unlike other Midwestern cities, such as the fundamentally nineteenth-century St. Louis, Kansas City underwent a building boom in the 1920/30s. The parking garages, apartment houses and commercial and municipal buildings that went up at that time are still well preserved. Most outstanding is the Kansas City Power and Light Co. Building, which has retained its spectacular illuminated tower and almost all the metalware in its lobby. The city has also been particularly lucky in the scores of glazed terracotta friezes which still adorn its commercial buildings.

Two buildings erected at the same time in Cincinnati have fared less well. One, the Union Terminal, designed by Fellheimer & Wagner, is today a makeshift shopping arcade, but its exterior still has an ascetic grandeur that touches on the International Style, and the interior has kept its tea room panelled in ceramic tiles from the local Rookwood Pottery, its mosaic mural by Winold Reiss, its terrazzo floors, and its women's lounge adorned with tooled leather walls by Jean Bourdelle. Machine Age chromed furnishings and accessories rounded off the sparkling moderne look.

The other, the Starrett Netherland Plaza Hotel, was part of the Carew Tower, designed by Walter Ahlschlager of Chicago, and Delano & Aldrich, associate architects from New York, and shared its block-long quarters with two large department stores, a garage, a restaurant and business offices. The hotel's interior, recently restored, is eclectic in its choice of styles, but Art Deco predominates among Beaux-Arts,

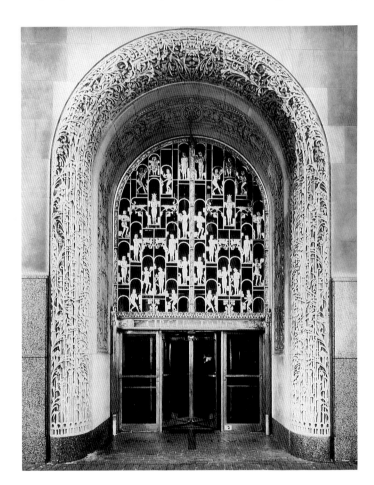

193 Rubush & Hunter (architects): entrance, Circle Tower Building, 5 East Market, Indianapolis; carved limestone with bronze doors, 1929–30 (photo Randy Juster)

rococo and Egyptian Revival themes. The Art Deco decoration relies heavily on 1925 Paris; designs by Edgar Brandt, in particular, are repeated in balustrades, chandeliers and the moulded borders on the rococo-style ceiling murals. The Continental Room, the Hall of Mirrors and the Palm Court, the last-mentioned with sea-horse torchères and a fountain in Rookwood Pottery, self-consciously reproduces art moderne.

The Circle Tower in Indianapolis (1929-30) is another gem of Midwest Art Deco, its stepped pyramid shape conforming to the city's 1922 zoning law. A profusion of carved botanical motifs adorns its limestone entrance frieze, including bellflowers, vines and sunflowers, surrounding a pierced bronze overdoor cast with a stylized Egyptian scene of pharaohs, courtiers and beasts. Inside the lobby the same elaboration continues. Bronze elevator doors, plaques, screens and reliefs, all Art Deco, contrast with alternating gold-veined black marble and plain black marble walls and a floor adorned with grey-green, cream and black terrazzo chevrons.

South of Kansas City, Tulsa boasted a number of notable Art Deco buildings. The 7-storey Halliburton-Abbott department store building, also known as the Skaggs Building (Frank C. Walter, 1929) – recently demolished – incorporated along its cornice a brightly coloured band of scrolled foliate panels in terracotta by the Northwestern Terra Cotta Company. Inside, plaster mouldings repeated the stylized Parisian theme. The Gillette-Tyrell (Edward W. Saunders, architect) was another Tulsa building at the time to be clothed in modern French terracotta and plaster ornament. Many otherwise nondescript store fronts and factories were lent colour and interest by a range of Art Deco motifs.

The most consistent display of Art Deco architecture in the United States is to be found in Miami Beach, an island paradise for those working-class people who could not meet the prices and exclusivity of its northern neighbour, Palm Beach. Here a new style of architecture appeared, one that tried to unite the Modernist vision with the fanciful colours and idiosyncrasies of the subtropics. It was a distinctly regional architecture, confined roughly to a square mile in south Miami Beach between 5th and 23rd Streets, a small enclave of holiday hotels and winter homes. They were generally of the same height (none exceed twelve or thirteen stories), and the basic elements recurred in various combinations from street to street: crisply streamlined, horizontal lines intersected in the centre by a series of strong verticals culminating in a Buck Rogers-type finned tower or cupola. A marvellous range of subtropical pastels – white stucco alternating with pink, green, peach and lavender façades or trim provided diversity. Windows were etched

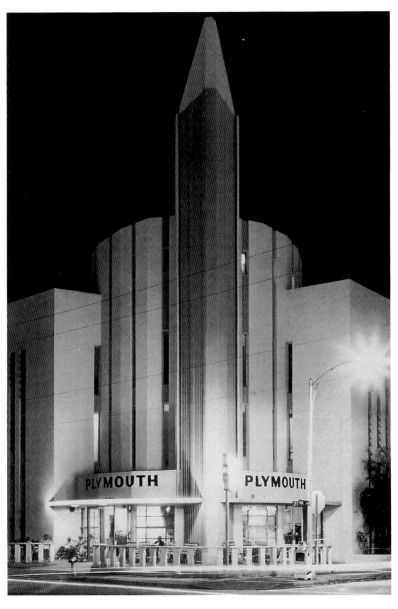

194 Anton Skislewicz (architect): Plymouth Hotel, 336 21st Street, Miami Beach, 1940 (photo Randy Juster)

with flamingoes, herons, seashells, palms and, most significant of all, sunbursts. Neon lighting and flagstaffs completed the effect.

Cinemas – 'movie palaces' as they were termed in the 1920s – gave most of the American population their only first-hand experience of the modern style. The glittering theatres that arose across the nation were a glamorous consolation for life's daily grind. Here, cradled in the most lavish and exotic surroundings conceivable, one could retreat for an hour into a fantasy world with one's matinée idol on the silver screen. Entire buildings – façades, marquees, entrance vestibules, lobbies and auditoria – were transformed into palatial fairylands.

At first, the arrival of the Modernist idiom, based on the prevailing French Art Deco 'high style', simply meant that there was another choice in this decorative vernacular. In time it became the standard cinema style, partly because it was modern, but equally because it was lavish. Impresarios such as Marcus B. Priteca and S.L. ('Roxy') Rothafel commissioned theatres in which every available inch was crammed with Modernist Parisian motifs – chevrons, tiered fountains, bouquets of summer flowers, sunbursts, and so forth. Among the most spectacular were the Pantages and Wiltern, both in Los Angeles, and the Paramount in Oakland, all recently restored to their original splendour. Equally exuberant were the Uptown Theatre, Philadelphia, and the Fox Detroit Theatre, Detroit. Less gaudy examples included the State Theatre, Philadelphia; the Pickwick Theatre, Park Ridge, Illinois; the Paramount in Aurora, Illinois; the Fox in Brooklyn; the Avalon, Catalina Island, California; and the St George Playhouse, Brooklyn.

By the 1930s a more streamlined modern theatre design had emerged. The new theory was that the screen should be the only focal point, its flanking ornamentation, if any, orchestrated largely by clever colour lighting effects. The Art Deco excesses of the Pantages Theatre were out of fashion now. Decoration became more restrained. Emphasis was placed increasingly on curvilinear forms, as exemplified by the stepped contours of the auditorium in Radio City Music Hall and, ultimately, the bold sweep of Eberson's Colony Theatre in Cleveland. Other fine examples of streamlined theatre design included the Earl Carroll Theatre, New York, the Trans-Lux in Washington, D.C., the Cape Cinema, Dennis, Mass., and the Chanin Building auditorium (all now demolished). Black glass, mirror and chromium-plated sheet metal panelling expressed the new mood.

Bibliography

BOOKS (General)

Battersby, Martin, *The Decorative Twenties*, London, 1969

Brunhammer, Yvonne, *Le Style 1925*, Paris, 1925

Bush, Donald J., *The Streamlined Decade*, New York, 1975

Cheney, Sheldon, and Cheney, Martha Candler, *Art and the Machine: An Account of Industrial Design in 20th Century America*, New York, 1936

Drexler, Arthur, and Daniel, Greta, *Introduction of Twentieth Century Design from the Collection of the Museum of Modern Art*, New York, 1959

Dreyfuss, Henry, *Industrial Design*, Vol.5, New York, 1957

Duncan, Alastair, *American Art Deco*, London, 1986

Encyclopédie des arts décoratifs et industriels modernes au XXème siècle en douze volumes, Paris, 1925

Frankl, Paul T., *Form and Re-Form*, New York, 1930

Garner, Philippe, *The Encyclopedia of Decorative Arts 1890–1940*, New York, 1978

Greif, Martin, *Depression Modern: The Thirties Style in America*, New York, 1975

Hanks, David A., *Donald Deskey*, New York, 1986

Hennessey, William J., *Russell Wright: American Designer*, Hamilton, Ontario, 1983

Herbst, René, *25 Années: Union des Arts Modernes*, Paris, 1955

Hillier, Bevis, *Art Deco*, London, 1968

Hitchcock, Henry-Russell, and Johnson, Philip, *The International Style*, New York and London, 1966

Janneau, Guillaume, and Benoist, Luc, *L'Exposition internationale des arts décoratifs et industriels modernes*, Paris, 1925

Klein, Dan, *Art Deco*, London, 1974

——, and Bishop, Margaret, *Decorative Art 1880–1980*, Oxford, 1986

Lesieutre, Alain, *The Spirit and Splendour of Art Deco*, London, 1975

McClinton, K. M., *Art Deco: A Guide for Collectors*, New York, 1972

Maenz, Paul, *Art Deco 1920–1940*, Cologne, 1974

Meikle, Jeffrey L., *Twentieth Century Limited: Industrial Design in America 1925–1939*, Philadelphia, Pa., 1979

Pevsner, Nikolaus, *Pioneers of Modern Design from William Morris to Walter Gropius*, New York, 1949; Harmondsworth, Middx, 1960

Read, Herbert, *Art and Industry: The Principles of Industrial Design*, London, 1953; New York, 1954

World of Art Deco, The, London, 1971 (catalogue of exhibition at Minneapolis Institute of Arts)

EXHIBITION CATALOGUES (General)

Brave New Worlds: America's Futurist Vision, The Mitchell Wolfson, Jr., Collection of Decorative and Propaganda Arts, Miami-Dade Community College, Mitchell Wolfson New World Center Campus, Miami, Fla., 1984

Carved and Modeled American Sculpture: 1880–1940, Hirschl and Adler Galleries, New York, 20 April – 4 June 1982

Davies, Karen, *At Home in Manhattan: Modern Decorative Arts 1925 to the Depression*, Yale University Art Gallery, New Haven, Conn., 1983

Design in America: The Cranbrook Vision: 1925–1950, The Detroit Institute of Arts and The Metropolitan Museum of Art, New York, 14 December 1983 – 17 June 1984

Machine Art, The Museum of Modern Art, New York, 6 March – 30 April 1934

Marter, Joan M., and Co., *Vanguard American Sculpture 1913–1939*, Travelling Exhibition, Rutgers State University Art Gallery, Rutgers, N.J., 16 September 1979 – 25 May 1980

Perreault, John, *Streamline Design: How the Future Was, The*

Queens Museum, New York, 28 January – 6 May 1984

Reynolds, Gary A., *American Bronze Sculpture: 1850 to the Present*, Newark Museum, Newark, N.J., 18 October 1984 – 3 February 1985

Wilson, Richard Guy; Pilgrim, Dianne H.; and Tashjian, Dickran, *The Machine Age 1918–1941*, The Brooklyn Museum, 17 October 1986 – 16 February 1987

PERIODICALS (General)

American Architect, The, 1925–38

American Magazine of Art, The, 1920–39

Architectural Forum, 1920–40

Architectural Record, 1913–36

Architecture, 1925–36

Art and Architecture, 1925–36

Art and Industry, 1936–40

Art Décoratif, L', 1920–35

Art et Décoration, 1918–35

Art Digest, The, 1926–39

Art et Industrie, 1920–34

Arts, The, 1920–31

Arts and Decoration, 1924–39

Commercial Art and Industry, 1932–35

Creative Art, 1927–33

Dekorative Kunst, 1920–35

Design, 1920–40

Echos d'Art, Les, 1925–30

House and Garden, 1920–37

House Beautiful, 1927–39

Interior Design and Decoration, 1934–36

International Studio, The, 1925–28

Mobilier et Décoration, 1920–39

Pencil Points, 1925–33

Studio, The, 1920–35

Studio Yearbook, The, 1920–37

Vogue, 1925–29

1 FURNITURE

Badovici, Jean, *Intérieurs français*, Paris, n.d.

Bujon, Guy, and Dutko, Jean-Jacques, *Printz*, Paris, 1986

Camard, Florence, *Ruhlmann: Master of Art Deco*, New York, 1983

Clouzot, Henri, *Le Style moderne dans la décoration intérieure*, Paris, 1921

Delacroix, Henry, *Intérieurs*

modernes, Paris, n.d.
Deshairs, Léon, *L'Art
décoratif français 1918–1925*,
London and Paris, 1926
———, *Intérieurs en couleurs
France* (Exposition des Arts
Décoratifs, Paris, 1925),
Paris, 1926
Duncan, Alastair, *Art Deco
Furniture*, London and
New York, 1984
Ensembles mobiliers
(Exposition Internationale
des Arts Décoratifs et
Industriels Modernes,
Paris, 1925) 3 vols., Paris
1925–1927
*Jean-Michel Frank, Adolphe
Chanaux*, Editions du
Regard, Paris, 1980
Kjellberg, Pierre, *Art Deco:
Les Maîtres du mobilier*,
Paris, 1981
Mannoni, Edith, and Bizot,
Chantal, *Mobilier 1900–1925*,
Paris, n.d.
Moussinac, Léon, *Le Meuble
français moderne*, Paris 1925
Olmer, Pierre, *Le Mobilier
français d'aujourd'hui
(1910–1925)*, Paris, 1926
———, and Bouche-Leckerq,
*L'Art décoratif français en
1929*, Paris, 1929
Petit Meubles du jour, Paris,
1929
Pierre Chareau, edition of the
Salon des Arts Ménagers,
U.A.M., Paris, 1954
Rapin, Henri, *Intérieurs
présentés au Salon des
Artistes Décorateurs*,
Paris, 1930
Riotor, Léon, *Paul Follot*,
Paris, 1923
Selvafolta, Ornello di, *Il
Mobile del Novecento*,
Milan, 1985
Sironen, Marta K., *History
of American Furniture*,
East Stroudsberg, Pa., 1936
Vellay, Marc, and Frampton,
Kenneth, *Pierre Chareau,
Architect and Craftsman*,
London and New York, 1985

Exhibition Catalogues
Foulk Lewis Collection,
*Ruhlmann Centenary
Exhibition*, 1979
Meubles et objets

*d'architecture dans les
années 1925*, Galerie Maria
de Beyrie, 19 November – 31
December 1976
Ostergard, Derek E.,
*Mackintosh to Mollino:
Fifty Years of Chair
Design*, Barry Friedman
Ltd, New York, 1984
Retrospective Ruhlmann,
Musée des Arts Décoratifs,
Paris, 1934

Periodical
Good Furniture, 1920–30

2 TEXTILES
Benoist, Luc, *Les Tissus, la
tapisserie, les tapis*, Paris, 1926
Delaunay, Sonia, *Tapis et tissus*,
Paris, 1931
Magne, Henri Marcel, *Décor du
tissu*, Paris, 1933
Moussinac, Léon, *Etoffes
d'ameublement tissées et brochées*,
Paris, 1926
Rambosson, Ivanhoe, *Les Batiks
de Madame Pangon*, Paris, 1925
Verneuil, M. Pillard, *Etoffes et
tapis étrangers exposés au Musée
des Arts Décoratifs*, Paris, 1925

3 IRONWORK AND LIGHTING
Clouzot, H., *La Férronnerie
moderne*, series 1, 3–4, Paris,
1923
Duncan, Alastair, *Art
Nouveau and Art Deco
Lighting*, London, 1983
Henriot, Gabriel, *La
Férronnerie moderne*, Paris,
1923
———, *Luminaire moderne*,
Paris, 1937
———, *Férronnerie du jour*,
Paris, 1929
Janneau, Guillaume, *Le fer,
ouvrages de férronnerie et
de sérrurie dus à des
artisans contemporains*,
Paris, 1924
Pinsard, Pierre, *Meubles
modernes en métal*,
(Librairie des Artistes
Décorateur) Paris, n.d.
Poillerat, Gilbert,
Férronnerie d'aujourd'hui,
Paris, n.d.
Regamey, Raymond, *Le

Férronnier d'art Edgar
Brandt*, (Archives Alsaciennes
d'Histoire de l'Art),
Strasbourg, 1924

Periodical
Le Luminaire (Exposition
internationale des arts
décoratifs et industriels
modernes, 1925), 4th series,
Paris, 1926–31

4 SILVER, LACQUER AND
METALWARE
Bouilhet, Tony, *L'Orfèvrerie
française au XX siècle*, Paris,
1941
Carpenter, Charles H., Jr.
Gorham Silver 1831–1981, New
York, 1982
Darling, Sharon S., *Chicago
Metalsmiths*, Chicago, 1977
De Bonneville, Françoise, *Jean
Puiforcat*, Paris, 1986
Herbst, René, *Jean Puiforcat,
orfèvre, sculpteur*, Paris, 1951
Hughes, Graham, *Modern Silver
throughout the World,
1880–1967*, London, 1967
Koch, Gladys, and Roas,
Thomas, M., *Chase Chrome*,
Stamford, Conn., 1978
Lorac-Gerbaud, Andrée, *L'Art du
laque*, Paris, 1974
Pinsard, Pierre, *Meubles modernes
en métal*, (Librairie des Artistes)
Paris, n.d.
Prouve, Jean, *Le Métal*, Paris,
1929

Exhibition Catalogues
Jean Dunand, de Lorenzo Gallery,
New York, 1985
Jean Dunand, Jean Goulden,
Galérie de Luxembourg, Paris,
1973

Periodical
Kaleidoscope, The, April
1928-January 1933
Metal Arts, 1928–30

5 GLASS
Arwas, Victor, *Glass: Art
Nouveau to Art Deco*, London
and New York, 1977
Barillet, Louis, *Le Verre*, Paris,
n.d.

Florence, Gene, *The Collector's Encyclopedia of Depression Glass*, Paducak, Kentucky, 1977

Gardner, Paul V., *The Glass of Frederick Carder*, New York, 1971

Geffroy, Gustave, *René Lalique*, Paris, 1922

Janneau, Guillaume, *Modern Glass*, London, 1931

Klein, *The History of Modern Glass*, London, 1984

Mourey, Gabriel, *Catalogue des verreries de René Lalique*, Paris, 1932

Neuwirth, Waltraud, *Glass 1905–1925: From Art Nouveau to Art Deco*, Vienna, 1985

Paulsson, Gregor (ed.), *Modernt Svenskt Glas*, Stockholm, 1943

Perrot, Paul N.; Gardner, Paul V.; and Plaut, James S., *Steuben: Seventy Years of American Glassmaking*, New York, 1974

Plaut, James S., *Steuben Glass* (Monographs on American Arts and Crafts, Volume 1), New York, 2nd edition, 1951

Polak, Ada, *Modern Glass*, London, 1962

Rosenthal, Léon, *La Verrerie française depuis cinquante ans*, Paris and Brussels, 1927

Exhibition Catalogues

Fifty Years on Fifth: A Retrospective Exhibition of Steuben Glass, Steuben Glass, New York, 1984

Gardner, Paul V., *Frederick Carder: Portrait of a Glassmaker*, The Corning Museum of Glass, Corning, New York, 20 April – 20 October 1985

Opalescence: La Verre moule des années 1920-1930, Banque Bruxelles-Lambert, 15 October – 29 November 1986

Perrot, Paul N., and Co., *Steuben: Seventy Years of American Glass Making*, Travelling Exhibition, Toledo, Ohio, 1974

6 CERAMICS

Dietz, Ulysses G., *The Newark Museum Collection of American Art Pottery*, Newark, N. J., 1984

Fare, Michel, *La Céramique contemporaine*, Paris, 1953

Fontaine, Georges, *La Céramique française*, Paris, 1946

Giacomotti, Jeanne, *La Céramique*, Paris 1933–35

Haggar, Reginald G., *Recent Ceramic Sculpture in Great Britain*, London, 1946

Janneau, Guillaume, *Emile Decoeur, céramiste*, Paris, 1923

LeChevallier-Chevignard, Georges, *Verriers et céramistes*, Paris, 1932

Mourey, Gabriel, *La Manufacture royale de porcelaine de Copenhague à l'Exposition Internationale des Arts Décoratifs*, Paris, 1925

Préaud, Tamara, and Gauthier, Sergé, *Ceramics of the 20th Century*, New York, 1982

Valotaire, Marcel, *La Céramique française moderne*, Paris and Brussels, 1930

Exhibition catalogues

Anderson, Ross, and Perry, Barbara, *The Diversions of Keramos 1925–1950*, Everson Museum of Art, 9 September – 27 November 1983

Bordeaux Art Deco, Musée des Arts Décoratifs de la Ville de Bordeaux, 28 May – 10 July 1979

Céramiques de René Buthaud, Musée des Arts Décoratifs de la Ville de Bordeaux, 1979

Darling, Sharon S., *Decorative and Architectural Arts in Chicago 1871–1933*, an illustrated guide to the Ceramic Historical Society, Chicago, 1982

Heuser, Hans-Jorgen, *Französische Keramikkunstler um 1925*, Museum für Kunst und Gewerbe, Hamburg, 25 March –22 May 1977

Keen, Kirsten Hoving, *American Art Pottery 1875–1930*, Delaware Art Museum, Wilmington, Delaware, 10 March – 23 April 1978

7 SCULPTURE

Arwas, Victor, *Art Deco Sculpture: Chryselephantine Statuettes of the Twenties and Thirties*, New York, 1975

Catley, Bryan, *Art Deco and Other Figures*, London, 1978

Gamzu, Chaim, et al., *Chana Orloff*, Paris, 1980

Gorham Company, Bronze Division, The, *Famous Small Bronzes*, New York, 1928

Karshan, Donald, *Csaky*, Paris, 1973

Kramer, Hilton, *The Sculpture of Gaston Lachaise*, New York, 1967

Mackay, James, *The Dictionary of Western Sculptors in Bronze*, Suffolk, England, 1977

Opitz, Glenn B. (ed.), *Dictionary of American Sculptors: 18th Century to the Present*, Poughkeepsie, New York, 1984

Parmelin, Hélène, et al., *Bela Voros*, Corvina, Budapest, Hungary, 1972

Proske, Beatrice Gilman, *Brookgreen Gardens Sculpture*, Brookgreen Gardens, S. C., revised edition, 1968

Read, Herbert, *A Concise History of Modern Sculpture*, London and New York, 1964

Magazine Article

Marcilhac, Félix, 'Joseph Csaky: A Pioneer of Modern Sculpture,' *The Connoisseur Magazine* (May 1974): 10–17

Exhibition Catalogues

Bush, Martin H., *Boris Lovet-Lorski: The Language of Time*, The School of Art, New York University, Syracuse, April 27 – May 26, 1967

Chana Orloff, The Montgomery Gallery, San Francisco, 1983

Chauvin: Sculptures, L'Enseigne du Cerceau, Paris, October, 1974

Collection Karl Lagerfeld: Art Deco, A. Godeau & P.E. Audap, Hôtel Drouot, Paris, 21 November 1975

Fauns and Fountains: American Garden Statuary, 1890–1930, The Parrish Art Museum, Southampton, New York, 14 April – 2 June 1985

Frackman, Noel, *John Storrs*, Whitney Museum of American Art, New York, 11 December 1986 – 22 March 1987

Gustave Miklos: Exposition Rétrospective, Centre Cultural Aragon, Ville d'Oyonax, 20 December 1983 – 29 January, 1984
Gustave Miklos, Sculpteur: 1888–1967, L'Enseigne du Cerceau, Paris, 25 October – 30 November 1973
Paul Manship: Changing Taste in America, Minnesota Museum of Art, 19 May – 18 August 1985
A Retrospective Exhibition of Sculpture by Paul Manship, Smithsonian Institution, Washington D.C., 23 February – 16 March 1958
200 Years of American Sculpture, Whitney Museum of American Art, New York, 16 March – 26 September 1976

8 PAINTINGS, GRAPHICS, POSTERS AND BOOKBINDINGS

Ades, Dawn, The 20th Century Poster – Design of the Avant-Garde, New York, 1984
Barnicoat, John, Posters: A Concise History, London, 1972
Brown, Robert K., and Reinhold, Susan, The Poster Art of A.M. Cassandre, New York, 1979
Clouzot, Henri, Papiers, peints et teintures modernes, Paris, 1928
Delhaye, Jean, Art Deco Posters and Graphics, New York, 1977
Derval, Paul, The Folies-Bergère, New York, 1955; London 1956
Kery, Patricia Frantz, Art Deco Graphics, New York, 1986
Lepape, Claude, and Defert, Thierry, From the Ballets Russes to Vogue – The Art of Georges Lepape, New York, 1984
Lieberman, William S. (ed.), Art of the Twenties, New York, 1979
Mouron, Henri, Cassandre, London and New York, 1985
Muller-Brockman, Josef, and Shizuko, History of the Poster, Zurich, 1971
Packer, William, The Art of Vogue Covers: 1909–1940, London and New York, 1967
Weitenkampf, Frank, The Illustrated Book, Cambridge, Mass., 1938

Exhibition Catalogues
A Century of Posters 1870–1970, Jack Rennert, New York, 1979
Exposition A.M. Cassandre, Musée des Arts Décoratifs, Paris, 1950
Livres illustrés 1900–1930, Slatkine Beaux Livres, Geneva, c. 1984
Painting in France 1900–1967, circulated by the International Exhibitions Foundation, Washington, D.C.: National Portrait Gallery of Art, 1968
Premier Posters by Jack Rennert, New York: Poster Auctions International, 1985
Tamara de Lempicka, Galérie du Luxembourg, Paris, 1972

9 JEWELRY

Battersby, Martin, Art Deco Fashion: Fashion Designers 1908–1925, New York, 1984
———, The Decorative Twenties, New York, 1969, London, 1976
———, The Decorative Thirties, New York, 1971; London, 1976
Becker, Vivienne, Antique and Twentieth-Century Jewelry, London, 1980; New York, 1982
Black, J. Anderson, The Story of Jewelry, New York, 1974
Bradford, Ernie, Four Centuries of European Jewelry, New York, 1953
Cartlidge, Barbara, Twentieth-Century Jewelry, New York, 1985
Deboni, Franco (ed.), Authentic Art Deco Jewelry Designs, New York, 1982
Garbardi, Melissa, Les Bijoux de l'art déco aux années 40, Paris, 1986
Gary, Marie-Noël de, Les Fouquet, Musée des Arts Décoratifs, Paris, 1983
Heiniger, Ernst A. and Jean, The Great Book of Jewels, Lausanne, 1974
Hinks, Peter, Twentieth-Century British Jewelry 1900–1980, London, 1983
Hughes, Graham, Modern Jewelry, New York, 1968
Nadelhoffer, Hans, Cartier, London and New York, 1984
Raulet, Sylvie, Art Deco Jewelry, London and New York, 1984

———, Van Cleef & Arpels, New York, 1987

Magazine article
Clouzot, Henri, 'Reflexions sur la joaillerie de 1929,' Figaro Supplement Artistique (11 July 1929): 685–688

Periodical
The Jeweler's Circular and Horological Review, 1912–1933

10 ARCHITECTURE

Cerwinske, Laura, Tropical Deco, The Architecture and Design of Old Miami Beach, New York, 1981
Chanin, Irwin S., A Romance with the City, New York, 1982
Cucchiella, S., Baltimore Deco: An Architectural Survey of Art Deco in Baltimore, Baltimore, Md., 1984
Ferriss, Hugh, The Metropolis of Tomorrow, New York, 1929
Gebhard, David, L.A. in the Thirties, Los Angeles, Calif., 1975
———, and Co., A Catalogue of the Architectural Drawing Collection, The University Art Museum, University of California, Santa Barbara, Calif., 1983
Gebhard, David, and Winter, Robert, Architecture in Los Angeles: A Complete Guide, Salt Lake City, Utah, 1985
Jacoby, Stephen M., Architectural Sculpture in New York City, New York, 1975
Krinsky, Carol Herselle, Rockefeller Center, New York, 1978
Pevsner, Nikolaus, The Sources of Modern Architecture and Design, London and New York, 1968
Robinson, Cervin, and Bletter, Rosemary Haag, Skyscraper Style: Art Deco New York, New York, 1975
Varian, Elayne H., American Art Deco Architecture, New York, 1975
Whiffen, Marcus, and Breeze, Carla, Pueblo Deco: The Art Deco Architecture of the Southwest, Albuquerque, N.M., 1984

Index